beauty is nowhere

ethical issues in
art and design

Critical Voices in Art, Theory and Culture
A series edited by Saul Ostrow

Now Available

Seams: Art as a Philosophical Context
Essays by Stephen Melville
Edited and Introduced by Jeremy Gilbert-Rolfe

Capacity: History, the World, and the Self in Contemporary Art and Criticism
Essays by Thomas McEvilley
Commentary by G. Roger Denson

Media Research: Technology, Art, Communication
Essays by Marshall McLuhan
Edited and with a Commentary by Michel A. Moos

Literature, Media, Information Systems
Essays by Friedrich A. Kittler
Edited and Introduced by John Johnston

England and Its Aesthetes: Biography and Taste
Essays by John Ruskin, Walter Pater, and Adrian Stokes
Commentary by David Carrier

The Wake of Art: Criticism, Philosophy, and the Ends of Taste
Essays by Arthur C. Danto
Selected and with a Critical Introduction by Gregg Horowitz and Tom Huhn

Beauty Is Nowhere: Ethical Issues in Art and Design
Edited and Introduced by Richard Roth and Susan King Roth

Forthcoming Titles

Music/Ideology: Resisting the Aesthetic
Edited and with an Introduction by Adam Krims
Commentary by Henry Klumpenhouwer

Critical Vices: The Myths of Postmodern Theory
Essays by Nicholas Zurbrugg
Commentary by Warren Burt

Difference/Indifference: Musings on Postmodernism,
Marcel Duchamp and John Cage
Introduction, Essays, Interviews and Performances by Moira Roth
Commentary by Jonathan D. Katz

Footnotes: Six Choreographers Inscribe the Page
Edited and with a Commentary by Elena Alexander
Introduction by Jill Johnston

When Down Is Up: The Desublimating Impulse
Essays by John Miller
Edited and with a Commentary by Ulf Wuggenig

Practice: Architecture, Technique and Representation
Essays by Stan Allen
Commentary by Diana Agrest

This book is part of a series. The publisher will accept continuation orders which may be cancelled at any time and which provide for automatic billing and shipping of each title in the series upon publication. Please write for details.

jean dubuffet
keller easterling
hans haacke
hachivi edgar heap of birds
jeffrey kipnis
joseph koncelik
maya lin
laura lisbon
ellen lupton
victor margolin
thomas mcevilley
w.j.t. mitchell
victor papanek

beauty is nowhere

ethical issues in art and design

edited and
introduced

richard roth
susan king roth

Australia · Canada · China · France · Germany · India · Japan · Luxembourg
· Malaysia · The Netherlands · Russia · Singapore · Switzerland · Thailand

G+B
ARTS
INTERNATIONAL

Amsteldijk 166
1st Floor
1079 LH Amsterdam
The Netherlands

British Library Cataloguing in Publication Data

Beauty is nowhere : ethical issues in art and design.—
(Critical voices in art, theory and culture)
1. Art—Moral and ethical aspects
2. Design—Moral and
ethical aspects
I. Roth, Richard II. Roth, Susan King
745.4

ISBN 90-5701-311-8

contents

Introduction to the Series	*vii*	
Foreword	*ix*	
Duty Bound		
Acknowledgments	*xvii*	
Introduction: Beauty Is ~~**Everywhere**~~ **Nowhere** ~~**Everywhere**~~	*1*	*Richard Roth and Susan King Roth*
Anticultural Positions	*9*	*Jean Dubuffet*
What Is at Stake in the Culture Wars?	*17*	*Thomas McEvilley*
Toward the Spiritual in Design	*37*	*Victor Papanek*
Interview with Hans Haacke	*49*	*Jessica Prinz and Richard Roth*
Round Table Discussion	*65*	*Maya Lin*
Political Space Part I: Moonmark	*75*	*Jeffrey Kipnis*
Sex Objects	*85*	*Ellen Lupton*
Round Table Discussion	*93*	*Ellen Lupton*
Interview with Hachivi Edgar Heap of Birds	*99*	*Stephen Pentak*
Design, Aging, Ethics and the Law	*113*	*Joseph A. Koncelik*
Distributive Protocols: Residential Formations	*151*	*Keller Easterling*
Painting and Ethics (or looking for painting)	*161*	*Laura Lisbon*
The Politics of the Artificial	*171*	*Victor Margolin*
The Violence of Public Art: ***Do the Right Thing***	*189*	*W. J. T. Mitchell*
Notes	*209*	
Permissions	*223*	
Contributors	*225*	

introduction
to the series

CRITICAL VOICES IN ART, THEORY AND
Culture is a response to the changing
perspectives that have resulted from the
continuing application of structural and
poststructural methodologies and inter-
pretations to the cultural sphere. From the ongoing processes of deconstruc-
tion and reorganization of the traditional canon, new forms of speculative,
intellectual inquiry and academic practices have emerged which are premised on
the realization that insights into differing aspects of the disciplines that make
up this realm are best provided by an interdisciplinary approach that follows a
discursive rather than a dialectic model.

In recognition of these changes, and of the view that the histories and prac-
tices that form our present circumstances are in turn transformed by the
social, economic, and political requirements of our lives, this series will pub-
lish not only those authors who already are prominent in their field, or those
who are now emerging—but also those writers who had previously been
acknowledged, then passed over, only now to become relevant once more.
This multigenerational approach will give many writers an opportunity to

analyze and reevaluate the position of those thinkers who have influenced their own practices, or to present responses to the themes and writings that are significant to their own research.

In emphasizing dialogue, self-reflective critiques, and exegesis, the Critical Voices series not only acknowledges the deterritorialized nature of our present intellectual environment, but also extends the challenge to the traditional supremacy of the authorial voice by literally relocating it within a discursive network. This approach to texts breaks with the current practice of speaking of multiplicity, while continuing to construct a singularly linear vision of discourse that retains the characteristics of dialectics. In an age when subjects are conceived of as acting upon one another, each within the context of its own history and without contradiction, the ideal of a totalizing system does not seem to suffice. I have come to realize that the near collapse of the endeavor to produce homogeneous terms, practices, and histories—once thought to be an essential aspect of defining the practices of art, theory, and culture—reopened each of these subjects to new interpretations and methods.

My intent as editor of Critical Voices in Art, Theory and Culture is to make available to our readers heterogeneous texts that provide a view that looks ahead to new and differing approaches, and back toward those views that make the dialogues and debates developing within the areas of cultural studies, art history, and critical theory possible and necessary. In this manner we hope to contribute to the expanding map not only of the borderlands of modernism, but also of those newly opened territories now identified with postmodernism.

Saul Ostrow

foreword
duty bound

WALTER BENJAMIN UNDERSTOOD, IN HIS essay "Art in the Age of Its Technical Reproducibility," that changes due to technology were not only affecting our cultural forms but also their reception. The effect of this transition was an increased level of anaesthetization. For Martin Heidegger, in "Concerning the Question of Technology and the Origins of the Work of Art," modernity represented the force by which technologies (any form of tool, be it language or the machine), the source of an illusionary reality of external objects, would eventually dampen the imagination, curtail creativity and enslave the will. The only chance of preventing this was a radical self-consciousness of the fact that we are responsible for putting these objects into the world and must exert control over them. The arts were a serious force in this program, for they are antithetical to this reifying logic.

In the early 1960s, Theodor Adorno, who had also recognized the coming crisis of modernist culture in the 1930s and 1940s, suggested that the value of its practices now lies in the process of trying to produce ideal situations and forms because the by-products of this endeavor were concrete models of what

is possible. This appraisal, given the instrumental logic of capital, was accompanied by a warning; for Adorno believed that the acritical implementation of this practice would lead to the aesthetization of everything. He proposed in his essay "On Tradition" that this would result in art's regression into the world of real objects and a cultivated nostalgia for what had been. Adorno's vision of the effect late capital's hegemonic logic had on the cultural sphere by the end of the 1960s seemingly was realized; the consequence of which was that the irreconcilable dichotomies of the metaphysical predilection of modernism's materialism not only became apparent, but an obstacle to the very point of view that it had advanced.

In the early 1970s, following a period in which the nature of popular culture had been reformed and high art's conceptualization had been completed, Jean Baudrillard announced (in "The Mirror of Production") that we had entered a period characterized by a tyranny of signs and simulations. Meanwhile, Jean-François Lyotard, who coined the term "postmodern condition" in his essay of the same name, analyzed the affect that the displacement of experience within a culture of information would have on the nature of our subjectivity and social expectations. Fredric Jameson, acknowledging these trends, set about to explain the ideological effects of these cultural changes in "The Political Unconscious." This was quickly followed by Arthur Danto's *The Transfiguration of the Commonplace*, which determined that—if not politically, at least culturally—we had entered into a posthistorical era in which the sole measure of significance within this context was the appropriateness of an act in relation to responding circumstances. In other words, an object could be judged to be a significant work of art because it could be *interpreted* as such.

With each new theoretical and ideological pronouncement and the corresponding shifts that were taking place within the interrelated spheres of politics, culture, and technology, the producers/consumers of culture found it necessary to reflect, to reevaluate and reorient their concepts of obligation and necessity. More recently, in plotting a course between the moot and "indiscernible" points that result from Jacques Derrida's deconstruction of the social and Richard Rorty's notion of reasoned responses as a means by which to sustain the foundation of liberal democracy, Ernesto Leclau proposed that in the

face of social and political dilemmas induced by the postmodern era, there is a need to realize a new hegemony of consciousness premised on a recognition of its own precarious state as a structure of various representations.[1]

Such philosophical and sociological characterizations of the effect of modernism's social and cultural ideologies point to the fact that the aspiration to maintain some form of cultural autonomy has been increasingly problematized since the emergence of mass media and production. Inherent in this modernism's ideology, after all, was a belief in our ability to self-consciously manage cultural change while expanding the means of expression, this being the task of the avant-garde. Obviously with time the system of values, criteria, and standards designed to accomplish these tasks was no longer capable of helping us negotiate the transit from the particular to the general, from the subjective to the social, from isolated events to the historical. Now, in the absence of a viable paradigm, competing models and priorities contend for precedence. It is this that marks the transition from the modernist era to one defined by such prefixes as "post-" or "non-."

While the works of Benjamin, Heidegger, Adorno, Danto, Derrida, Rorty, and Leclau do not appear in *Beauty Is Nowhere*, their views, orientations, and ideas inform the essays, interviews, and transcripts Richard Roth and Susan King Roth have assembled. Like the aforementioned philosophers, the artists, designers, critics, and theorists included in this collection explore, from diverse and divergent perspectives, the terms and conditions of culture's implicit social content and its affect on the cultural economy of intention, signification, and interpretation that forms our subjectivity.

Jean Dubuffet's text "Anticultural Positions" sets the tone for this discursive exploration of what is at stake when aesthetics' social role is acknowledged as more than a question of taste. In this essay, Dubuffet establishes a critique of the classic belief in the higher ideals embodied in the search for beauty. His text proposes that something as innocuous as aspiring to the appreciation or production of the beautiful is limiting and discriminatory, serving various unstated ideological ends when uncritically upheld as merely an unbiased ideal. Given the role this essay plays in the organization of this book I was tempted to title this foreword "Resisting Aesthetics", but that concept has been used elsewhere in

this Critical Voices book series.[2] I settled instead on "Duty Bound," because of the double entendre and because it emphasizes another theme that is fundamental to this particular book, the thorny problem of where the duty and culpability lie for those who produce culture and those who consume it.

This question of art's implicit political and social content and effects becomes of utmost concern as traditional cultural values are eroded and "everyday life," that realm of the private and the public, becomes subjected to aesthetization. The consequence of this is that the opposition between art and design, between aesthetic and artistic, between the senselessness of one and the practicality of the other, slip the bonds of their respective histories and meld together. Over time we have seen a migration away from a concern for aesthetic experience and self-consciousness, and toward a concern for the conceptual content of signs, events, and practices formed or maintained by the cultural sphere. With this movement away from the experiential, the limits and paradigms that once defined the aesthetic barrier between art and its other have evaporated before our very eyes. The effect of this has been an intensification of the impact of high and low culture upon the complexity of social issues that face us.

In the mediated and anesthetized environment of everyday life—with simultaneous events having a conspicuous impact on one another due to the effects of mass media, and the culture industries' integration into our daily lives—no one escapes being affected by the broad range of practices that come under the aegis of cultural production. With this comes a realization that the values prescribed by both the form and content of products supplies us with the perspectives from which our subjectivity and identity are constructed. The result is what have become known as the "culture wars"—a political struggle by proxy in which the opposing sides seek to establish cultural priorities as a means to achieve political ends, therefore, underlying the question of ethical responsibility and the social role that artists and designers may play is the question of what comprises the myriad array of means available to them—and their audience—in discerning what constitutes desirable effects. Obviously the problems of determining goals, effects, and criteria are not imposed one on the other, but are intimately intertwined. It is within this economy, as mediated by self-consciousness and desire, that the ethical manifests itself.

At the heart of any exchange, be it cultural or economic, the question of propriety is premised upon how we judge the nature of the existence of the "other." The philosopher Emmanuel Levinas locates the foundation of ethical behavior and thought within this conundrum of determining if our existence is relatively, or absolutely, independent of an other. He proposes that it is through this relationship to the other and its objectification that we mediate our relation to will and history. While the humanist ideology of modernism proposes that the "I" and the other are one in the same—and that by ignoring or negating all differences the essential qualities of being will be established—Gilles Deleuze and Felix Guattari find behind this (in their essay "Schizoid Culture") a discourse of dominance and submission, as each "I" attempts to establish itself as the norm. This conflict has revealed the impossibility of realizing such a universal self. This awareness that the self is a cultural product torn between promises of individuality and collectivity has required a reexamination of the subjectivities induced by our aesthetic and cultural environment.

A further undermining of Western society's cultural norms stemmed from the fact that modernism's agent—an avant-garde forged by the tasks of merging art and life while maintaining art's aesthetic and conceptual autonomy—has gained institutional status. This vanguard, which established itself by breaking new ground and expanding traditional forms and definitions through a process of negation, has been left with nothing to rebel against but itself. The result is that, rather than creating taste or challenging formal or conceptual limitations, its practices now generate novelties that appeal to its audiences' expectations. This transformation of the *traditional* practice of modernist artists and designers creating works or styles that mirrored the interiority of their respective fields and the conditions under which they existed likewise brought forth a reconsideration of their social function and responsibility.

What does persist as a residual attitude of modernism is the belief that within the multidimensional space of the cultural sphere there resides the means to recuperate social structures, forms and practices. To achieve this, and to resist what might be conceived of as cultural degeneration, a diverse range of cultural producers still seek to infuse their own practices with an ethical if not moral stance. Interestingly, those who explore this dimension of cultural production

in the name of a radical reordering of priorities presuppose an organic community into which they may be integrated. More often than not they act in the name of general principles and abstract causes because they perceive themselves as individualized or autonomous producers—and the content of their practices is self-determined rather than utilitarian. In the face of the loss of real communities and the increased abstractness of the social, the ability to produce a model practice that might allow someone to navigate the complexities of the culture of late capital is more elaborate than merely taking a ready-made political position or defining some idealistic stance.

The self-conscious effort to generate a mode of thought that will allow us to comprehend and evaluate the impact of our cultural practices, as well as those issues that circumscribe them, has produced an interdisciplinary approach. This mode—as a response to new demands as well as older ones—replaces outdated subjects by constructing supplementary ones. The debates concerning the end of history, multiculturalism, and the proliferation of cultural studies and visual culture programs are manifestations of this reorientation. Yet such an approach to the reordering of social and cultural priorities and practices is not a panacea, for it brings with it its own practical and ideological problems.

Because interdisciplinary practices construct cultural texts by forming chains of reference and inference, there is a temptation either in the name of creativity or political revelation to engage in an infinite regression toward indeterminacy or absurdity. Given that an analysis from one perspective often appears to be either arbitrary, subjective, or chaotic and from another to make all frames of reference from the civic to the sexual appear slippery, this has raised the question: Are we to accept that in this age of information, discursive inquiry, and fluidity that meaning and judgment can never be anything more than arbitrary or imagined? It is this indeterminacy that has preceded—and been a catalyst for—both the call for a return to the traditional Western canon and the cynical belief that if all that lies behind such readings are subjectivity, politics, and opportunism, there are no positions that can be taken, since all things are relative.

The alternatives of idealistic nostalgia and cynicism leave us with a seemingly hopeless situation, yet within this volume numerous models of resistance and

intervention—both personal and theoretical—are represented. These stem conceptually from such differing sources as the nineteenth-century romantic model of the power of the aesthetic to those views of cultural politics derived from the writings of the Frankfurt school to those more consistent with the methodologies and definitions established by poststructuralist thought. Within the exchange of views and modes of expression produced by the interaction of these varied texts, culture's details are exposed as being dependent on societal objectives, and beauty, quality, wealth, poverty, and the like are shown to be arbitrary concepts laid down by remote categorizational processes. Given the subtitle of this volume it can be inferred that if something is to be done about our present cultural state, it is this process of classification that anticipates our participation that must be looked into and understood, because it forms and gives representation to our individual subjectivities by establishing the narratives that delineate both our imagination and vision.

Saul Ostrow

acknowledgments

FIRST AND FOREMOST WE EXTEND OUR gratitude to the distinguished contributors to *Beauty Is Nowhere: Ethical Issues in Art and Design.* Thank you Keller Easterling, Hans Haacke, Hachivi Edgar Heap of Birds, Jeffrey Kipnis, Joseph Koncelik, Maya Lin, Laura Lisbon, Ellen Lupton, Victor Margolin, W. J. T. Mitchell, Thomas McEvilley, Victor Papanek, Stephen Pentak, and Jessica Prinz. We are honored as well to be able to include Jean Dubuffet's essay.

Beauty Is Nowhere grew out of a thematic lecture series, "Ethical Issues in Art and Design," sponsored by the Center for Interdisciplinary Studies in Art and Design in the College of the Arts at The Ohio State University in 1993. The contributors to this book participated in various ways in the Center's programming that year, except for Victor Margolin who participated the following year, and W. J. T. Mitchell and Jean Dubuffet whose contributions were selected to augment this anthology. Though *Beauty Is Nowhere* has taken on a life of its own, it owes a great deal to the original series. We are indebted to Donald Harris, Dean of the College of the Arts, and Judith Koroscik, Associate Dean, for their

advocacy. The Center for Interdisciplinary Studies was underwritten by the College of the Arts with additional support from the Wexner Center for the Arts, the Departments of Art, Industrial Design, Architecture, Art Education, History of Art, and the Center for Women's Studies. We are grateful to Patricia Trumps, Director of Education at the Wexner Center for her gracious cooperation, and to Robert Arnold, William B. Cook, Georg Heimdal, Robert Shay, Jose Oubrerie, Michael Parsons, Mark Fullerton, Sally Kitch, Kay Bea Jones, Mark Robbins, Charles Leinbach, Donald Perone, and Bruce Bartoo for their support.

We thank our original advisory committee: Terry Barrett, Nathaniel Belcher, Wayne Carlson, and Stephen Melville, as well as Sarah J. Rogers who made our productive ties to the Wexner Center possible and supported this effort in countless ways. We acknowledge the invaluable assistance of Lyz Bly, Cathy Ellis, Todd DeVries, and Paul Solomon, and thank Hari Krishnanath for his help and Rebecca Shore for her detective work in Chicago. The Center for Interdisciplinary Studies in Art and Design was a grass-roots effort supported by numerous faculty, graduate students, and staff who graciously volunteered services.

We are especially grateful to Saul Ostrow for his assistance in realizing this book and for his insight, warmth, and good humor. We thank Alfred van der Marck, Liza Rudneva, and Brian Bendlin for their support.

We must acknowledge our gratitude to our son Justin Roth for putting everything in perspective.

We dedicate our efforts to the memory of Irving M. Roth (1918–1982).

Richard Roth
Susan King Roth

introduction
beauty is ~~everywhere~~
nowhere ~~everywhere~~

richard roth and
susan king roth

Tetsugen, a devotee of Zen in Japan, decided to publish the sutras, which at that time were available only in Chinese. The books were to be printed with wood blocks in an edition of seven thousand copies, a tremendous undertaking.

Tetsugen began by traveling and collecting donations for this purpose. A few sympathizers would give him a hundred pieces of gold, but most of the time he received only small coins. He thanked each donor with equal gratitude. After ten years Tetsugen had enough money to begin his task.

It happened that at that time the Uji River overflowed. Famine followed. Tetsugen took the funds he had collected for the books and spent them to save others from starvation. Then he began again his work of collecting.

Several years afterwards an epidemic spread over the country. Tetsugen again gave away what he had collected, to help his people.

For a third time he started his work, and after twenty years his wish was fulfilled. The printing blocks which produced the

*first edition of sutras can be seen today in the Obaku monastery
in Kyoto.*

*The Japanese tell their children that Tetsugen made three
sets of sutras, and that the first two invisible sets surpass even
the last.*

—Zen Story[1]

AWARE OF THE IMPOSSIBILITY OF EASY
answers or universal pronouncements,
we look at the relationship of ethics to
the disciplines of art and design, con-
vinced of the necessity of this investiga-
tion as we balance precariously on the edge of the millennium.

Along with forces of coercive power, ethnic warfare, culture wars, and
dangerous new technologies, the escalating complexity of postindustrial life
brings uncertainty. Assuming the possibility of formulating a cogent moral
position in a given instance, acting on it in the entangled contemporary world
to produce the desired outcome is increasingly a gamble. Ethical thought
grounded in religion, rationality, and consensus has become destabilized as
postmodern discourse challenges our every assumption. What do we make of
these widely held contemporary ideas that appear to encompass ethical
thought, the arts, and in fact all of culture? As postmodernism debunks mod-
ernism's dearest notions it contributes to the creation of a landscape of uncer-
tainty, a landscape devoid of universal truths, facts, and objectivity. The
boundaries between disciplines, between high culture and mass culture, and
between art and non-art have become blurred. To the postmodern mind the
modernist notion of progress based on rationality, science, and the preemi-
nence of Western culture was but a means to domination. All representations
are seen as sites of authority and power. Hierarchies are being rearranged as
feminism challenges male hegemony and marginalized Others struggle for
empowerment. In this environment, ethical thought is reconfigured, and art,
which has been on the run since the invention of the camera, exists in a state of
crisis.

While it might appear that the solidity and clarity of modernism have vaporized, it is productive to view postmodernism as a set of positions that do not replace modernism and its faith in rationality, but exist concurrently with modernist thought. Postmodernism is but another discursive layer. It does not erase modernism, as modernism in turn failed to eradicate premodern romantic beliefs, religion, and superstition. In this view we exist in an increasingly multi-layered field of consciousness where nothing is actually lost though much is hidden or overlooked as beliefs accumulate.

Beauty Is Nowhere exists in recognition of the need to redefine and regroup in the arts, to make art and design "matter" in a new terrain. The interdisciplinary, multifaceted perspective of this anthology is intended to illuminate important concerns and spark unexpected connections. From informal discussion to formal essay, distinguished artists, curators, scholars, designers, and architects contribute, through theoretical discourse and practical policy, to the necessary "working out" of the relationship of ethics to art and design.

Some enduring ethical positions that form our legacy and stand in opposition to postmodern thought serve here to present a more complete picture of contemporary attitudes—to remind us of the diversity and complexity of discourse at the dawning of the twenty-first century.

Almost every human society has exhibited fundamental forms of proto-moral altruistic behavior involving the raising of children, regard for kin, tribal responsibilities, constraints on killing and harming group members, and reciprocity—the obligation to return favors. Human-made artifacts, whether "decorative" or "functional," and structures for habitation have always been generated by specific social requirements which are to some extent biologically determined.

Pleasure, comfort, usefulness, entertainment, and intellectual challenge are functional characteristics of so many designed artifacts, from Neolithic stone tools to computers, magic potions to antibiotics, paintings to television. The philosophy of utilitarianism, which maintains that one should act so as to provide the greatest happiness (and least pain) for the greatest number of people, continues to be a widespread moral precept. In *The Body in Pain*, Elaine Scarry

encourages us to see handmade and even industrially manufactured functional artifacts as spiritual gifts contributing to the general good: "But anonymous, mass-produced objects contain a collective and equally extraordinary message: Whoever you are, and whether or not I personally like or even know you, in at least this small way, be well." She compels us to recognize "the collective human salute that is implicit in the very manufacture of such objects."[2] All artifacts, ideologies, and the built environment—as protective talismans embodying physical and psychic shelter—participate in the ethics of utilitarianism.

> *What are the landscapes of fear? They are the almost infinite manifestations of the forces for chaos, natural and human. Forces for chaos being omnipresent, human attempts to control them are also omnipresent. In a sense, every human construction—whether mental or material—is a component in a landscape of fear because it exists to contain chaos. Thus the children's fairy tales as well as the adults' legends, cosmological myths, and indeed philosophical systems are shelters built by the mind in which human beings can rest, at least temporarily, from the siege of inchoate experience and of doubt. Likewise, the material landscapes of houses, fields, and cities contain chaos. . . . Generally speaking, every human-made boundary on the earth's surface—garden hedge, city wall, or radar "fence"—is an attempt to keep inimical forces at bay.*
> —*Yi-fu Tuan*[3]

Aristotle proposed that moral virtue shared characteristics with good works of art—both occupied middle positions between excess and defect—and they were appropriate responses.[4] The doctrine of the relative mean, so critical to Greek philosophy ("nothing in excess" was inscribed on the temple of Apollo at Delphi) has survived to the present as a strong cultural notion. Revitalized at the Bauhaus, appropriateness and the avoidance of excess and defect became tenets of modernist design.

Most recently we see the relative mean reappear as the rallying cry of designers concerned with the environment and global social issues as they attempt to

maintain a reasonable balance between a product's "use value" and its economic, social, and environmental cost. The idea of the mean has staying power. Its pragmatic benefits are quantifiable. When huge systems fail all hell breaks loose. As the disciples of moderation go forward into the technological unknown they invest in the future as well as protect the past.

Art and art history are not simply honorific projects focused on paying attention to all that is worthy. Art and art history are political and ideological discourses—editorial projects—banishing all that is deemed unworthy.

In 1951 Jean Dubuffet gave a lecture, "Anticultural Positions," at the Arts Club of Chicago that became legendary among Chicago artists seeking validation for their interest in "naive" expression and for their opposition to what they felt to be a depleted and repressive European/New York establishment. Re-presenting this text in a different time and context, its far more radical proposition—a challenge to the notion of beauty—becomes provocatively conspicuous. Perceived as universally good, the concept of beauty is one of the most deeply ingrained and naturalized cultural notions. Dubuffet exposes the implicit exclusionary nature and the violence embodied in the concept of *beauty*: "I intend now to speak of the notion of beauty adopted by occidental culture. I want to begin by telling you in which [*sic*] my own conception differs from the usual one. The latter believes that there are beautiful objects and ugly objects, beautiful persons and ugly persons, beautiful places and ugly places, and so forth. Not I. I believe beauty is nowhere, I consider this notion of beauty as completely false—I refuse absolutely to assent to this idea that there are ugly persons and ugly objects. This idea is for me stifling and revolting. . . ." Dubuffet makes it clear that there is much more to be gained than lost by rejecting a philosophy of exclusion, and he concludes by stating "that any object is able to become for any man a way of fascination and illumination."[5]

The above quotation and this book's title, *Beauty Is Nowhere*, are taken from a copy of Dubuffet's original handwritten lecture notes. The text version in this anthology is a translated variation of that original lecture. "Anticultural Positions" is a courageous moral stand against the hierarchical concept of

beauty, a critique of Western cultural arrogance, and an index of Dubuffet's distrust of language. First he wrote "beauty is everywhere," then in an almost comical sequence of rewrites and strike-throughs he concluded: "beauty is ~~everywhere~~ nowhere ~~everywhere~~."[6]

> When Banzan was walking through a market he overheard a
> conversation between a butcher and his customer.
> "Give me the best piece of meat you have," said the customer.
> "Everything in my shop is the best," replied the butcher.
> "You cannot find here any piece of meat that is not the best."
> At these words Banzan became enlightened.
>
> —Zen Story[7]

Imaging and the construction of reality are no longer the private domain of professionals. From the videotaping of the Rodney King beating by George Holliday, an amateur with a camcorder, to the purchase at auction of industrial pollution rights by a group of law students who pooled $3,256 to let these rights expire unused (preventing the emission of eighteen tons of sulfur dioxide),[8] there is an abundance of powerful and surreal images, acts of resistance, transformative events, and meaningful actions beyond the borders of our cultural disciplines.

An ethical task of the art world is that of cognitive decolonization—to continue the project of dismantling hierarchies, relinquishing privilege, and standing in opposition to forces of exclusion (while not forgetting the ethical significance of play and pleasure). Dubuffet's view, in this context, is not an anomaly, but a natural extension of the long history of iconoclastic activism and populist sentiment in the visual arts, a history in which artists have opened themselves to the widest range of visual and material culture.

Legislation and public opinion are influencing design and architecture, especially in the realm of ethics. The shape of the future will be increasingly determined by these administrative forces, less by individual designers. The expected acceleration, complexity, and institutionalization of twenty-first century life suggest that design and architecture extend their disciplinary boundaries to

include and/or reprioritize their commitment to design research, design law, design activism, and design legislation.

The future is often perceived as either a dystopia of uniformity or a faithless place where "anything goes" (a social order resembling the outlaw bikers in the postapocalyptic film *The Road Warrior*). But there is reason for optimism as cultural workers become increasingly sensitive, in whatever they do, to the widest social field. Contemporary artists and designers are agents and initiators of new social realizations, and these realizations are essentially ethical.

anticultural
positions

jean dubuffet

AN IMPORTANT CHANGE APPEARS TO BE taking place in many minds within the field of art as well as so many other areas. Certain values long held to be definite and indisputable are now beginning to seem dubious if not completely false; others, formerly neglected or even despised, are now turning out to have great worth. This change is, no doubt, largely due to the knowledge we have been gaining during the past fifty years in regard to so-called primitive civilizations and their specific ways of thinking. Their art works have greatly disconcerted and engrossed the western public.

We are beginning to ask ourselves whether our Occident doesn't have something to learn from those savages. It could very well be that in various domains, their solutions and approaches, which have struck us as simplistic, are ultimately wiser than ours. It could very well be that we're the ones with simplistic attitudes. It could very well be that they rather than we are characterized by refinement, mental ability, and depth of mind.

I, personally, have a very high regard for the values of primitive peoples: instinct, passion, caprice, violence, madness. Nor do I feel that these values are

in any way lacking in our western world. Quite the contrary! But the values cel-
ebrated by our culture do not strike me as corresponding to the true dynamics
of our minds. Our culture is an ill-fitting coat—or at least one that no longer fits
us. It's like a dead tongue that has nothing in common with the language now
spoken in the street. It drifts further and further away from our daily life. It is
confined to lifeless coteries, like a mandarin culture. It has no more living roots.

I aim at an art that is directly plugged in to our current life, an art that starts
out from this current life, that immediately emanates from our real life and
our real moods.

I would like to enumerate certain points in our culture with which I disagree.

One of the chief traits of the western mind is its habit of ascribing to
humankind a nature quite different from that of all other creatures, a refusal to
identify our nature with, or compare it in any way whatsoever to, such elements
as the wind, a tree, a stream—except in jest or in poetic figures. Western man
despises trees and streams. He hates the very thought of being like them. The
"primitive" however loves and admires trees and streams. He takes great plea-
sure in resembling them. He believes in an actual similitude between a human
being, a tree, and a stream. He has a very strong sense of the continuity binding
all things, especially humanity and the rest of the world. These "primitive" soci-
eties certainly have a greater respect than western man for all the creatures on the
earth. They do not see humankind as the lord of other creatures but merely as
one of them.

Western man believes that his mind is capable of acquiring a perfect knowl-
edge of things. He is convinced that the rest of the world keeps perfect step with
his reasoning faculties. He strongly believes that the principles of his reason and
especially those of his logic are well founded.

"Savages" feel that there is something weak about reason and logic, they rely
on other ways of gaining knowledge of things.

This is why they so greatly esteem and admire those states of mind which we
refer to as delirium. I must confess that I have a very keen interest in delirium.
I am convinced that art has a great deal to do with delirium.

I would now like to speak about the western world's great respect for elabo-
rated ideas. I do not regard elaborated ideas as the better part of the human

function. They strike me as being a lesser degree of the mental processes, a level on which the mental mechanisms are impoverished, a kind of outer crust formed by cooling. Ideas are like steam that condenses into water upon touching the level of reason and logic.

I do not believe that the best part of mental functioning is to be found in ideas. The workings of the mind does not interest me on that level. My real aim is to capture thought at a developmental point prior to the stage of elaborated ideas.

All art, all literature, and all philosophy in the West operate on that level of elaborated ideas. My own art, my own philosophy, derive entirely from subjacent areas. I try to seize a mental motion at the greatest possible depth of its roots, where I am sure the sap is far richer.

Western culture dotes on analysis, but I have little taste for analysis, little confidence in it. People think that everything can be revealed by disassembling and dissecting all the parts and then studying each individual one.

My own impulse moves in the opposite direction. I am much more apt to treat wholes rather than parts. The moment an object is dismembered even in two, I feel that it's lost for my study, I feel further away from it rather than closer to it.

I believe very strongly that an inventory of parts does not render an account of the whole.

When I really want to view an object, I tend to look at it within the context of everything surrounding it. If I desire to know the pencil lying on my table, I focus my vision, not on the pencil but on the center of the room while trying to see as many objects as possible at once.

When I see a tree in the country, I don't transport it back to my laboratory to look at it through a microscope, because I feel that the wind blowing on the leaves is crucial to any knowledge of the tree and cannot be subtracted. The same holds for the birds in its branches, for the singing of these birds. My cast of mind is such that I always add more of what surrounds the tree and what surrounds the things that surround the tree.

I have dwelt on this point because I feel that this cast of mind is an important factor in my art.

The fifth point is the fact that our culture is based on complete trust in language (particularly written language) and on a belief in its capacity to translate

and elaborate thought. Now this strikes me as a mistake. Language, I find, is a gross, extremely gross stenography, a system of highly rudimentary algebraic signs, damaging rather than serving thought. The spoken word, more concrete than writing, animated by the timbre and intonation of the voice, a bit of coughing, some grimaces, a whole range of mimicry, seems a lot more effective.

I consider written language a poor tool. As an instrument of communication, it conveys merely the carcass of a thought: what slag is to fire. And as an instrument of thought, it overloads the fluid and adulterates it.

I believe (and here I am in agreement with the so-called primitive civilizations) that painting, a medium more concrete than the written word, is a far richer instrument for communicating and elaborating thought.

I have said that what interests me about painting is not so much the moment at which it crystallizes into formal ideas as the preceding stages.

I want my painting to be seen as a tentative language fitted to these areas of thought.

I now come to my sixth and last point: I would like to talk about the western notion of beauty.

First I want to tell you how my conception differs from the usual viewpoint.

For most western people, there are objects that are beautiful and others that are ugly; there are beautiful people and ugly people, beautiful places and ugly ones.

But not for me. Beauty does not enter into the picture for me. I consider the western notion of beauty completely erroneous. I absolutely refuse to accept the idea that there are ugly people and ugly objects. Such an idea strikes me as stifling and revolting.

I think it was the Greeks who invented the notion that some objects are more beautiful than others.

The so-called savages do not believe in this at all. They do not comprehend what you mean by beauty. This is precisely the reason why we call them savages. A name reserved for anyone who fails to understand that there are beautiful things and ugly things and doesn't really worry about it either.

The odd thing is that for centuries and centuries (and today more than ever) western man has been arguing over which things are beautiful and which

are ugly. No one doubts for an instant that beauty exists, but you'll never find two people who agree on which objects are beautiful. The objects differ from one century to the next. In each new century, western culture proclaims as beautiful something that was proclaimed as ugly the century before.

The rationale given for this uncertainty is that beauty, while definitely existing, is hidden from the view of many people. The discernment of beauty would require a special sense with which many people are not endowed.

People also think that this sense can be developed through exercise and even instilled in people lacking it. Schools are set up for this purpose.

The teacher in such a school tells his pupils that there *is* definitely beauty in things, but he instantly has to add that there is disagreement on which things are endowed with it, and that we haven't as yet managed to establish which they are. He urges his pupils to examine the question themselves, and thus from one generation to the next the whole matter remains up in the air.

And yet this notion of beauty is one of the things to which our culture attaches so much value. It is customary to regard this faith in the existence of beauty and the cult devoted to beauty as the chief justification of western society. The very principle of civilization is inseparable from this notion of beauty.

I find this idea of beauty a meager and unintelligent invention. I find it mediocrely stirring. It's distressing to think about those people who are denied beauty because their noses are crooked or because they are too fat or too old. The idea that our world is mostly made up of ugly objects and places while the beautiful objects and places are scarce and hard to find does not strike me as very exciting. I feel that if the West were to discard this idea, then good riddance! If we came to realize that any object in the world may fascinate and illuminate someone, we would be in much better shape. This idea would, I think, enrich our lives more than the Greek notion of beauty.

What will happen to art? For the Greeks, the goal of art was allegedly the invention of beautiful lines and beautiful color harmonies. If we abolish this notion, what's to become of art? Let me tell you. Art will then revert to its true function, a far more effective one than arranging shapes and colors for a supposed delight to the eyes.

The function of assembling colors in pleasing arrangements does not strike me as particularly noble. If this were all there was to painting, I wouldn't devote a single hour of my time to it.

Art addresses the mind and not the eyes. That is how it has always been regarded by "primitive" societies; and they are correct. Art is a language, an instrument of cognition and communication.

I think that our culture's enthusiasm for writing, which I mentioned earlier, has led us to view painting as a crude, rudimentary idiom good only for the illiterate. In order to allow art some kind of *raison d'être* we invented the myth of plastic beauty, which I feel is utter flimflam.

I have said and I repeat that in my opinion painting is a far richer language than the language of words. It is quite useless to seek any other *raison d'être* for art.

Painting is a far more immediate language than that of written words and at the same time it is charged with far more meaning. It operates with signs that are not abstract or incorporeal like words.

The signs in painting are much closer to the objects themselves. After that, painting manipulates subjects that are in themselves living substances. This is why it permits us to go much further than words can in approaching objects and their evocation.

Painting (and this is quite remarkable) can more or less evoke things at will, that is, with more or less presence. At any degree between being and non-being.

Finally, painting can evoke things not in isolation but linked with everything surrounding them: a huge quantity of things simultaneously.

Furthermore, painting is a much more spontaneous and much more direct language than words: much closer to a shriek or to dancing. This is why painting is a means of expression for our inner voices and far more effective than words.

It lends itself, as I have said, much better than words to translating thought in its different stages, including the lowest levels (those on which thought is close to its birth), the underground levels of mental spurts.

Painting has a twofold advantage over language. First of all, it evokes objects more forcefully, it gets closer to them. Secondly, it opens wider gates to the inner

dancing of the painter's mind. These two properties make painting a marvelous instrument for provoking thought—or, if you like, clairvoyance. And also a marvelous instrument for exteriorizing this clairvoyance and permitting us to share it with the painter.

By utilizing these two powerful means, painting can illumine the world with magnificent discoveries. It can imbue man with new myths and new mystiques, to reveal the infinitely numerous undivined aspects of things and values of which we were formerly unaware.

This, I think, is a much more engrossing task for artists than assemblages of shapes and colors to please the eyes.

what is at stake in the culture wars?

thomas mcevilley

RECENTLY WE VE BEEN EXPERIENCING A rare moment when art has become a prominent issue in national politics. I don't think such a moment has occurred since the McCarthy era, when some American congressmen expressed the belief that abstract art was a communist plot. But today it is not abstract art that is under the light; those who oppose the arts today would welcome a return of abstract painting as something familiar and safe—something reassuringly rooted in aesthetic, rather than social, realities. Now, surprisingly, it's various kinds of figurative art—previously regarded as safe—that seem subversive and offensive.

We're all familiar, from reading the papers, with the famous moments of high drama. On May 18, 1989, for example, Senator Alfonse D'Amato, Republican of New York, took a contemporary art catalog (it was for an Andres Serrano exhibition) onto the floor of the United States Senate, denounced it, tore it into pieces, threw them on the floor, and trampled on them with tasseled

A Talk Given at the Wexner Center for the Arts on March 4, 1993

loafers. Not long after that, a candidate in the Republican primaries, Patrick Buchanan, announced as one of the planks of his electoral program that if he were elected he would not only shut down the NEA, but seal and fumigate it. Buchanan, in a newspaper column that coincided with his entering the primaries, recorded the ten or so atrocities that he felt had happened in American culture in the eighties necessitating the stance of culture war; five or six of them were in the visual arts (Andres Serrano, Karen Finley, Robert Mapplethorpe, etc.). It was a remarkable public acknowledgment of the importance of the visual arts today, an area which is usually more sheltered from public view.

That much and more has happened in the mainstream press. In addition, I'm sure, if you've been following the art press for the last few years, you've noticed an extraordinary stream of bitterly hostile articles directed against contemporary art from the inside; that is, from art critics who have turned against the art of their own time. One of the most outrageous of these attacks was made by Robert Hughes who in the introduction to the collection of his so-called critical essays, remarked that the eighties had been, in his opinion, the worst decade in the history of American art—a totally absurd and overwrought remark. In fact, the eighties was an extraordinarily rich and important era in the history of art in general. Still, we've had similar types of denunciations from critics like Hilton Kramer and Jed Perls in the *New Criterion* and elsewhere. There was a massive denunciation of most of the really interesting recent art by Adam Gopnik in the *New Yorker* a few months ago, and just last Sunday, in the magazine section of the *New York Times*, there was a long and relentlessly ignorant denunciation of contemporary art by a writer named Deborah Solomon whom no one in the art world seems to have heard of but who nevertheless, and unaccountably, was judged competent by the *Times* to make this sweeping denunciation.

What's behind all of this very unusual and intriguing attention to the arts is the fall-out of that shift in cultural attitude which has often been called a shift from modernism to postmodernism. The tension arises from the implication, inherent in the terms themselves, that modernism is not something simply given and eternal—that it, too, is a passing cultural phase that may be over. So tense, in fact, has the situation become, that the terms themselves have come

under relentless attack as if they were sacrilege, or false advertising, or better, treason.

I don't think that one *has* to use those terms, and I agree that there are problems with them, but nevertheless I still find them useful and I will be using them here. The main problem with the terminology as I see it is that it's a little apocalyptic; it implies a *tabula rasa*—that is to say, it implies that one epoch has definitively ended and another definitively begun in an almost metaphysical or cosmological sense—as when the *trita yuga* gives way to the *Kali yuga* in Hindu cosmology. This is one of the big questions about so called postmodernism: how deep a change in cultural attitude is it—and how lasting will it prove?

Fredric Jameson is on record as thinking that it's a really fundamental paradigmatic shift in Western cultural attitudes, so deep and radical that we can never go back. I'm somewhat skeptical of that degree of conviction, which seems almost religious. I am more inclined toward the view proposed by Lyotard in *The Postmodern Condition* when he says that postmodernism is a gradual shift in attitude that proceeds a little bit here in a culture, and a little bit there, and then accumulates. I think it happens that way in a personality too. Postmodernism won't really be a deeply established new epoch until it has reformed our personalities or been incorporated into them. And I think that in a personality, as in the culture at large, it happens in this way—a little bit of a change in attitude about certain issues, and then a little bit of a change about others, and then it accumulates.

Of course, if change is taking place in this gradual and piecemeal fashion, then it would seem that it could also be reversed. One of the essays in my book *Art and Discontent* discusses the fact that the postmodern attitude (or rather the attitude to which we have given the name postmodern but which in the past has been called various other things), has arisen in Western culture repeatedly and been turned back or reversed each time. This may be said to have been going on at least since the faith-reason controversy of the twelfth century—and in fact it may be seen much earlier in certain events of the late Roman Empire.

Today, contrary to the *tabula rasa* approach, modernism still clearly exists. That is why there is such tension and hostility. The so called "culture wars," as Richard Bolton called them in a recent book on the subject, arose because

modernism still exists in a powerful reactionary area of our culture and post-modernism could slam into a wall and stop at any moment, as has happened on numerous earlier occasions in our culture. I'll try to make clear some of the values that I think are at stake in this conflict.

It's convenient to illustrate the difference between modernism and post-modernism with the subject of education. In the classical modernist era it was customary to study any area of culture with a kind of tunnel vision or, as it were, in a kind of a tube, so that if you were studying music history you would be looking down a tube and at a certain point in the tube you would see Bach's *Mass in B Minor* and at another point you would see Mozart's *Requiem*, and there would be certain relations between them but there would be no other type of vocabulary element inside the tube—everything else would be excluded. Or, if you were studying art history, you'd be looking down a tube and you would see a moment when Boucher's influence on Fragonard was interrupted by the intrusive influence of Dutch models on Fragonard's brushwork. And that was the only kind of thing you would see inside the tube. All of society, all of history, and in a larger sense the whole global reality, all of that was outside the tube and implicitly understood as out-of-bounds.

From a postmodern point of view one doesn't necessarily say that that type of study of cultural history is invalid; rather, that that type of study will and should continue, but only as a part of a more varied scholarly praxis. We now try to look not only down the tube but also outside the tube at the same time—to get a little distance on the tunnel vision and see the global situation around it as an enclosing matrix that definitely affects its meaning. As a part of our task and responsibility as cultural workers we try to drive out into the open that network of causal connections that links the reality inside the tube to the reality outside it.

Now, if one looks outside the tube at the geopolitical events surrounding European cultural history, one sees it contextualized within a matrix of two massive movements in world history: one is colonialism, when the Western European nations, expanding their influence outside their inherited territories, gained dominance over effectually the entire rest of the world and wrested

wealth from it; and the second great movement is decolonization, when the European nations recontracted back into their original area, leaving the rest of the world changed in ways not yet defined.

Colonialism may be regarded as beginning in the Crusades, but more definitively in the year 1442, when the first Portuguese slave raid on sub-Saharan Africa occurred. Of course this was also the height of the early and fresh period of the Renaissance. Yet when we study Renaissance art, we rarely think that in fact slave-raiding and early colonialism was the background on which that art was taking place and that the social function which that art was serving had something to do with this background—the fact, for example, that in 1509, about the time Leonardo painted *The Last Supper* and Michelangelo began work on the Sistine Chapel, the first shipload of enslaved Africans arrived in the Caribbean, and then in 1619, again a kind of crucial moment in the history of art, African slaves began to be sold at auction in Richmond, Virginia, and so on. The triangular trade really lies in the background of everything that was happening in European culture during those centuries.

And it had considerable ideological effect, as any source of wealth must. You see, in order to do that kind of thing—in order to rape, plunder and kill your fellow humans in great numbers—you've got to have an incredible degree of self-confidence. You can't do that with a lot of self doubt. So you need a really strong cover story to prevent any possible emergence of self-doubt or tentativeness in what you do. In the early period of colonialism, starting with the Crusades and going up through the seventeenth century, a theological justification was in place: the obligation to baptize the heathen to save them from eternal Hell. As the English poet Richard Crashaw put it, "let it not be a forlorn hope/to wash the Ethiope," meaning the idea that nonwhite people can be rendered into a kind of pure condition supposedly like white people by undergoing the ritual of baptism. This was a perfect justification for colonialism, really, because the doctrine is that if you baptize someone you are essentially giving them a shot at eternal happiness in Heaven after the life here below. So that even though you may have to make them really miserable for a few years here below, look what you're giving them in return. You're giving them eternity—so really they're getting the best of the bargain. Meanwhile,

as another English poet, John Milton, put it, "barbaric pearl and gold" were being heaped up in Western coffers in enormous amounts—and this is where the connection with the history of art comes in. There was a kind of reciprocal connection in which the art activity supported colonialism through its images and colonialism in turn supported the art activity through its development of surplus wealth.

On the one hand, European art's fixation with Christian subject matter during the era of the baptismal or theological justification meant that the entire visual realm of culture was one-dimensionally saturated with the ideology that God was on our side. From the point of view of visual conditioning or visual propaganda there was simply no way to think anything but this ideology. It was impossible to get outside of it, and it seemed not merely to justify but actually to mandate colonial expansion.

Reciprocally, as "barbaric pearl and gold" poured into the Western colonialist states, the effects of enormous surplus wealth were felt in Europe. When a society gets a lot of surplus wealth it means that a lot of people are going to be freed from body-serving types of occupations such as tilling the soil and made available for mind-influencing occupations such as art and culture; this situation leads inevitably to a cultural flowering. In seventeenth- and eighteenth-century Europe, as this flowering gained historical momentum, the attitude arose that the European arts were superior to those of the rest of the world; this served to suggest, in a different way from religion, the imperative of western leadership. The arts thus both sustained and offered a justification for colonial depredations of the rest of the world; at the same time they were themselves supported and exalted and driven on by the wealth that derived from those colonial adventures. It was a self-sustaining reciprocal system.

By the eighteenth century, faced with the de-Christianization of Europe, the theological justification for geopolitical adventurism by the European nations had lost credibility. At this point it had to be translated into some kind of secularized ideology that would perform the same function of eliminating the possibility of self-doubt as our agents moved out around the world on their dark adventures. This ideology, developed in the eighteenth century, is what we call Modernism with a capital M, modernism as an ideology. It is most fully expressed in the works of Hegel in the early nineteenth century, especially the

Phenomenology of Spirit, 1806, and the *Philosophy of History*, a volume compiled from his lecture notes in 1841.

In the ideology of modernism the baptizing mission was redefined as a so-called civilizing mission: Europe, having defined itself as the most civilized of the world's cultures, posited for itself the moral obligation to lead the rest of the world into a comparably civilized condition. The new ideology that effected this transformation was supported by three pillars, which—while ostensibly secular—reproduced covertly much of the structure of the Christian myth.

The first was the idea of progress: history was to be regarded as having an internal directive and an internal momentum that was carrying it inevitably toward a certain end or culmination. This—History with a capital H—was a thinly disguised version of the Christian idea of providence, with the controlling deity excised for the purpose of believability in the secular and skeptical societies of the time.

The second great pillar of the modernist ideology follows with a kind of logical inevitability from the first. If it's true, the implicit reasoning went, that all the world's cultures are in fact on an arc of development that will take them inevitably and ultimately toward the same culmination of spiritual realization, then the question arises as to why they are different from one another. One way to account for cultural differences is to posit that some cultures must be further along toward history's goal than others. Thus the second great pillar of the ideology of modernism was the idea that there are more- and less-advanced cultures, that is to say, the hierarchization of cultures. Since this is a European myth, it was, of course, the European nations that were identified as the most advanced. Just as the European nations in the period of the Christian ideology had been in effect the chosen people whose duty it was to bring the rest of the world into the fold, so now the European nations saw themselves as chosen to drag the rest of the world into history and reveal to them the work of progress. Colonialism became, as yet another British poet, Rudyard Kipling, put it, "the white man's burden." It was simply the white man's responsibility to go out there and drag all of these somewhat dilatory nonwhite people into the stream of history, no matter how roughly you had to handle them in doing so.

The third great pillar of the modernist ideology also follows with a kind of logical inevitability from these first two. In order to justify the hierarchization of

cultures one must posit transcultural universals of value; if there are no universals which apply to all cultures then there is no basis on which to claim that one culture is more advanced than another. Progress, hierarchy, and universals are the three great elements of the modernist, or colonialist, ideology.

The idea of universals of value, in order to function fully, must apply throughout the levels of culture: *everything* cultural must be hierarchized. So one has as part of modernist ideology, the idea that there are universals of aesthetic value, among others. And of course European art happens to emerge as the most advanced, the one that most closely incorporates the aesthetic universals that all the other artistic traditions of the world are ineptly falling short of.

In the nineteenth century this ideology gained terrific momentum due to Darwinism. Darwin himself was deeply affected by the idea of cultural progress, and his idea of natural selection in the competition of species was based hiddenly on it. He felt that biology, like culture, was pursuing a destiny based on a type of progress, that evolution meant that species are always getting better, that weaker species are progressively being eliminated and stronger or fitter ones taking the leadership. A century later, evolutionists in general no longer believe that. Stephen J. Gould, for example, is on record countless times as arguing that in fact changes in the development of species take place in apparently random ways and that the Darwinian idea of the competition of species and natural selection through the survival of the fittest was a kind of species chauvinism derived improperly from the modernist ideology of cultural progress. In a stunning circularity, Darwinism, derived partly from the idea of cultural progress, was conveniently converted into social Darwinism by Herbert Spencer and others and used, reciprocally, to confirm the idea of cultural progress. According to these thinkers, the principles that Darwin had seen in the development of species also applied to cultures, with the result that the most dominant cultures were by definition going on be the fittest ones. So the fact that European culture was in the process of violently establishing its domination over the rest of the world simply showed that it was healthily participating in the competition of cultures, and if its hegemonic move succeeded, this success simply demonstrated that it was in fact the fittest culture and thus it really was for the benefit of all cultures

in the world that Europe should succeed in its self-appointed role of historical domination.

A second nineteenth-century event that added momentum to the modernist ideology was the industrial revolution, which seemed to clearly demonstrate that in fact things *were* getting better, things *were* advancing in some way—and that way was specifically the production of wealth. The whole idea of progress that was enshrined in the modernist ideology was based on the conviction that if a society devises a way to produce more wealth than it has produced in the past then that is progress. But this idea of progress, as already mentioned, had to pervade society and apply evenly to everything. For example, it had to apply to art, so that art fulfilled again, as it had in the Christian era, a dual role of justifying and guaranteeing the idea of historical progress, on the one hand, and, on the other, of being justified and guaranteed by them in turn. That same reciprocity went on, for example, when Kant wrote his *Critique of Judgment*. I'm not proposing that this was Kant's conscious motivation in writing the third critique, but that in his subtly and powerfully argued presentation of the case for aesthetic universals he was, if one looks at it outside the tube, providing a very powerful support for the project of European economic domination of the rest of the world. If Europe was in fact the fittest culture to dominate the rest of the world, then a part of the demonstration of this would be the claim that European art was the most advanced body of art in the world. This is why the study of art history developed the enormous cachet that it did in the nineteenth century. Art history, by showing in a very limited and focused arena the progressive sequencing of linked problems and solutions, with a kind of inarguable but assumed implication that art was always getting better through these changes, acted like a laboratory experiment to guarantee that progress was in fact happening. This limited laboratory-like focus on the history of art confirmed the whole system of cultural rhetoric that eliminated the possibility of self-doubt entering into the colonial project in which about 4 percent of the world's people—that is adult middle-class white Western males—actually managed to pull off the incredible feat of gaining unquestionable control of about 80 percent of the world's wealth. Whatever else, this was an astonishing accomplishment; there is nothing quite like it in history. And it involved an enormous

cultural rhetoric, of which the practice of art and the analysis of art history formed a part. So the possibility that self-doubt would enter into the program was cut off in every direction by this seamless body of cultural rhetoric.

An imperial domain of representation developed wherein all of reality was represented continually in every way—literarily, philosophically, artistically, musically—as leading inevitably toward the domination of the world by that 4 percent. Everyone outside that group—women, nonwhite peoples, non-Western cultures in general—was represented as inadequately developed, as *needing* the leadership of the grownups to grow up properly themselves. So that, for example, when, in 1884, the Berlin Conference occurred in which the European colonial powers carved up the continent of Africa between them, the confidence in the project was so unquestioned, the blindness as it were, that within a very few years every square inch of Africa—except Liberia, which nobody wanted, and Ethiopia, which managed to repel a number of colonial invasions—was under the iron domination of some Northern white culture.

In terms of the visual arts, it was above all the easel painting that performed this role of imperial representation. The omnipresent Christian iconography of the fifteenth through seventeenth centuries had one-dimensionally guaranteed the unthinking assumption that God was on our side in the colonial project. The idealized representations of knights and conquerors that both accompanied and followed the period of Christian image-saturation showed the proper role of the western male in the world. To a degree one can think of the painted cloth as the flag on the masthead of the slave ship. At the same time, art served the purpose of distracting attention from the global view. As long as the student of culture is absorbed in what's going on inside the tube he or she won't notice with all possible alertness what's going on outside of it.

In a social sense this is the reason why the idea developed, and gained total dominance in the eighteenth century (in the works of Shaftesbury and Kant and others), that art was autonomous, that the history of art was a thin pure stream that had nothing to do with anything else. The viewer could become enamored of the beauty of the view inside the tube to the point where it would distract his attention from the possibility that the social reality going on around it might

not be comparably beautiful; the beautiful painted cloth then acted as a kind of deceptive veil over a far more difficult and painful reality. So-called autonomous art was dangerously disengaged from fundamental truths about reality such as that we exist here in bodies, in societies, in history. And the beautiful distracting dance of the painted cloth is meant in part to convince us that those are not the fundamental realities—the body, society, and history in the larger sense—and that, on the contrary, the fundamental realities are about aesthetic pleasures, vague appreciation of spiritual universals, and so on.

So much for the first great movement of history seen outside the tube; the second one is still in progress. In the twentieth century, the modernist ideology peaked out as the unbelievable series of disasters that comprise twentieth-century history made it difficult to maintain innocent belief in the idea of progress. The reassuring conviction that history was on our side—that history was going somewhere, and someplace that we wanted to go, someplace good—became increasingly untenable. World War I, World War II, the development of nuclear endgame weaponry (and its actual *use* against a nonwhite people!), the increasing realization of imminent ecological disaster—these and other events gradually made it difficult to believe that history was any longer on our side. Postmodernism begins at the moment when one realizes that one no longer believes in the myth of progress, that as a matter of fact, as far as the myth of progress goes, the joke is on us, that history in fact has the most terrible things in store for us, things we do not want to experience.

So I think for some sensitive Westerners the postmodern attitude dawned at the time of the first World War. One can see this for example in the work of Marcel Duchamp. In 1914 Duchamp changed his artistic practice from a modernist to a postmodernist one, abjuring aesthetic delectation, transcendent ambition, and tour de force demonstrations of formal agility in favor of aesthetic indifference, acknowledgement of the ordinary world, and the found object or readymade.

A couple of years later the work of the American poet Ezra Pound, who was living in Europe at the time, also became essentially postmodern from the same, I think, devastated loss of faith in the modernist ideology and the religion of

historical progress. Pound's emphasis, in the *Cantos*, on quotation rather than composition, and his avoidance of literary form in favor of an indefinite changing voice with no apparent roots or destination, foreshadowed much of what came later to be called the postmodern. In fact, throughout the classical literature of the twentieth century one sees prescient individuals—James Joyce was another—whose practice obviously had a great deal of modernist ideology in it, but also foreshadowed postmodernism in certain ways. In Joyce's case these would include his lack of commitment to any particular style and his adoption of styles as references rather than statements. The postmodern attitude toward history, furthermore, is summed up perfectly and succinctly by the remark of Stephen Dedalus in Joyce's *Ulysses*, "History is a nightmare from which I am trying to awaken." The moment of the realization that the intoxicatingly beautiful dream of history as a story of progress has turned into a nightmare is the moment when postmodernism dawns.

I think at the end of World War II postmodernism—meaning the loss of faith in history—would have dawned in the Western world in general except that World War II was followed by the brief and euphoric period of American hegemony which lasted approximately until the first manned lunar landing. Still, regardless of the temporary American reprieve, the trajectory of European history changed radically at that time. Immediately after World War II the European colonial powers began releasing their colonies, a process that in some people's minds ended in 1976 when Portugal released its last official colony, East Timor. (There are others who would say that the process of releasing the colonies from the leash is still going on in terms of residual colonial places such as Ireland, Puerto Rico and Martinique.)

So at that moment when Europe stumbled and fell and dropped the white man's burden with that unbelievable war in which European civilization with all of its acknowledged greatness in music and art and so on just began to destroy itself—a saga as incredible as the story of European dominance—at that moment the United States, obligingly, picked up the white man's burden for a while. But it wasn't really long before it began to dawn on Americans too, very uncomfortably, that the dream was becoming a nightmare. I was on a panel on postmodernism once with John Barth and Dave Hickey, and Barth said that in

his opinion postmodernism in the United States began on November 22, 1963, with the assassination of John F. Kennedy. That certainly was a moment when many Americans suddenly realized with a really sinking feeling in the pit of the stomach that history was maybe not our friend after all and that maybe history had even more devastating symbolic and real jokes in store for us. Hickey, speaking as an art critic, said that in his opinion postmodernism began in the visual arts in the United States with the first exhibitions of pop art in 1962. Again I think that is exactly right, since pop art was born out of the desire to puncture the ego-inflated bubble of the spiritual pretensions of abstract expressionism.

Pop art was the beginning of the current wave of artistic postmodernism, though it took about twenty more years before postmodernism became a dominant attitude in the visual arts. That was one of the terrifically important events that happened in the art history of the eighties (and is probably what Hughes was referring to when he said the eighties was the worst decade in the history of American art—that is, the decade when American art became postmodern.)

At the moment of the realization that one wanted to wake up from the nightmare of history the three pillars of the modernist ideology began to fall. And in their place two options remained—first, a premodernist revivalism, in which attempts were made to reestablish types of communality and harmony with nature that were regarded as characterizing traditional cultures, even at the cost of jettisoning the package of Enlightenment values; this was the movement that involved the culture of the flower child, the commune, and the drop-out. The second available option was postmodernism, understood as an attempt to retain the values of the Enlightenment without allowing them to lead to insanely inflated types of international political gestures.

The first of these, neo-premodernism, so to call it, involved two great critiques of the idea of progress. One was based on the observation that a culture which, in its drive to produce ever more wealth, destroys its environment is not a viable culture, and that perhaps premodern types of societies, which seem to have remained in harmonious relationships with their biomass for thousands of years, are preferable on the basis of survivability alone, despite the fact they don't exhibit a dynamic of progress. A second critique of the idea of progress, that arose when the faith in the crypto-religion of modernism died, involved the

realization that the societies that were characterized by modernism have not been conspicuously kind societies. If one believes, as Richard Rorty remarks, that "kindness is the most important thing we do," then one sees a big problem in the history of European societies—not only in their way of relating globally but in their way of relating internally, also. In traditional or premodern societies one cannot easily find a situation such as we have in this country now of homelessness, of so many people who are absolutely dispossessed and who have dropped totally through the cracks. In a clan or tribally oriented society it is unlikely that this could happen, except perhaps at times of extreme economic scarcity; in any group, of course, there may be people who can't compete, but in a traditional society their clan or tribal affiliates will ordinarily take care of them—it would be a disgrace for them not to do so; we no longer have that. So as the idea of progress falls, the second pillar of modernism, the idea of the hierarchy of cultures, is also no longer believable. If cultures are not all headed toward a similar culmination, then there is no longer any justification for saying that some of them are farther along toward that culmination than others. Suddenly the idea that some cultures are more advanced than others seems like a hollow and exploitative idea and one begins to realize that every culture simply is what it is. One might describe each culture as, let's say, being the most advanced example of its unique kind.

As the pillar of progress falls and the pillar of cultural hierarchization falls with it, the idea of universals of value falls also, and a situation of relativism of value structures ensues. So there no longer seems to be any place where you could stand to make a judgement that, say, the art of one culture is superior to the art of another culture. Suddenly, with these three pillars or dogmas of the modernist ideology gone, the whole world is seen in a rather new way. It becomes painfully obvious, for example, in the midst of the process of decolonization, that all cultures have a claim to be heard, and that this claim has not been honored. In the modernist period, when all significant acts of representation were performed by the dominant Western societies, voices of most of the cultures in the world were silenced; an urgent imperative of the emergence of postmodern culture comes to be a special attention to those voices that have been silenced for so long. The bottom-line of this situation is that in 1950 there

were about 50 members of the United Nations and now there are 180-some. Where did the 130 "new" nations come from? They all had been colonies, their voices silenced, their presences invisible, their cultures excluded from the international discourses of art, philosophy, politics, and everything else. Now each of these newly independent communities will insist on expressing itself as itself, writing its own history, exhibiting its own art, presenting its own idea of the meaning of human life to the rest of the world. And the time—in terms of attention, airwaves, newsprint, exhibition space, and so on—that they will require will come at the expense of the handful of privileged nations that had previously dominated all media. And as the content of the mass of words and images in the cultural atmosphere changes, human reality will change with it. The mass of voices will seem like a chorus to some and like Babel to others. The sense of what the world means will become, comparatively, out of control.

All this and more is what is at stake in moments of passionate intensity such as D'Amato's trampling of the Andres Serrano catalog. It's much more than art that is at stake. The whole meaning of human life, of global society, and of the function of Western civilization and its relationship to other civilizations—all this is at stake.

The many who feel that they have lost something precious in the transition to postmodernism can indeed point to injured sensibilities. In terms of the art reality in particular, one thing that happened with the dawning of the postmodern realization, and which has been experienced by many as a shattering loss, was that the idea of aesthetic ennoblement lost credibility. A traditional idea basic to the modernist way of looking at art held that the activity of contemplating beautiful artworks is somehow innately ennobling. The artist makes these beautiful objects, and then a variety of individuals contemplate them and become nobler inside, and thus all of society is incrementally improved. The problem is that history does not seem to bear this idea out. Many of the leading Nazi power figures, for example, were aesthetes who collected art and were highly sensitive to its modes of stimulation, but their devotion to beauty seems to have had no effect whatever on the way they related to society. In fact, an argument could be constructed to the effect that societies that have featured

highly aesthetic arts have tended to be totalitarian, the smooth aesthetic facade acting as a cover-up of social reality.

In addition to the loss of the religion of beauty, the idea of autonomous art lost credibility. Part of this realization unfolded in a crucial series of articles that appeared in *Artforum* in the 1970s, the first by Max Kozloff, "American Painting During the Cold War," (1973), and then the famous article by Eva Cockcroft following up Kozloff's insights, "Abstract Expressionism, Weapon of the Cold War," (1974). What these articles—and subsequent research that has been done on the topic—uncovered was the fact that starting in the 1950s, the undeniably great and beautiful works of the New York school were appropriated by the foreign policy aims of the U.S. government in the Cold War, and that a series of exhibitions—in which the Museum of Modern Art essentially acted as a front organization occurred—in which the works of Pollock, DeKooning and others were sent to Europe as weapons in the struggle for the soul of Western Europe that was going on between the Soviet Union and the United States. As the Soviet Union was sending into Western Europe those robotic pictures of happy peasants and assembly line workers called socialist realism, our government decided in a covert way to send the works of these rugged individualist Yankees abroad to demonstrate the fact that our society allowed freer range for self expression and for the development of the individual personality along its own lines.

This was a deeply confusing series of events for the New York school artists themselves, because most, perhaps all, of these great artists had felt themselves to be deeply alienated from the society around them. They had felt that their work was in part a protest against the American society of the McCarthy era and the Cold War. But in fact, their work was appropriated by those forces that it was protesting against and used as propaganda for those forces. The deeply confusing nature of that experience may have had something to do with the essentially tragic turn that the lives of many of those artists took from about the middle fifties on.

Interestingly, it was the very autonomy of their art, so praised by Clement Greenberg, that had left it open to this mode of appropriation. Because it had no subject, supposedly, it could be used for anything at all. As the force of this research by Kozloff and Cockcroft and others went on, as the force of the real-

ization spread through the art world, abstract art, as the most obviously autonomous type of art, became deeply suspect because it was perceived that these artists, to use Edward Said's phrase, had not "placed their work in the world" with sufficient preciseness. Because of the vagueness of the abstract, it became possible for anyone to appropriate the work and to insert it into the meaning-system of the world in any position at all. In the modernist era, in which artists were supposed to be like children or inspired idiots, the artists was supposed to only be responsible for what happened inside his studio. (I say *his* because the modernist ideology really didn't acknowledge the existence of women artists. That is another absolutely fundamental difference between modernism and postmodernism: postmodernism is an innately feminist point of view.) The artist was supposed to make a beautiful object just out of an intuitive, inarticulate, existential confrontation with the blank of the canvas; reaching deep down into the abysses of his soul he was to find a vision of ultimacy and tear it out of the darkness and hurl it onto the canvas and then, exhausted, lie down on a chaise while the work itself went out of the studio and had its life out there in the world, which was not supposed to be a part of the artist's responsibility.

In addition, as a part of their childlikeness or sacred idiocy, artists were not supposed to be able to articulate the hidden presuppositions of their own work. Jackson Pollock was the great example. The only remark that Pollock ever made really, that's on record anyway, that seemed like a very significant explanation of his work was when he used to say, "I paint out of myself." If he had been able to say more about it his articulateness would have been suspect, since he was supposed to be an idiot savant. This is one reason, I think, that Barnett Newman's work was not immediately recognized and accepted into the cultural situation of the New York school—because he was too articulate, he was too able to give a verbal account of what he was doing and this made it suspicious; it made it seem like some kind of fakery rather than true creative frenzy. I talked this over once with Leon Golub, who was already painting figuratively at the time when abstract expressionism was unfolding with such unbelievable impact in New York City, and Golub said that he was horrified by the fact that these artists wanted to make their art unconsciously. He said, "I did not want to paint

unconsciously. I was fascinated by the presuppositions behind my own work." This is another of the fundamental changes in the situation for the artist between the modernist and postmodernist eras, that nowadays an artist is supposed to be able to give an account of the presuppositions underlying his or her work. So that finally, rather than simply giving aesthetic pleasure, which has now become a suspect activity on the grounds that it demonstrably served for centuries as a kind of distraction from social realities, the postmodern artist sees his or her responsibility as involving the critiquing of social traditions, taboos, repressions, and so on.

In this transition or revision the practice of the curator has changed as much as that of the artist or critic. A series of controversial exhibitions of the eighties and after were based on the fact that modernism seems to be an ideology that grew up as a cover story for colonialism, while postmodernism occurs, not only contemporaneously with, but as the intellectual and cultural expression of, the global historical event of decolonization. The first was the *'Primitivism' in Twentieth-Century Art* show at the Museum of Modern Art in 1984, in which the artistic traditions of the non-Western world were called to heel on a leash as kind of pets or mascots behind the work of great Western modernist masters such as Picasso and Klee. The rawly neocolonialist and racist subtext of this exhibition shocked many people and was crucial in precipitating the postmodern discourse in the visual arts. It was followed five years later by an equally famous and controversial exhibition, *Les magiciens de la terre*, at the Centre Pompidou in Paris, an exhibition with aspirations toward the global, in which the works of fifty Western and fifty non-Western contemporary artists were shown in a loose, neutral and unsystematic way that didn't involve presuppositions of center and periphery, or of higher and lower, or of more or less advanced. In fact there were many flaws to the show's construction of neutrality, and there were many critics who pointed them out; still, that neutrality was the curators' stated intention, and they broke important new ground by working the premise out despite problems of detail.

The impact of that show at presenting the Western tradition not as the imperial master leading the rest of the world on a leash but as just one culture among many, was so devastating to residual modernist sensibilities that, for example, one famous British critic was overheard to remark that the *Magicians of the Earth* show simply

marked the end of Western civilization. And this too, for all its enormity, is a part of what seems to be at stake in the remarks of Pat Buchanan and Jesse Helms and Alfonse D'Amato and for that matter Robert Hughes and Hilton Kramer and other critics who are resolute enemies of contemporary art in the sense that art made since the demise of the modernist faith in aesthetic universals has seemed to them to be a fundamental insult to their sense of the whole meaning of life and of history.

The *Magicians of the Earth* show has been followed by a series of remarkable developments that couldn't have happened in the Western world prior to it. A couple of years ago in New York, for example, there was a show at what was then called The Center for African Art called *Africa Explores: Contemporary Art from Africa*. In the modernist period "contemporary art from Africa" was a contradiction in terms, a misnomer. There *was* no contemporary art from Africa; there was only primitive art from Africa. There have been lots of such events in recent years, including the remarkable proliferation of so-called third world biennials.

The great international art exhibitions of Europe, such as the Venice Biennale and Documenta, have always been parochial, focussing almost exclusively on the works of Western artists who were prominently placed in the gallery system in New York or Paris. Recently we have witnessed a number of major international exhibitions that have arisen in great cities of the nonwhite or non-Western world that not long ago would probably not have been able to feel themselves as places from which an international or global viewpoint could legitimately be expressed. Of course, the *Sao Paulo Bienal* has been around for decades, and so has the New Delhi Triennial, but recently we have also witnessed such exhibitions in Istanbul, Cairo, Dakar, and elsewhere. What happens, of course, when those voices or those visions that were excluded from the discourse during the modernist period are attended to at last is that they break apart that imperial domain of representation with a series of counter representations.

These counter representations will accumulate until they have created a new picture of the world and of the meaning of life. This will not be an absolute newness in the sense of a *tabula rasa*; it will incorporate elements of the view

whose dominance is passing. Still, in terms of the analogy with evolution (but without the discredited notion of progress as its guiding force), it may be a moment of punctuated equilibrium, a moment when the engine races before settling down again. One of the cultural functions that art is pursuing today is an antenna-like sensing of the future to offer its insight into the emergent vista. This project may take it into exploratory moves in many directions—indeed, that may be a characterization of postmodernist pluralism and relativism. So in its way, art is contributing to and participating in the guidance of an apparently momentous opportunity to redefine history. Those whose sense of selfhood— not to mention livelihood—is indissolubly rooted in the previous definition may do well to resist, to undermine, to condemn.

toward the spiritual in design

victor papanek

It may be true that one has to choose between ethics and aes-thetics, but whichever one chooses, one will always find the other at the end of the road.

—Jean-Luc Godard

AT FIRST SIGHT, THERE IS NO SUCH thing as a piece of industrial design that is invested with spiritual values. There can be no transcendental refrigerator, no righteous chair, no moral tea kettle. We cannot find a spiritual advertisement, a soul-stirring logo or trademark. In the fields of fashion and textile design it is impossible to locate an immaculate cotton print or a saintly dress.

the function of beauty

Can the spiritual exist in design? The men and women working and studying in Germany in the 1920s at the Bauhaus (possibly the most influential school of design in history), would have answered affirmatively and without hesitation. Their conviction was: 'If it functions well, it will be beautiful—and therefore have spiritual value.'

Looking at this proposition from the vantage point of the mid-1990s, things are less clear. The cool elegance of the Bauhaus style has gained some cachet. We are also somewhat seduced by the fact that age has bestowed the seeming blessings of permanence on these buildings, pieces of furniture, tools, crafts and graphic designs. We respond affirmatively to the daring and revolutionary re-structuring of the human environment reflected in the work. At the same time we have also gained greater detachment from the shock of what was formerly new. We are more able to diagnose the 'cool elegance' as cold sterility. We may applaud the attempt to build a 'Cathedral of Socialism'[1] and the effort to 'join artists, workers, industry and the crafts', but we are well aware that the experiments at Weimar and Dessau found their admirers amongst a comparatively small group of artists, the intelligentsia and the *haute bourgeoisie*, rather than the workers and farmers that the designers and architects had envisaged as their target audience. In short, the Bauhaus style was élitist and seen as alienating by many.

To the statement, 'If it functions well, it will be beautiful', we now add the questions: 'If it functions well, doing what? It will be beautiful in what sense? Function and Beauty in what context?'

We have also seen many of the pioneering works of the Bauhaus domesti-cated, trivialized and cheapened. The cantilevered tubular steel chairs with cane seats and backs were a truly new concept of tool and material. Marcel Breuer used the bending moment of steel to build in a 'feathering' action that added comfort without visual or mechanical clutter. However we have seen the descen-dants of these chairs—in kitchens and 'dinettes', and in some of the seediest cafés around the globe—shoddy and cheap, the caning replaced by flamingo-coloured plastic.

This Bauhaus Lamp of 1923–24 shows the cool elegance typical of the style.

Is a bullet-shaped shade on a flexible arm, both enamelled shiny white on metal, really the most appropriate task-light? Or would it be more fitting in a laboratory making false teeth? Can we find no better way to serve a fine sherry or port than from a clear glass bottle resting on a cork ring—obviously adapted from a flask in some chemical laboratory? Ironically, I am presently designing a birthing-chair for a women's group, a design that is based on a reclining lounger developed at the Bauhaus. Let me emphasize quickly that I am adapting the Bauhaus original for ergonomic reasons only. Aesthetically the original is far from satisfying since a birthing-chair needs to communicate associations of safety and comfort—the sterile-seeming cleanliness of the original did not carry these reassuring patterns.

Latter-day apologists for a strictly utilitarian idea of beauty will frequently point to, say, a 747 aeroplane, an F-16 fighter aircraft, or a high-performance sailplane such as the Mini-nimbus. Their form is—allegedly—based on pure aerodynamic considerations, 'purely functional' (in the narrowest sense). Things aren't that simple. The 747 is an awkward compromise between seating capacity, ticket sales and class separation; engineering logistics, aerodynamic factors and fuel capacity are among many other modifiers, and also the trade-off between leg comfort, safety and square-foot cost of each seat written off over ten years. The fighter-bomber strikes a balance between high speed, close turning ratios and fuel capacity; it must also carry bombs, cannons, machine guns and heavy armaments. The design of the Mini-nimbus demands an advantageous descent ratio, and extreme lightness in weight, coupled with strength; the reason that it seems so 'right' for its purpose, and therefore beautiful, is the complete absence of unnecessary ornamentation or decoration. *Unnecessary* ornamentation. This is equally true of the 747 and the F-16.

At the same time, we know that decoration is deeply satisfying to human beings and has been throughout history. When I lived among the Inuit I was struck by the time devoted to carving ornament on tools. Some of the objects of 35,000 years ago unearthed from Willendorf and the Neander valley in Austria show detailed chipping and colouring. We take pleasure in adding adornment to plain areas—yet this is functional decoration: it fulfils the aesthetic part of

A whisk for a Japanese tea ceremony, cut from a single joint of bamboo.

the six-fold function complex* by relieving the monotony of the large, plain areas. It is only when we are dealing with survival conditions in design that we are forced to abandon the extraneous 'beautifying', and a dynamic form may be revealed that we experience as satisfying.

We can sift through the history of designed objects. In so doing we must beware of the distortions when we gaze at anything through a rear-view mirror. We will find much that enchants us with its restrained elegance and simplicity: the ceremonial tea whisk, cut from a single joint of bamboo to serve in a traditional *cha-no-yu* tea bowl in Japan; the water bucket made of birch staves for a Finnish sauna; a Viking boat; furniture made by the Shakers in America during the 18th and 19th centuries; a Chinese rice bowl of the T'ang dynasty.

We can try to probe the mechanism at work here. To begin with, we are guilty of the sin of 'Presentism'.[2] Living in overdeveloped countries with underdeveloped taste, we excel in ornamentation, visual braggadocio and excess. Our natural sense of order and simplicity makes us overly impressed by the austere, yet we flaunt the flashy and ostentatious. In order to extract the essence from these objects, we must examine them against the cultural and social matrix from which they developed. When we do so, we find that all of them are related to spiritual values in some sense.

The tea whisk is pure ceremonial gear. Powdered green tea is not normally consumed as refreshment; it is reserved for the traditional tea ceremony. Nor is tea-water whipped in Japan, except as part of this rite. The bucket used in the sauna—like the sauna itself—goes far back in Finnish history to pre-Christian traditions. It is a purification ceremony that is still surrounded by some mystical values, occupying a similar place in their view of the universe to Navajo sweat-lodges, Bedouin sand-cleansing and the Inuit smoke-igloo. Over the centuries the few sauna utensils became simplified to the point of anonymity.

For the Vikings, deep spiritual values were interwoven with wood technology, the resistance and strength needed to cut cleanly through ocean waves, and considerations of safety for the voyagers. Out of this web emerged the

* Editors' note: Papanek's "six-fold function complex" consists of: Use, Method, Association, Aesthetics, Need, and Consequences; from *The Green Imperative*, page 34.

Viking boat as a metaphysical tool for exploration and a transformative journey. The sparse simplicity of Shaker furniture directly reflects the sect's religious values and rules,[3] which, in promoting austerity and order, attempted to reduce wants and false needs and to permit a journey unencumbered by worldly possessions. The traditional Chinese rice bowl speaks eloquently to the unique symbolic—almost holy—place of rice in traditional southern Chinese culture.

The fighter-bomber gives us a hint. When I organized an exhibition of great Finnish design, a number of designers and architects were deeply shocked by my choice of a 22mm rifle as one of the exhibits, explaining to me that anything that was dedicated to death could not have beauty—let alone spiritual value.[4]

We seem here to have reached a key point in our examination of what separates all industrial design from architecture. Through the manipulation and orchestration of interior spaces, it is possible to release transcendental feelings, hints of the sacred in people. This can't be done as directly in any tool, object or artefact. We may admire the pure lines of a birch-bark canoe, or a glider, but this aesthetic response—caused by simple elegance—may only infrequently release in us intimations of the sublime.

the designer's intent

I firmly believe that it is the intent of the designer as well as the intended use of the designed object that can yield spiritual value. The European word 'form-giving' may express best what industrial designers do—always being careful to include the workings of the device in the form-giving and making sure that a degree of inventiveness is part of the design process. As we practise our art and skill, what we do moulds who we are and what we are becoming.

- When we become the hired guns of greed-driven corporations, we are driven to conform.
- If we generate status kitsch for a jaded élite, and allow ourselves to become media celebrities, we perform.
- When we twist products to reflect the navel-gazing of market research, we deform.

- If our products divorce appearance and the other functions—a telephone that looks like a duck and quacks instead of ringing, a clock-radio that looks like a female leg—we misinform.
- When our designs are succinct statements of purpose, easy to understand, use, maintain and repair, long-lasting, recyclable and benign to the environment, we inform.
- If we design with harmony and balance in mind, working for the good of the weaker members of our society, we reform.
- Being willing to face the consequences of our design interventions, and accepting our social and moral responsibilities, we give form.

All this can be done only if we learn to recognize the ethical dilemmas of our profession. This means thinking dispassionately about what we do. This is desperately difficult for designers. Our professional education is deeply divisive, almost schizoid. On the one hand we learn many aspects of high technology. We study mass-production methods, industrial techniques from explosive moulding to micro-chip regulators, CAD-CAM (computer-assisted design and computer-aided manufacture) to random extrusion bundling. We investigate materials-technology and explore many aspects of plastics and electronics engineering.

On the other hand we are encouraged to think of ourselves as artists. This part of our education frequently leads towards totally self-indulgent aesthetics. In our age, it is the nature of aesthetic processes that users are never consulted. This may give great freedom to a painter or sculptor to express his or her convictions, dreams, demons or hopes. In a wider public art, such as the design of everyday things, this can only encourage the peacock's strut, eccentric perversity, the fraudulent posturing of the charlatan.

Designers asked for more than a hundred years: 'How can I make it more beautiful?' After the Bauhaus and the lessons of Scandinavian form-giving, this changed to: 'How can I make it work better?' The logical question, 'Can it work and look better?' isn't put often enough. Just look around at our buildings, cities, automobiles, furniture or tools. It is tempting to think that form-givers—faced by this false choice between appearance and utility—answered: 'Neither!' The 'statement' or 'gesture' have replaced the object, and designers emerging from

this bifurcated education tend to ask themselves: 'How can I make it different?' Theoretically this might lead to an endless and lackadaisical repetition of stylistic mannerisms, varied by frequent sorties into the past.

Into this zany mixture caused by a misconceived education and a social structure devoted to no higher aspiration than, 'Take the money and run!', we now introduce the question of the spiritual in design. As if by magic, we can begin to see clearly. I repeat, it is the intent of the designer as well as the intended use of the designed object that can yield spiritual value. The questions that must be asked are:

Will the design significantly aid the sustainability of the environment?

Can it make life easier for some group that has been marginalized by society?

Can it ease pain?

Will it help those who are poor, disenfranchised or suffering?

Will it save energy or—better still—help to gain renewable energies?

Can it save irreplaceable resources?

A positive answer to these or similar questions does not make the design visibly spiritual. But the performance of such services to our fellow humans and the planet will help us inwardly. It will nourish our soul and help it to grow. That's where spiritual values enter design.

New directions in design and architecture always arise out of real social and cultural changes. The monotonous sterility that still existed in household products, especially furniture and furnishings in the early 1970s, eventually led to a counter-revolutionary movement in the upper levels of the market. Both Memphis (led by the witty style of Ettore Sotsass) and Alchimia were stylistic protest movements—primarily in the field of furniture—that tried to expose the visual poverty of the late Modern movement through promoting non-functional

pieces that were carefully designed to violate all the strictures of the Modernist gospel. The effect of these movements on furniture design are comparable to that of Dadaism, the 'anti-art' movement, on the arts immediately after World War I. Memphis and Alchimia gave us chairs that could not be sat on, bookcases that could not hold books and other non-functioning devices. The results were 'camp' or 'funky', but found little appeal outside a few museum exhibitions and the more avant-garde salons of Milan. Memphis and other Italian counter-functional movements, however, have forced industrial designers to lighten up in the design of tools and objects.

Following yet another new direction, the influence of the designer Luigi Collani has been strong in the fashion for biomorphic, organic and fluid shapes. His published materials are a major influence combining ergonomic considerations with shapes that seem almost to have grown around the electronic and mechanical parts.

The sometimes subversive influence of design-styling on a simple tool is shown by seven fish hooks that I collected in Papua New Guinea. The simple hook made of bone worked fairly well for centuries, but later it was realized that a barb independent of the shank, yet attached with twine to give it a slight 'feathering' action, could be larger and catch fish more effectively. Then someone made a barb of tortoiseshell whose light-reflecting properties would be attractive to fish; at the same time he decided to straighten out the shank, with the result that the hook hangs at a useless angle. The fourth hook shows that the designer has learnt his lesson; the shank is curved and the tortoiseshell barb is larger.

Design development (left to right) in fish hooks, Papua New Guinea.

Possibly the robust egos of designers make them feel that bigger is always better, and biggest is always best. The designer of the next stage decided that if a medium-size tortoiseshell hook worked in attracting fish, then an enormous one would work even better. He also replaced the shank with a highly-reflective abalone shell. From my own observation, fish would come for miles to look at this shining object, but it never occurred to them to put it in their mouths. The sixth hook marks the decadent stage of design development. The shank is made from the most rare and precious material in Papua New Guinea, part of the plastic canopy of a fighter aircraft shot down over the island in the 1940s. It was soon found that the plastic shank dissolved in saltwater, making it useless as a fish hook, so the designer decided to sell it as an amulet, forgetting that human sweat is also salty. The seventh hook shows that by rethinking the problem statement, it is possible to go beyond degeneracy and develop a better design. It is made of heavy teak, containing enough natural oils to be impervious to saltwater. The shank has been artfully curved with the line somewhat offset so that it will hang at the most opportune angle. The barb has two retro-hooks and is carved from bone. It is secured to the shank with tarred hemp twine permitting the 'feathering action' that works it more deeply into the fish.

There is a point at which beauty and high utility through good design interconnect. If both conditions exist simultaneously in an object, and are furthermore clear expressions of the social intent of the people who designed it, it is possible to speak of the spiritual in design. We have seen that the old Modernist saying, 'If it works well, it will be beautiful,' is false. We are surrounded each day by hundreds of objects that nullify this approach. At the same time we know that the reverse, 'If it is beautiful, it will work well,' is ridiculously wide of the mark.

The OXO corkscrew and the jar-opener are superb examples of high aesthetic function married to utility; both were designed and are made with the needs of arthritic and elderly people in mind. The sensuous curves of the corkscrew don't just look inviting, they also sensibly and sensitively guide the hands through correct use. This tool looks remarkably handsome when closed, open or in the various mid-range positions. The designers have exhibited unusual understanding of plastics as a permanent and good-looking material

rather than a substitute for something else. The jar-opener is as much of a conceptual breakthrough, a great solution to the difficult problem of removing a tight lid, though it does not have quite the same sensuous flair as the corkscrew. In using these two tools it becomes clear that nothing could possibly be added or taken away—they seem perfect statements just as they are.

Betsy Wells Farber is the design director of OXO International. She is an architect who suffers from arthritis herself, and the jar-opener is her concept. The design development was by Stephan Allendorf, who also with Peter Stathis designed the corkscrew for the industrial design firm 'Smart Design' of New York. Both appliances are part of a series of kitchen, garden and measuring tools marketed under the name of 'Good Grips' which have won several design awards.

We are still looking for a new reality-based aesthetic direction. Concern for the environment and for the disadvantaged of our society are the most profound and powerful forces with which to shape design. They may indeed develop the new styles that are so desperately needed. Whole technologies, based on alternative power sources, have to be invented and designed. Lifestyle changes will be required to make many of the most radical changes acceptable.

interview with
hans haacke

jessica prinz
and richard roth

JESSICA PRINZ In 1970, and partly in response to your work, Daniel Buren wrote
that "art, whatever else it might be, is exclusively political." Do you believe that
art is exclusively political?

HANS HAACKE *No, but it always is also political.*

RICHARD ROTH I sense in your work a sincere desire to communicate. That seems
to me an overriding aspect, but people talk about your work also in terms of art
world strategy; whether you challenge minimalism as an art strategy.

HH *Like other fields, the art world has its own history, practices and social dynam-
ics (and, let's not forget, there are many art worlds coexisting, here and in the rest
of the world). Of course, these peculiar social enclaves are not isolated from society
at large. In fact, they are affected by that general social environment more than
many of their denizens believe. It varies from case to case to what extent artists are
aware of these often undeclared customs, influences, and constraints, and how they
unquestioningly adjust to or are ready to challenge them. I usually take into account
the context for which I prepare a work. In that sense I think strategically. And in that*

sense I sometimes also make references to art historical periods or mannerisms—and, perhaps, provoke a rethinking of accepted positions.

RR Should art transcend the market place? Is art privileged in its ability to do this?

HH *Yes, of course. If supply and demand were the exclusive criteria, I wouldn't be involved. It would be too boring. Historically, the demands of the market, galleries, collectors, institutions, etc. have been a powerful but by no means exclusive factor in determining the work of artists. In spite of the amply justified griping about the pressures of the market and the willingness of many artists to sail with the wind, the market isn't the only motivating force today either. Many of the more interesting projects I and others have been involved in were not inspired by the art world's trading posts. But the "marketplace" is not a forum to be shunned at all cost. Communication via commercial galleries can be quite effective—and, if one is lucky, can help pay the bills. Because I have a secure teaching job, I am more independent from market whims than others. I am also fortunate in being with a gallery that tolerates my not being market driven.*

RR Why is it so objectionable for corporations to use art or use culture to make themselves more desirable?

HH *The corporate agenda, i.e. the maximization of "shareholder value" is incompatible with the values of what is fuzzily referred to as "culture." The last thing people think of when they decide to get involved with the arts, as artists, art historians, dealers, etc. is to become marketing and public relations operatives for products and attitudes they do not believe in or even reject. It is the very aura of the disinterested, the noncommercial, bordering on the "otherworldly," that makes culture so attractive to corporations or, for that matter, to the promotion of a political agenda. The cloak of culture protects them against public scrutiny of, for example, their labor practices, the health and safety of their plants and products, their environmental record, as well as their attempts to influence public policy on taxes, trade, regulations, etc. We must fend off the takeover of culture, our turf, and its subjection to the business rationale—with its inevitable consequences of censorship and self-censorship. We have to fight against being made stooges in corporate and political strategies.*

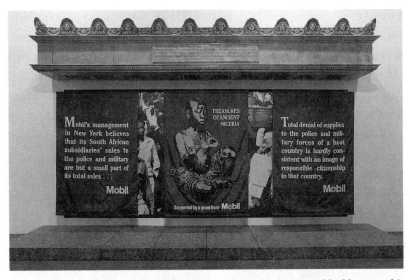

MetroMobiltan, 1985 by Hans Haacke. Mobil sponsored numerous blockbuster exhibitions at the Metropolitan Museum in New York, among them *Treasures of Ancient Nigeria* (Mobil has petroleum interests in Nigeria). For years, the company rejected shareholder resolutions to stop supplying the South African military and police who were enforcing the racist policies of the apartheid regime. The photo behind the banners was taken at a funeral of blacks killed by the police in 1985. The text on the entablature is excerpted from the Museum's flier *The Business of Art Knows the Art of Good Business.*

JP Leo Steinberg observed that your work is basically apolitical since, as he said, "it is hard to conceive any action resulting from it." He writes, "The artist knows perfectly well that Mobil will not be induced to retreat from its South African market; that its shareholders will continue to expect maximum earnings; that no museum can refuse money, no matter where or how it was made; and that few museumgoers will forego an interesting art exhibition just because it was funded by a corporation whose politics differs from theirs. In short, nothing practical can, or will, come of it." Do you agree with this characterization of your work and what do you see as its consequences or effects?

HH *No, I don't agree with him on this. I believe Leo Steinberg has a rather mechanical understanding of how public opinion is shaped, and how, in turn, public opinion affects what corporations and politicians do. Social interaction (both public and*

private) is influenced by a myriad of factors. The art world, part of what has been called the "consciousness industry" participates in this "negotiation." What happens in the art world rubs off, usually not in a mechanical, easily traceable manner but rather at the level of "atmospherics," i.e. of the social and political climate. It affects the cocktail and dinner party talk, particularly in media capitals like New York, Paris, and London, where the so-called movers and shakers get together. We should not underestimate the political power of such seemingly silly party talk. It often is in the unpressured setting of social gatherings that opinions are formed and shared, and decisions are made on what will be printed, what will go on the air, and what slant it will have. And that, of course, has political repercussions. In this indirect manner, and often only in a slow and perhaps homeopathic way, the art world participates in shaping public opinion. Like the art world, the universities are not isolated, and what happens on campuses, as we have seen, has consequences elsewhere. The lecture I give here, this interview and its possible future publication, the books and catalogs you and your students discuss, they also play a little role in the process of adding ingredients to the social consensus. At many varied levels, in concert with events and activities in diverse fields, the art world has an impact and participates in the shaping of what we call the zeitgeist. It is at that level that it has a political effect.

Let me give you an example. Contrary to what Leo Steinberg anticipated in 1986, Mobil did pull out of South Africa in 1989. I like to believe that, even though only in a very minor way, I contributed to this move by showing Mobil's sponsorship of the arts for what it was designed to do, namely, throw up a smoke screen behind which the company thought it could continue supplying the police and military of the apartheid regime with strategically essential petroleum. At Cooper Union, where I teach, like in many universities, student protests led the trustees to rid the school's portfolio of Mobil stock. State and municipal pension funds dropped their Mobil investments (obviously, they acted independently of my work). The press and, with it, the public and Washington became increasingly critical of the racist South African regime. Singly, none of these efforts would have made Mobil and other corporations pull up their stakes. But together they did have an effect—with the happy ending of free elections and the presidency of Nelson Mandela.

I can give you two examples for a more direct impact. My memorial to the Nazi victims of the Austrian province of Styria in the center of Graz, which was fire-

bombed, not only led to prison sentences for the arsonists but, as a sociology profes-
sor of the university in Graz assured me, it served as a catalyst for the reexamination
of the city's Nazi past (amplified by the Austrian media).

And in 1990, I exhibited in a New York gallery two works which revealed that
Philip Morris, in addition to its known campaign contributions to Jesse Helms, also
contributed heavily to a Jesse Helms museum, that was to promote the Senator's
"American principles." Philip Morris's sponsorship of Helms coincided with his
assault on the NEA and Robert Mapplethorpe. When the gay community learned
about the cowboys' support of Helms, ACT UP called for an international boycott
of Miller beer (a Philip Morris product). Miller sales did, in fact, drop that year,
possibly because of the cancellation of contracts by gay bars. I saw a sticker "Boycott
Philip Morris" on a cigarette vending machine even in Berlin. Philip Morris has
since strenuously tried to smooth its relations with the gay community. And it con-
tinues to woo the art world, obviously, in order to mute criticism of its peddling
deadly products. Not entirely with success: a number of prominent artists no longer
participate in exhibitions sponsored by Philip Morris.

RR There is a view that art is just another object if we strip away its privileged
status. I think art in general has been moving in this populist direction, recon-
sidering the idea of aura, which is more or less artificial. You seem to be utiliz-
ing the acceptance of art's aura as a subversive tool.

HH *For the time being, art still does have this aura. That's why corporations and*
others like to associate themselves with art and hope to profit from what public rela-
tions people call a "positive image transfer." I believe the longer this instrumental-
ization continues, the more the aura will wear off. I also believe that the recasting of
culture as entertainment has a corrosive effect on its status. However, as long as art
has a privileged status, certainly artists can use it as an asset.

RR I seem to be resisting the easy separation of art and aura from that which is
not art and "auraless." These categorizations no longer seem very meaningful
and perhaps they are not healthy in the long run.

HH *The notion of art as we understand it today is fairly short. It is not older than*
five hundred years. It has been around since the Renaissance (let me add, it is a

Western idea). Before that time the objects we celebrate today as works of art were considered craft, and artists were considered craftsmen, ordinary folks with no elevated social status. During the romantic period, the idea of the "genius" was born, a kind of secularized sainthood. In many ways, that is the world in which we still live today. However, for some years now, that elevated status has been challenged. In certain ways I participate in this questioning. But I am not sure whether "art" can again be totally integrated in our social relations, as it appears to have been in the past, as well as in non-Western and in tribal cultures. I certainly do not consider its subjection to a globalized marketing rationale a desirable "integration."

JP I have a very different kind of question. In *The Theory Death of the Avant Garde*, Paul Mann argues that because you use museum and gallery spaces your art is recuperated or co-opted and as a result it is not as adversarial as it appears to be. How do you respond to Paul Mann?

HH *I haven't read Paul Mann's Theory. I can therefore only respond to his argument as you state it. If "adversarial" means challenging generally accepted ideological notions and social practices, and if one is not satisfied with doing that merely as a "bohemian" gesture, it is necessary to do so not only outside, whatever that may mean, but also inside existing institutions, including museums and commercial galleries. The German sociologist Oskar Negt once criticized calls for a boycott of Documenta by remarking "we should not leave these institutions to the Right." I agree with him not only for strategic reasons. Most art institutions in this country are tax-exempt and thus indirectly supported by all of us. In Europe, Canada, and Australia they are for the most part municipal or state institutions and as such directly maintained by taxpayers' money. I think we have a constitutional right in a democracy, as the loyal opposition, so to speak, to having access to our institutions. The fear of co-optation makes us impotent. Paul Mann's thesis, again, as you describe it, strikes me as romantic, based on old, bohemian ideas of the avant garde. Similar to Leo Steinberg, it does not seem to be based on a full understanding of contemporary social dynamics, how they are managed, controlled—and challenged.*

JP So you believe it's possible to be adversarial while within an institution?

HH *Oh, absolutely. But let's not forget, "adversarial" work is usually not what institutions are looking for, as I can testify to from my own experience. However, they do not form a homogeneous block. If they did, we would not be talking here, I would not have been invited to speak at your art center, and I would not have been able to show you slides of work produced in the kinds of institutions we are talking about.*

JP You actually asked this question in your 1973 "Visitors Profile 2" at the John Weber Gallery, but I'd like to ask you the same question. Do you think the preferences of those who financially back the art world influence the kind of work artists produce?

HH *I would have answered yes in 1973, and I would answer yes today. The survival of galleries and to some degree also of artists depends on sales. Galleries are businesses. Most artists are eager to have a gallery and sell their work. Collectors, both private and institutional collectors, as well as agencies that give grants or commission art works, are not all alike; their predilections differ and, like people, they respond to the social climate and are not insensitive to what their peers think and do. Whatever their differences, their financial power does have a considerable impact on what gets to be seen, produced, and talked about. It would be naive to assume that artists don't have a sense for this. Irrespective of whether they are aware of it, I believe many make the appropriate adjustments. It would be presumptuous for me to exempt myself from this. And that has been the case throughout history.*

JP I have a question about the book *Unfinished Business*. Do you think that is a good vehicle for your art or do you think it's important for people actually to see your work in museums and galleries? If somebody just saw the book would that be an adequate introduction to your work?

HH *Adequate no, but not useless. I think the encounter with the actual work is essential. The sensuous experience of its materials, surface and shapes, of its size in relation to one's body, the peculiarities of the space in which it is seen, and the kinesthetic experience of the encounter, all that matters a great deal and cannot be reproduced in a book. You remember me saying that the slides of the locker room of my installa-*

tion Eagle with Prey *were totally inadequate to give you a sense of what it was like being in this dark space lit only by two electric candles. Also, there is no way to duplicate in a book the experience of the social significance of the site in which a work is located. A good example for that is the watchtower in the deathstrip between East and West Berlin, that desolate area which had been cleared of mines only a few months before I tinkered with the watchtower. When it comes to the dissemination of information, newspapers, magazines, books, catalogs and the electronic media are very important. I met people from faraway places, from Moscow, Australia, and South Africa who spoke to me in great detail about a work of mine and what it meant to them, based on seeing pictures and reading about it. At the secondary level, publications can be influential and, as I explained earlier, can affect the zeitgeist.*

RR The book *Painting as Model* by Yve-Alain Bois mentions a discussion with you from 1977. Bois says "A brief return to our early dialogue with Haacke will introduce yet another type of blackmail, the *sociopolitical* (the obligation to offer a sociopolitical interpretation of a work of art, recently supplemented by the obligation, for an artist, to make explicit the sociopolitical implications of his work). In our 1977 debate about Greenberg, politics had been the stumbling block, the dividing line: if you were a formalist, you were a reactionary." What is your reaction to this, now sixteen years later? Do you still see a dividing line between formalism and sociopolitical art?

HH *Oh absolutely.*

RR Please tell us more.

HH *I would have to reread the introduction to his book to get the context of this quote before I give you a reasoned response. But when it comes to Clement Greenberg's position not to consider as art any work that incorporates social or psychological elements (inevitably they also have a political dimension), then this is just silly. According to this doctrine, Greenberg must excommunicate almost all things we have come to accept as belonging to the history of art. Being consistent, he, in fact, dismisses as "extra-artistic" surrealism, constructivism, and dadaism, some of the most fertile cultural movements of the twentieth century from which we still take clues today and which, ironically, have inspired many of the artists he cham-*

pioned. Seen from an anthropological perspective, his peculiar version of formalism is a fascinating even though ludicrous episode of cultural sectarianism.

RR Let's not talk about Greenberg. Let's talk about art that is about form, sensuality, personal pleasures.

HH *Visual articulation means giving form to something, giving it a sensuous presence. If done well, that gives pleasure to both the maker and the receiver. I very much hope you didn't get the impression that I don't care about form and sensuousness, or that I have no fun.*

RR Could we talk a little about education? I know you've taught for a long time, and I'm always concerned about what's happening in terms of educating artists. Maybe you could describe what you think of as an ideal art school. If someone came to you and said, "Hans, we want you to educate artists of the future, here are the facilities, you can have anything that you want, what would you do?

HH *I wouldn't know.*

RR Turn down the opportunity?

HH *I don't know. If people ask me, "What do you want for your ideal art school?," as you do now, I'm always at a loss for a specific answer. The reason is probably that I'm not thinking about things which are, for all practical purposes, impossible. I'm thinking about what I am confronted with today and I try to come to terms with that. That's hard enough. But let me try to give you a few general thoughts. I would like students to develop a critical understanding of where we are coming from, why things are the way they are today and how to critically evaluate the present. Most important, I want them to be resourceful and able to think for themselves. And I would hope they are given an ethical core strong enough to guide them in whatever situation they may find themselves. Adequate facilities and a good curriculum are important. More important, however, is an intelligent faculty that cannot only teach the tricks of the trade but is inspired by these principles.*

RR Tell us a little about what you teach.

HH *That's a bit easier. For one, I teach a three-dimensional design course for fresh-men. It is predominantly a formal introduction to the peculiarities of working in space. Most beginning students are rather inept in dealing with the three-dimensional. Different from my generation their experience with the world is mostly two-dimensional, by way of paper, the movie, and the TV and computer screen. To some extent the course therefore performs a remedial function. It also includes an introduction to the structural peculiarities of various materials, to working with light and motion and a hint at the semiotic and ideological implications of what the students bring to class. Reference is made also to historical examples of visual communication and art, both high and low. At Cooper Union we agree that our 3-DD course is not a beginning sculpture course but is to serve, like the other foundation program courses, all fields to which the students might gravitate after finishing their freshman year. Sculpture classes are offered from the second year on. Because the sculpture faculty believes that students learn as much from each other as from their faculty, sophomores, juniors and seniors are working in the same class. Contrary to the program of rigorous assignments of the freshman year, like most of my colleagues, I do not give assignments in my sculpture class. We fear that by continuing with assignments we would not only risk producing clones of ourselves (which would be a horrendous disservice to the students) but also discourage their moving in rather diverse directions, including the exploration of things that are traditionally not associated with sculpture. Their work is reviewed by all in the class. We pay particular attention to the expressed or implicit meanings it conveys and position it in a historical context. These discussions are held in the spirit that I alluded to in my answer to your previous question. As children get through a variety of childhood diseases, students are allowed to and must make mistakes. They have to get things out of their system before they develop a sense for what is worth doing and can add to what has been done already. I see my role as that of a coach. I encourage and push them. But they have to do the running.*

Invited by the Center for Interdisciplinary Studies in Art and Design, Hans Haacke presented a lecture on his work at the Wexner Center for the Arts at The Ohio State University. This interview took place January 28, 1993; the transcript was edited November 1996 by Richard Roth, Jessica Prinz, and Hans Haacke. Remarks by Hans Haacke © Hans Haacke.

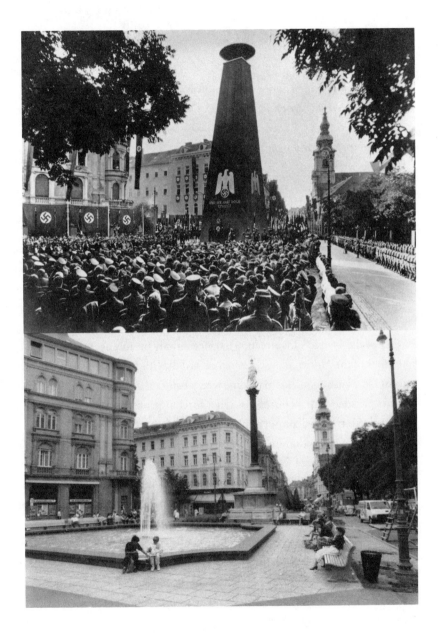

and you were victorious
after all, 1988

by hans haacke

Temporary installation during Bezugspunkte 38/88, an exhibition organized by the Steirischer Herbst (Styrian Fall Festival), October 15-November 8, 1988, in Graz, Austria.

 Curator of the exhibition: Werner Fenz.

 Photograph from 1938: Bild- und Tonarchiv, Landesmuseum Joanneum, Graz.

 Photograph of the destroyed obelisk: Angelika Gradwohl, Graz.

One of Graz's older monuments, the *Mariensäule* (Column of the Virgin Mary), rises in a square at the south end of Herrengasse, the most prominent street in Graz. Erected late in the seventeenth century to commemorate the victory over the Turks, it is a fluted column on a massive base, crowned by a gilded statue of the Virgin astride a crescent moon. It has been a popular landmark ever since.

When Hitler conferred on Graz the honorary title *Stadt der Volkserhebung* (City of the People's Insurrection), the ceremony on July 25, 1938 was held at the foot of the *Mariensäule*. Graz had earned the title for having been the foremost Nazi bastion in Austria. Some weeks before the *Anschluss*, thousands of Nazis paraded down Herrengasse in a torchlit procession, the swastika flag hanging from the balcony of city hall, and Jewish shop windows were smashed.

For the 1938 celebration, the *Mariensäule* was hidden under an enormous obelisk, draped in red fabric, and emblazoned with the Nazi insignia and the inscription "*UND IHR HABT DOCH GESIEGT*" (And you were victorious after all). This claim of an ultimate triumph referred to the failed putsch in Vienna on July 25, 1934, four years earlier, during which Nazis murdered the Austro-Fascist chancellor, Dr Engelbert Dollfus.

Guided by photos from the era of its transformation into a triumphal Nazi column, the ensemble was rebuilt in 1988 for the Styrian Fall Festival. The reconstruction differed from the original only in an inscription around the base that gave a list of the vanquished of Styria.

During the night of November 2, a week before the end of the exhibition, the

AND YOU WERE VICTORIOUS AFTER ALL

The Vanquished of Styria:
300 Gypsies killed, 2,500 Jews killed, 8,000 political prisoners killed or died in captivity, 9,000 civilians killed during the war, 1,200 missing, 27,900 soldiers killed.

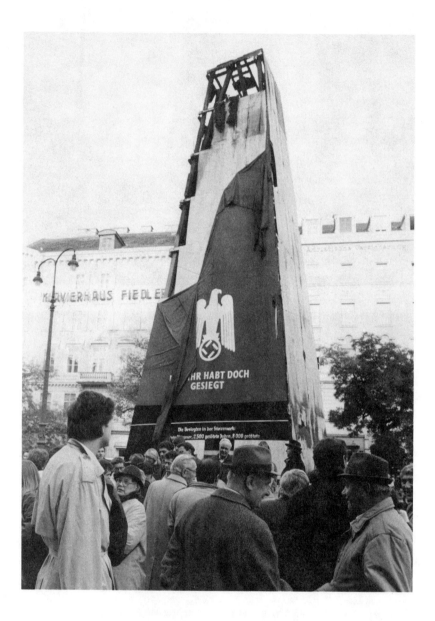

memorial to Nazi victims in Styria was firebombed. Even though firemen were able to extinguish the flames rapidly, much of the fabric and the top of the obelisk burned, and the statue of the Virgin was severely damaged.

The local and national press, as well as the German press, reported the fire-bombing, some likening it to the hostile reactions to the Burgtheater's premiere of *Der Heldenplatz* by the Austrian playwright Thomas Bernhard. Many head-lines referred to the ruin of the *Mahnmal* (memorial) as *Schandmal* (monu-ment of shame), condemning the arson and its suspected political motivation. An exception was the *Neue Kronen Zeitung*, the largest and most conservative Austrian daily tabloid, which had been the strongest supporter of Kurt Waldheim. The Graz editor used the occasion to attack the leaders of the Catholic Church for having permitted the encasement of the *Mariensäule* and the politicians for having squandered tax money on such a shameful project.

Richard Kriesche, an artist from Graz, called for a 15-minute silent demon-stration at the ruin at noon on the following Saturday. About a hundred people belonging to the local art community came and discussed the meaning of the event with the crowd of Saturday shoppers that had gathered around. For days afterwards, inspired by the *Katholische Aktion* (a lay apostolate), leftist politi-cians, students, and others left flowers and lit candles by night at the foot of the burned obelisk.

Thanks to a police sketch and the descriptions given by two people who had seen the arsonist from afar, he was arrested out of the crowd of bystanders lining the streets of Graz during the silent march commemorating *Kristallnacht*. He was identified as an unemployed, 36-year-old man who had been moving in neo-Nazi circles. The instigator of the fire-bombing was also arrested. He was a well-known 67-year-old Nazi. They were both sentenced to prison terms.

round table
discussion

maya lin

ROUND TABLE What changes need to be made in architectural education?

MAYA LIN *Architecture is a multidisciplinary field and yet it is taught as its own discipline. Whereas I think I would have learned a lot from taking psychology courses, cultural anthropology courses, more art history, architectural history, structures, and engineering. Say, for instance, at the college I went to, everything you were taught was taught by the architecture department. Well, if we would have just tapped back into the university, it would have been convenient to access other departments, rather than one school trying to bring so many disciplines together. There are certain things that form an architectural training, but we could have learned a lot from the psychology department, or art history, or anthropology department: but there was no communication between the graduate schools. I would say bring in more communication, because there is something about architecture that is potentially multidisciplinary. I branched out and went over to the school of art. I spent the last year and a half of my three years in graduate school outside of the architecture school. I was teaching in the undergraduate program and I was also working in the graduate sculpture department. There's a lot of tension between the departments and maybe there's a lot of tension between the different schools.*

{65}

RT You said you wished that you could have tied together different areas in your education but didn't mention—

ML —*Landscape. They didn't have a landscape department.*

RT That's what I was getting at. You've made an important contribution to landscape architecture. How did you decide to integrate that within your work?

ML *It wasn't a conscious decision, but rather a response to my childhood experience. I grew up in Athens, Ohio. It's extremely hilly. As a child growing up surrounded by woods, I would take walks every day. That was my backyard, the moss gardens, these rolling hills, pileated woodpeckers, deer. In a way a lot of what I do is inspired by that landscape.*

I have never been trained as a landscape architect. Probably one of the works of art that has left a lasting impression on me was Robert Smithson's Spiral Jetty. *But part of me is very much locked into the landscape. No formal training, it's just where I'm coming from. I don't know how landscape architecture is taught, because I was never officially exposed to it. I'm beginning to do even more work with topography. I want to take a plane of earth and fracture it. I might be doing that in a piece in Michigan, and I'm going to be working with landscape architects because of the contour lines and the drainage.*

I think a lot of what we are all taught is a conceptual creativity but the difference between, say, painting and sculpture and the professional fields like architecture and landscape architecture is: architects are given a problem. There is always fundamentally a problem to be solved.

My attitude is, if I'm doing a house, I would never want to not do the landscaping. Because I find it strange that you would treat the object/house separate from the land. I want to fragment that house and bring it into the land. Of course Luis Barragan is someone I love immensely. I remember ten to twelve years ago raving about Barragan to a professor in architectural history and he said, Barragan's not really an architect, he's more of a landscape architect. And I laughed and said, you're missing the point. The two disciplines can be fully integrated.

RT Both deal with space. One deals with the inside space, the other with outside space. I wish architects and landscape architects could collaborate at the university level.

ML *Well, there is a real separation between the different departments. Between the graphic designers, landscape architects, architects, and painters and sculptors there was no communication. I always sensed that the fine arts department thought that we were somehow compromising art because we built things for people as opposed to being pure and doing it for yourself. You'd walk in and feel, "Oh, we don't quite fit in here." There was an invisible hierarchy that seemed so unnecessary.*

RT There are several discussions about the way things are going. For a long time, specialization was the key to being successful in the profession of architecture. Right now we are beginning to see a whole host of reasons for a person to be multidisciplinary. Do you see a trend for people to—

ML *—Yeah, I think specialization is a direct product of the industrialized era. You can translate it to an assembly-line mentality. Specialization was the most efficient way to build on a large scale. You can also look at the problems fifty years down the line—where we are today. By the time that I went through school there was so much skepticism. If you didn't specialize, you were basically a dilettante. If you were going to waffle between art and architecture then you could not give enough attention to either field and were not considered to be serious about either field. And I think that's a direct result of industrialization, modernism. Things got very very isolated.*
 Maybe the death knell of specialization was after the eighties. Collaboration was the first acceptable road in. It started happening in the art world when people like Robert Smithson started making their art—landscape, environmental earthworks. They stepped across the line. You would consider those landscape solutions, but it sometimes takes one artist walking into another's domain to open up discussion.

RT They use our tools and methods but give them a different conceptual bent.

ML *Exactly. When one person goes in and is maybe completely naive about the discipline and, because they weren't taught a certain approach, they weren't told how to think, something new and fresh comes out—that I find really interesting.*

RT There is a backlash at certain institutions like the American Institute of Architects, licensing boards, in landscape architecture, and interior design. They are all beginning to mobilize and institutionalize, trying to prevent that sort of crossover.

ML *We live in a bureaucratic age. It has taken me six months and they still can't figure out how to get me design insurance. Am I an artist? Am I an architect? Well I'm not licensed. They're having a field day—they send it off, it comes back; they send it off, it comes back. Finally they redefine you this way or that way. It's the nature of how we've ended up and I think it is changing. We should take a more holistic approach. Even to designing a house where you begin to think of the thing more as a living organism and you don't separate things into highly specialized fields. Take it to another extreme—when you ask someone in South America to cut down all of their crops and just grow bananas—they can't feed themselves. But I don't think everyone should go run off and do everything. At this stage of the game I am totally exhausted from trying to do a couple of things. It's taken me ten years to finally see a thread of continuity between the architecture and the sculpture.*

One of the main reasons I went into architecture is because it was a field women weren't in very much. It's a very hard profession. I think it's very, very, very hard even to this day if you start working up the ranks in architecture offices to become a top designer. And it tends to be the men who are building, not the women. I don't think it's because the men know more than the women, but I'm seeing it happen. I'm a little bit luckier, but if I had been a man, where would I be in my architectural career? Would it have taken me X number of years to get my first house offer? I don't know. One reason for going into architecture was to begin to build as a woman because there are very few women who are building. It will be within our lifetime that you'll probably see the emergence of a more female aesthetic. There is a lot of ego and arrogance involved in being able to make something and put it out there. We don't talk about that. What is the difference between female ego versus male ego? Why are women interior designers, not the architects—the people who design the actual structure?

RT Often we're talking about this particular culture. I'm studying African architecture and the women are very much involved in making the house. They are the

primary builders in a lot of ways. The first thing that came into my mind (and forgive me for quoting Camille Paglia) was, "if women were in charge of everything we'd still be living in grass huts," and I thought you know that really wouldn't be such a bad thing.

ML *I have a question; for ten years I have been making monuments, making large-scale earthworks, and this comment has been used: "It's so cute, someone so petite making such large objects." Are men talked about this way? Do they comment on the physicality of the men? The other allusion is to my work as my children. It's likened to a nurturing. You're making something and you're putting it out there, but it's your child, of course you're going to be protective of it, it's your baby, well you'll just have to let it go. If you're a man creating, you're playing God, you're a city builder, you're the master builder. You are literally at times (if you read through architectural history), in a way, the gods. So when a man creates, he is a God, when a woman creates it is natural, she's a mother. What does that do to people's perceptions of going through your spaces? How is that going to affect how men create and how women create differently? Interesting, we'll see what happens in the next 100, 150 years, when women are building more.*

RT Is there a feminist architectural aesthetic?

ML *There is an emerging one. Though I wouldn't call myself a feminist I am very aware that, because of my Asian American heritage as well as coming from a female aesthetic, I'm going to be different. I don't talk about my works in terms of feminist polemic. I did not make my pieces because I wanted to prove a feminist polemical point. That's the difference. I just make what I make because I'm more interested in educating or dialoguing with people. I don't have any specific theoretical or politically based ideology that I reiterate over and over again in my work. Though I am very interested in how women in the next 100, 150 years will change how we live.*

RT Can I ask you about your upbringing? What was your environment like?

ML *I grew up in a small town at Ohio University. The library was always there and my brother and I used it. My parents are both educators, both emigrated from China. I probably have a bit of distance from the United States and yet at the same*

time see myself as American. But every time I go home to Athens, Ohio and I go to buy a book in this town I was born in, and someone will say, "Oh, your English . . . you speak so well." I was born here. I'm definitely American. At the same time, throughout my education, I look at Versailles and it doesn't do much for me. It never will. I think Western European architecture just—

RT —Leaves you cold.

ML *Yes. Whereas I was never taught what other cultures produced. It's incredible! We were taught Western European man's outlook on architecture. You can start there, going back to the first question you asked—I'm Chinese, but Shintoism and the Japanese gardens of Japan are probably the most unbelievably beautiful spaces I've ever walked in. I'm sure there are other cultures we could all benefit from knowing about—other cultures' aesthetics. The way we're taught is severely lacking. I love Scandinavian architecture so I went and lived in Denmark and studied, and took courses there. I immersed myself for half a semester. Not just taking courses in Danish architecture, I don't think that's how you learn about a culture, but just taking the subway every day. Immersing yourself in a culture that you might want to learn about. Same with Japan. I lived in Tokyo for a summer and went traveling, working in an architect's office, just being there to see, because I loved the design so much. But my parents were key. My mother is a writer and a professor and my dad was a dean of Fine Arts and a ceramist and they let us do whatever we wanted to do as long as it made us happy. Which is very unusual, there was very little pressure on us. In fact, I think, what would have been frowned upon, though it was never said, was to go out and make money. Which is very unusual, because they weren't wealthy. When they first moved here, emigrating from another country, my father had to take on four jobs just to get himself through school at the age of thirty-five or forty. He switched over from one career in China to another in the U.S.: studying ceramics at the University of Seattle. They had to leave everything and start all over again. But they had certain beliefs that what was important was information, teaching, knowledge, education, art. Art was key and I'm sure that's mostly why I am where I am, and my brother is a poet.*

RT Did you have a sense of the effect the Vietnam Memorial was going to have on people?

ML *I made it because I truly believed in it. I was studying funereal architecture and I knew what a memorial should be doing. Especially in 1981. We were still very much worried about nuclear war and the possibilities of World War III. War is not black and white, there shouldn't be any winners and losers and yet memorials in the past have always dealt with the victories. For one thing, I focused on the individuals. I knew what I was doing, I knew that people were going to cry, that it was going to be a cathartic experience. I believed, once it was built, people would understand it. The whole piece was psychologically designed, it was a cathartic experience. The ten foot height was chosen because it had to be high enough to submerge you, not high enough to overpower you. Scale is critical to how people respond. The sound drops when you are there. It sounds so conscious, but I designed it in a sketch in about two seconds when I saw the site. I had researched memorials for two months before I ever put pen to paper. I think a lot without drawing. I didn't want to make a formal design solution so I just read. I just read and read and then boom! Usually the design shows up instantaneously as a complete design. You might fine-tune it here and there but in the chronology the names were key because psychologically that's what makes you come into that time. If they were alphabetical it just would have been too clinical.*

RT It must have been very difficult for the jury to recognize all that by viewing drawings.

ML *It was as much the essay describing the piece as the drawing that won the competition. I never thought it would get built. It went in under the Carter administration. The veterans themselves had to build their own memorial with private donations. It was under Carter that the land was granted. When was the last time this country didn't build its own memorial? It was sort of disgraceful, all indicative of the time period. And finally the veterans get the funding, they've gone to all of this work, they want all the names on the monument too, which is a very strong political statement because for the first time war is not just a statement of the government, it's*

an acknowledgement of individual lives. That is done in small civic arenas, it hasn't been done in the States for large-scale memorials. It was done for World War I memorials.

Reagan, Bush, Watt, Perot—I didn't think it was going to be built. At that time things were starting to get propagandized over to the point where the generals were very upset that the names were all being listed. It had nothing to do with the fact it was black or below ground, it was because it was dealing honestly with war as a place where individual lives are lost. What surprised me was that it was built.

RT What do you think about the books and other spin-offs related to the wall? How does that affect you?

ML *It doesn't. It's become part of popular culture, which is fine. I never react and that's why veterans had so much trouble with me in Washington. Things like this just don't affect me. The wall worked, I'm very happy it worked, I never thought what would happen if it didn't work. That's what's so weird. But I was really young and I think when you're young you're wonderfully sure of yourself. Then maybe you go through your whole life being less sure. As an adult you're always very conscious, questioning, and maybe when you're seventy or eighty you get that incredible assuredness again, but it's from experience. My youthfulness definitely made me get through D.C. knowing that that was the right solution. No one could make me afraid of compromising because I believed in that piece.*

RT What do you think of the figurative sculpture erected near the wall?

ML *You know where they were originally going to place it, right? Right in the middle of the wall, and the pieces would have been higher than the wall. It would have been a disaster—trying to treat the wall as a backdrop. Fortunately we were able to relocate the statues away from that area, essentially creating two separate pieces. But I have always felt that the compromise had been decided upon before it had ever been built. My argument is, had they waited until it was built, there would have been no need for this compromise, but once they had voted on the sculpture of three men they had to put it somewhere.*

Again, it's very interesting in terms of art and architecture which is why I ended up teaching a course at Yale on artists' rights. And I co-taught it with a lawyer. I was

very interested in these differences. I would never want to legally bind someone who hires me to do a house. They're going to live in it. It's theirs, but hopefully they'll like the design enough to be sensitive to it, not to alter it. But for my sculptures I am extremely protective of what one may do to alter it. Maybe to a fault at this point. But it's very interesting that there's copyright for art and not for architecture.

RT I'm surprised they didn't call you and ask if you had any ideas about the sidewalk.

ML *I was too. I learned a hard lesson from the Vietnam Veterans Memorial, it was treated as an architectural project, there are no rights. I didn't even go for copyright, which means I can't protect it from being copied. The end result is the piece was done, I was very happy, I went away, I come back nine months later and Cooper Lucky, the architects of record, have, at the request of the Park Service, totally changed the sidewalk. They needed to enlarge it. They didn't bother to take the existing clean granite out, they just threw in cobblestones. So now you've got this very busy situation.*

Maya Lin visited The Ohio State University campus during 1992–1993 as a Wexner Center Artist in Residence in order to prepare her installation *Groundswell*. This discussion took place on April 29, 1993, following a public lecture, at a round table of graduate students and faculty sponsored by the Center for Interdisciplinary Studies in Art and Design. This transcript was recently edited by Maya Lin. Round table participants: B. Barnes, N. Belcher, L. Bly, G. Catoe, B. deFusco, N. Eder, W. Fisher, F. Jammer, M. Kinnard, K. Luymes, S. McCandliss, J. Murphy, S. Myers, A. Olson, G. Pierce, R. Roth, B. Sweney, M. Watanabe, G. Wyrick.

political space
part I: moonmark

jeffrey kipnis

WHAT WOULD HAPPEN IF YOU GATHERED all of the nuclear weapons on earth, some fifty thousand warheads each averaging the explosive power of one hundred thousand tons of TNT, put them on the moon, and blew them up? What, that is, would be the effect of the explosive equivalent of five billion tons of TNT detonating on the moon?

. . .

Before addressing this question, allow me to shift my attention from the moon to space; I shall return. What is space? An ancient question, a question as old as any in the form *What is?* The history of the meditations on space constitutes some of the most profound, troubling, and poetic thought in Western civilization, from Plato to Einstein.

As Henri Lefebvre recounts in *The Production of Space*, along a certain trajectory of this history, the notion of space has been progressively denuded of social and political texture. Space has been objectified (Descartes's *res extensa*),

neutralized (Newton), and treated as ideal *ur*-category (Kant). More recently, this trajectory has thrown the proper contemplation of space into the realm of mathematics, where it has become even further abstracted and specialized (for example, four-dimensional space-time, Hilbert space, phase space, infinite-dimensioned vector space). The metaphoric emanations from this trajectory draw upon the increasing abstruseness of space to energize such narrative exotica as hyperspace and cyberspace.

This progressive technicalization of the notion of space has left the disciplines of architecture and urban studies in a frustrating position. As the discourses of these disciplines confirm, some effective conception of space is essential to both. Yet, operating against a rationalist background in which the notion of space is regulated by the scientistic objectivity of geometry, the use of the term occurs in these disciplines almost euphemistically, fluctuating along a spectrum of meanings from something like "void with aesthetic or perceptual qualities" to something more mystical like "the ineffable je ne sais quoi of a particular circumstance."

This euphemistics occurs despite the fact that architects, urban designers, and others operating in related disciplines know fully well that a neutralized, geometrical concept of space is wholly inadequate to account for the texture of effects engendered by programmed material-form in an urban field. Because even the most important of these effects are to some extent unstable and unpredictable, they do not lend themselves to a formulation modeled on empiricism or mathematization or scientific reproducibility. Yet neither can such intuitive surrogates as ambience, atmosphere, and aura grasp what is at stake in these undisciplined effects. Thus a tacit agreement arises to refer to them broadly under the auspices of an increasingly empty term, *space*.

In cultural discourse, a great deal has been written over the last twenty years about reformulating the notion of lived space, which (with reservation) I will term *political space*. Such authors as Jameson, Deleuze/&/Guattari, Virilio, and Hollier come immediately to mind. But architectural design theory in the same period, particularly in the U.S., has concentrated primarily on various treatments of the architectural object as a source of meanings.

This focus has occurred for important reasons that can be traced to the legacy of premodern and modern design, and it is not my intent to impugn such an emphasis. Nonetheless, whether in its structuralist, poststructuralist, phenomenological, or existential modes, whether its disposition has been progressive or conservative, radical or reactionary, design theory during this period has for the most part implicitly treated space as a determined aftereffect, a product of an object. With some notable exceptions (Koolhaas, Tschumi, Diller & Scofidio, and also Hejduk, though this aspect of his work remains largely unconsidered), few designers of influence in the U.S. have couched their work in terms of a reconsideration of design's inflection of political space. Those who lay claim to a notion of space as a social condition do so in terms of establishing a fixed (and usually traditional) social geometry.

If we take political space to be the particular dynamic matrix that stages and conditions the flux of personal, social, economic, and political encounters at varying scales in a provisionally framed zone, then such space must be conceived as an indissoluble manifold of material-form, context, and event. Because it is engendered within and by boundaries, political space is always finite; this finitude is the source of material-geometry's traditional preeminence in the theorization of political space. Yet because the boundaries are always constructed not only by material-form but as well by event and context, political space is always unstable; this is the source of the increasing inadequacy of geometric formulations in certain zones.

Some care must be taken here, for event and context are not reified conditions, that is, stable and decidable. Events are the disjoint episodes that emerge from a context as discrete, discontinuous manifestations. Context is a generalized notion of background and includes not only proximate influences such as existing physical conditions, languages, values, community compositions, myths, and mores, but remote influences as well.

Context should not be confused with the term's use in contextualism, where it means loosely the physical surrounds of a site. Always underestimated but equally important to context are its various and changing remote influences. The frustration arising out of an awareness of the import of context to design

confounded by the impossibility of specifying the context is a well-known problem in architecture, emerging and reemerging time and again under the guise of such themes as zeitgeist, regionalism, genius loci, and so on.

In certain settings, such as smaller, homogeneous communities, context may be semistable and may approach site, while in other settings it can and does change precipitously and unpredictably. Indeed, for certain communities constructed entirely around technology-facilitated remote exchanges (fax, telephone, television, satellite, automobile, airplane, etc.) the proximate site component of context is almost negligible.

The effects of the recent coup attempt in the former Soviet Union provide a dramatic example of the dynamics of political space, as well as architecture's significant but limited role. In the context of the democratic reforms and economic crises of the Soviet Union, the events associated with the coup unfolded in front of an international media audience—an unpredictable but essential component, therefore, of the context. The Russian Parliament Building conditioned the precarious inside/outside confrontation over Yeltsin's position and the public square staged the assembly of offensive and defensive forces. But the political space of the episode was not embodied or latent in these prior material conditions, it was engendered in the conspicuous reframing of material-form by changing context and events.

We might well consider the transformation in political space engendered by the Thomas/Hill hearings. The most persistent effect of these hearings has been the widely reported change in the social texture of the common workplace. While in retrospect we might analyze it in semiotic terms, I believe the change in the texture of the workplace as lived experience is better described in spatial terms. In any case, the hearings clearly perturbed the manifold of material-form, event, and context.

Yet we need not rely on headlines to consider the role of material-form, context, and event in the dynamics of the production of space. Consider, for example, lavatories designed for the disabled. As the context changes, as the persons served by these facilities come to be understood not as a quasi-institutional collective but as possessing the characteristics of a genuine community, the space engendered by the clinical, stainless-steel fixtures typical of these settings changes.

Though a Marxist or other semiotic reading of the subtext of these fixtures is possible, it is important to emphasize that we are discussing a change in engendered space, an issue connected to but different from semiotic analysis. Clearly, as I have described it, space is inextricably linked to the semiotic field. Indeed, it is the very instability of the political space manifold that undermines the stability of any and every semiotics, an effect known as "reframing." Yet, as the scene of readings, political space is lived, not read.

On the one hand, no reduction, no abstraction, no effort to isolate "for the moment" a spatial consideration from the material-form/event/context manifold can be free of political consequence. On the other, political space is fundamentally beyond any architecture's thorough control. While the architect always works with a determined site, site is only a provisionally framed subset of the undecidable fluidity of context. While the architect always works with a specified program, program is only a provisionally framed subset of the protean indeterminacy of events. The limitations of the architectural component of political space are as important as its contributions.

In a certain sense, because this view emphasizes architectural design's limited role in the engenderment of political space, it could be construed to support the position that architectural design has no political possibilities or responsibilities. Indeed, the argument of limited effect does vitiate those theories that seek to obligate design strictly to any single discourse, such as the social discourse, on moral or ethical grounds. Whether these theories derive from a Marxist or empirical tradition, they overestimate architecture's capacity to concretize political space and underestimate the political force of aesthetics. Yet I believe the conclusion that the argument of limited effect immunizes design from the possibility of and responsibility to a political discourse is also incorrect.

The stylistic destitution and empoverishment of vocabulary that was the dominant legacy of architectural modernism in the U.S. has led recent design theory to be written in semiotic (and postsemiotic) terms, emphasizing the meaning-engendering function of architectural design and symbolism. It is, however, both possible and desirable to rearticulate the same concerns in spatial terms.

Outlined very broadly, such an argument would note that architectural design strategies at the turn of the century, those of the beaux arts, for example,

were directed toward a space whose reified hierarchy supported received political, economic, and class distinctions and underwrote their systems of enfranchisement and disenfranchisement. European modernism, motivated in part by a discourse that emphasized commonalty and equality, rejected this stratified spatial hegemony and sought to produce a more homogeneous space, a space that was held to be universally enfranchising. Modernism's optimism that it could exercise comprehensive, rational control over political space through architecture to an extent stemmed from a naïve understanding of the complex interplay of the components that produced this space, a naïveté partially born out of a confidence in the neutered, geometrical conceptualization of space.

As we have grown increasingly aware that any discourse of empowerment must respect difference, we have also grown aware that the homogeneous space aspired to by modernism was equally hegemonic in suppressing difference. The problem that faces postmodernist design in spatial terms, therefore, has been to reinvigorate the exploration of heterogeneous space. Some argue that premodern hierarchies are essential to spatial heterogeneity, others argue that genuine heterogeneity flows from georegional differences, while still others pursue a radical heterogeneity, one that supports the proliferation of differences without alignment and without allowing difference to sediment into any reified, categorical hierarchy.[1]

It seems to me that this latter pursuit holds the most promise for providing architecture/urban design with an affirmative political direction that, at the same time, takes advantage of design's limited contribution to space. Even if it never determines this space, insofar as architecture/urban design seeks to exercise increasing control, it suppresses the elasticity of political space.

In certain zones, contemporary circumstances call for a fluid political space of greater texture as populations become more heterogeneous and as communities established under the traditional dominion of the proximate exchange give way to new, authentic communities founded on the remote exchange. In these zones, the architect concerned to contribute to an elastic political space must explore the proliferating of potential effects through a disciplined relaxation of traditional systems of control, regulation, and group identity, without

abdicating architecture's relationship to these functions. Emphasis shifts from how architecture can be made to meet the obligations established by one or another discourse of social responsibility to how to increase the production and elaboration of architectural effects. While many discourses from the mundane to the arcane can contribute to and motivate such a study, no single discourse can dominate it.

The thematics of political space outlined here, particularly as it articulates the possibility of an unreifiable heterogeneous space, may provide an escape from the double bind that always arises in standard interpretations of the relationship between architecture and politics. For example, in "Architecture and Politics in the Reagan Era: From Postmodernism to Deconstructivism," published in *Assemblage* 8, Mary McLeod paints a brooding landscape of the architecture of the 1980s with a familiar Marxist palette and social moralist's brush. However provocative and insightful her reading may be, it is entirely conditioned by the conviction that architecture can and should determine political space.

Allow me to comb out a strand of her argument:

"The intersections between architecture and politics can be seen as twofold: the first involves architecture's role in the economy; the second, its role as a cultural object."

"The modern movement in architecture was deeply concerned with the first of these dimensions. The advocacy of standardization and serial production, the emphasis on housing as a social program, the concern for a mass clientele— all were examples of the modern architect's attempt to redefine architecture's economic and social role."

"In the 1980s most schools stopped offering regular housing studios; gentleman's clubs, resort hotels, art museums, and vacation homes became the standard programs. Design awards and professional magazine coverage have embodied similar priorities. Advocacy architecture and pro bono work are almost dead."

"That contemporary architecture has become so much about surface, image, and play, and that its content has become so ephemeral, so readily transformable and consumable, is partially a product of the neglect of the material dimensions

of architecture—program, production, financing, and so forth—that more directly involve questions of power. And by precluding issues of gender, race, ecology, and poverty, postmodernism and deconstructivism have also forsaken the development of a more vital and sustained heterogeneity. The formal and social costs are too high when the focus is so exclusively on form."

There is much to commend in McLeod's essay; whether or not one agrees with her analysis and/or her conclusions, her interpretation of a subtle collusion between one period's various vectors of architectural speculation and the infantile indulgences, neoconservativism, and speculative economics of the same period cannot simply be dismissed. In fact, it was upon reading the underlying tension between McLeod's work and Mark Wigley's essay published in the same issue, "The Production of Babel, the Translation of Architecture," that I began to explore the considerations that I preliminarily set out here. As I read the essays, I felt a bit like *Fiddler on the Roof's* Tevya listening to a debate between two wise men of Anatevka. After hearing the first argument, Tevya declares, "That's right!" Then, upon hearing the counterargument, he again asserts, "That's right!" Another bystander points out to him that they cannot both be correct. Tevya responds, "You know, you're right!"

(To be continued.)

. . .

Back to the moon (though, no doubt, some readers will contend I never left). Asking the What-would-happen-if question of many audiences in the U.S. and Europe, I have found, almost without exception, the answers to be something like "blow the moon to bits" or "knock it out of orbit," physics notwithstanding. In fact, even were the devices arranged for maximum effect, the result would be a scar on the surface almost invisible to the naked eye on earth. We tend to misinterpret the threat these weapons pose to the fragile life on earth as extreme mechanical ability. This mistake, coupled with a casual relationship to the moon still colored by its perceived size, yields the distorted responses. The asteroid or comet that collided with the earth and caused the demise of the dinosaurs is estimated to have struck with the force of ten million

times our combined nuclear arsenal. As of yet, we have not located its site of impact.

Some eight years ago during the resurgence of the nuclear disarmament movement, I proposed the *Moonmark* project as a disarmament solution. I considered mankind's capacity to commit global suicide and to destroy virtually all life to be a stunning if perverse achievement. The thought of retreat, of simply disassembling all of those weapons, was not to be countenanced. Rather, I preferred to use them constructively; so, with the help of artist C. Glenn Eden, *Moonmark* was conceived.

The proposal required a continued production of weapons to reach a force of at least ten thousand times the then-current capacity. The cost of production, delivery, and execution was estimated at three to six times the gross world product (1983 dollars). The result would have been the first man-made object visible to everyone on earth within a twenty-four-hour period.

The location of the mark was calculated to take maximum advantage of the moon's changing phases, and the orbiting ejected material could have been shepherded with satellites into Saturnlike rings around the moon. But the work was not merely sculptural; rather, it was functional, converting the moon into a giant scientific instrument suitable for delicate occlusion studies of the objects of the cosmos. Because it functioned, because it made large demands on scarce resources, because it intruded irresistibly and relentlessly into the public domain, the proposal qualified as a work of architecture. It seemed to provide a fitting testimony to our collective decision to survive and progress beyond our potential for massive self-destruction.

However fond I continue to be of *Moonmark* (and secretly committed to its realization), I am these days as interested in its capacity to contribute to a changing political space as I am in the original meanings it was intended to embody. *Moonmark* would certainly extend the architectural horizon of the world quite a bit, activating the entire subtended void between the earth and the moon as potential space, a traditional perimeter/center effect. As the context and events surrounding its realization gave way to other contexts and events, nonetheless, so would the engendered political spaces in which it would continuously participate. Because it is neither symbolically referential nor

formally archetypal, it would lend itself easily to a wide spectrum of spatial reframing.

Perhaps a light-hearted example would help make what I hope is a serious point. During the time *Moonmark* was first conceived, Gorbachev was virtually unknown to me. If the project had been realized, however, it might well operate today as a mirror image of Gorby's birthmark. Completely aside from the symbolic issue, would not having Gorbachev as the man in the moon for a little while also unexpectedly inflect the texture of our political space?

sex objects

ellen lupton

THE SEXUAL DIVISION OF LABOR IS A central feature of the modern home and office. Certain tasks, accomplished with certain tools, have become associated with "women's work," while others traditionally have been assigned to men. Mechanical devices, from the washing machine to the typewriter, are designed to perform work; the work they do is cultural as well as utilitarian, helping to define the differences between women and men.

Human personalities are shaped by social conditions, from ideals of family life and norms of gender behavior to the economic opportunities available to people based on their cultural identities. The self is, to some degree, a manufactured object, a social product. Over the past two centuries, people increasingly have defined themselves through the products they buy and use. The American "standard of living," which rose dramatically in the 1920s and the 1950s, is embodied in an endless inventory of objects. Married women, as the chief purchasing agents for the typical family unit, have been the main targets for many consumer products, from domestic appliances and cleaning products to ready-made clothing and industrially processed foods.

Manufactured goods are connected intimately to the minds and bodies that use them. Through industrial design, marketing campaigns, and the narratives of popular entertainment, useful things perform functions beyond mere utility. As objects of emotional attachment, mechanical devices animate the scenes of daily life, stimulating feelings of love, possibility, and connection, as well as guilt, restriction, and isolation. The self emerges out of material things, which appear to take on lives of their own.

As a feminist study of design, this publication looks critically at the values that distinguish the experiences of women and men. Every history has a bias; by calling oneself a feminist, an author names the position from which her story will be told. Accounts of design that claim to speak in a neutral voice tend to center, by default, on male designers, inventors, entrepreneurs, and other *producers* of culture. Women, as the buyers and users of numerous consumer products, are a crucial field against which to view modern design. The concept of "woman" addressed by design and advertising consists of cultural fantasies as well as demographic facts; it encompasses idealized media Moms and eternally sexy secretaries as well as the concrete diversity of the marketplace.

America's consumer economy gathered force during the nineteenth century. By the 1880s, many urban and suburban families were buying factory-produced clothing, food, furniture, housewares, and other goods that once had been made at home. While men commonly left the house to work for wages, their wives became responsible for buying, using, cleaning, and maintaining consumer goods. Advertising made women its primary object of address, as did modern industrial design, which emerged out of the advertising business in the late 1920s.[1]

From the 1930s through the 1950s, industrial designers applied the aerodynamic styling of trains and planes to home appliances, office machines, and other immobile objects, transforming them into emotionally appealing commodities. By concealing the moving parts of machines inside smooth skins, designers made appliances easier to clean by female users, who have served as the chief custodians of modern standards of hygiene. J. Gordon Lippincott, one of the pioneers of the industrial design profession, claimed in 1947 that since 90 percent of consumers were women, male designers and manufacturers must learn to speak to them.[2]

"If hard-headed business men [could] build up . . . the cosmetic industry in a few years, and do it on sheer emotional appeal to the American woman, there is no reason why such common everyday objects as alarm clocks, prefabricated homes, hair curlers, and helicopters should not be sold on the same basis."
—*J. Gordon Lippincott, Design for Business, 1947.*

Until recently, the ideal of the white, middle-class family promoted by most advertising consisted of stay-at-home mothers and employed fathers. Despite this mythic image, however, economic necessity and personal ambition have brought women steadily into the work force over the past two centuries. In the late 1800s, keyboards, switchboards, and telephones became central to new urban, female-identified jobs. This movement of women into employment has been marked by the conflict between their domestic obligations and desires, and their opportunities and expectations as wage-earners.[3] Some employers and unions have capitalized on this conflict by invoking the ideal of domesticity to discourage women from competing with men for wages and to characterize their work as temporary and nonessential. The domestic ideal also has functioned to define women as naturally suited to jobs involving neatness, courtesy, and personal service.

Accompanying women's dramatic entry into the work force in the 1950s and 1960s was a growing awareness among women of how the home shapes female identity. Betty Friedan fueled the postwar revival of feminism with the publication of her 1963 book *The Feminine Mystique*.[4] Friedan studied the media culture of housework, locating in domestic advertisements and magazine features a powerful ideology that limits the ambitions of middle-class housewives. Friedan's book draws on the personal archives of consumer researcher Ernst Dichter, who used emotional appeals to sell appliances and other goods to women.

Friedan's feminist critique of consumer culture was part of a broader critical look at the aesthetic and psychological power of commercial media. Marshall McLuhan's 1951 book *The Mechanical Bride: Folklore of Industrial Man* includes an essay about depictions of the female body as a machine-like aggregate of

detachable, interchangeable parts, a pattern McLuhan found in the croppings and juxtapositions of photographs in journalism and advertising. His phrase *mechanical bride* recalls the Dada and Surrealist fascination with sex and technology. Marcel Duchamp, Man Ray, and other avant-garde artists had seen eroticism and destruction—not just rationality—in machines; McLuhan recognized a similar impulse in everyday media.[5]

> *"Marriage today is not only the culmination of a romantic attachment . . . it is also a decision to create a partnership in establishing a comfortable home, equipped with a great number of desirable products. . . ."*
> —Ernst Dichter, quoted in Betty Friedan, The Feminine Mystique, 1963.

By looking seriously at popular media, Betty Friedan and Marshall McLuhan studied their own society in the way anthropologists examine foreign cultures. They set precedents for the field now called cultural studies, which examines the relationship between artifacts—from consumer goods to city plans—and their social context.[6] While history traditionally focuses on written documents, and art history values rare and precious objects, cultural studies turns to the material remnants of everyday life. For cultural studies, objects do not have a stable meaning, decreed by their makers and frozen in their formal structure (materials, style, technique). Instead, meaning emerges through social practices, including an object's representation in various media, its connection to shared customs, and its significance to the people who own or operate it.

Advertising and design serve to amplify the value of useful things, transforming functional tools into appealing commodities that promise to satisfy emotional as well as material needs.

Scholars of religion traditionally have used the word *fetish* to describe objects that societies invest with the magical ability to control the forces of nature.

Karl Marx borrowed the word *fetish* to characterize the cult object of capitalism: the commodity.[7] In a consumer economy, objects are manufactured primarily to be sold, and only secondarily to satisfy a human need. The object

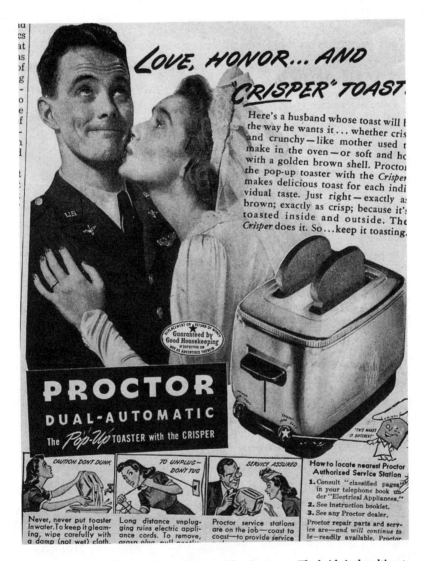

Love, Honor . . . and Crisper Toast. Proctor-Silex, Inc., 1942. The bride is the ultimate consumer, the person for whom everyone buys things and who is presumed to own nothing already. Here, a young soldier departs for war knowing that when he returns, the toaster will be plugged in and ready to go.

becomes a fetish as its functional aspects give way to psychological incentives. The inanimate object *speaks* through advertising, packaging, styling, and brand name recognition. The corporate personality invoked by a familiar brand name such as the Hoover Company's logo can raise the value of an appliance, regardless of its functional difference from other brands.

> *"Since buying is only the climax of a complicated relationship, based to a large extent on the woman's yearning to know how to be a more attractive woman, a better housewife, a superior mother, etc., use this motivation in all your promotion and advertising . . ."*
> —*Ernst Dichter, quoted in Betty Friedan,* The Feminine Mystique, 1963.

> *"I only had one dream where she [my mother] was naked . . . She was vacuuming. It wasn't sexual. It was about cleanliness."*
> —*Nicolas Cage in* Honeymoon in Vegas, 1992.

Marx assigned a feminine personality to the commodity fetish by describing the alluring, extra-functional features of the consumer product as "amorous glances" that solicit the inner hopes and passions of the buyer. Freud used the word *fetish* to name an inanimate thing or an isolated body part that becomes a substitute for a forbidden sexual object. A foot or a shoe, a hand or a handbag—each can become the target of desire, invested with intense emotional significance.[8]

The fetish, whether sexual, economic, or both, is an object that acquires magical functions. Advertising and design have compared machines to living things by picturing them as extensions, substitutes, metaphors, or erotic mates for the human body. Women, in their roles as consumers and workers, have been wed to technology; meanwhile, the design and promotion of machines have borrowed physical and emotional attributes from women, making domestic appliances and office equipment into glamorous but hard-working brides themselves.

Technology also is fetishized when it is viewed as an independent, autonomously developing organism, capable of altering society by itself and evolving into steadily improving forms. All technologies, from the washing machine to the atom bomb, are invented and used by human beings; they often

The One You've Always Wanted, General Electric, 1938. In the 1930s, an electric refrigerator such as this one, designed by Henry Dreyfuss, was a new appliance that few young women would have known in their own mothers' homes.

are used by one group at the expense of another. The myth of an inexorable technological progress fuels the notion that household appliances have consistently liberated women. To study design from a feminist perspective, one must look at the social framework in which objects are put to work.

> *"What is domesticated woman? . . .*
> *She only becomes a domestic,*
> *a wife, a chattel, a playboy bunny,*
> *a prostitute, or a human dictaphone*
> *in certain [social] relationships.*
> *Torn from those relationships, she is*
> *no more the helpmate of man than*
> *gold itself is money. . . ."*
> —*Gayle Rubin,* "The Traffic in Women," 1975.

A person articulates herself *as female* in part through the material objects and images that frame her daily activities. "Gender" is the set of behavioral norms and expectations that members of a given society attribute to the physical differences between women and men. In the words of anthropologist Gayle Rubin, who has analysed the difference between biological "sex" and cultural "gender," the making of a woman is a social process.[9] Feminist studies of design and technology look at products, buildings, cities, and media in relation to women users. Although the built environment is designed largely by men, much of it is constructed with female consumers in mind; design thus contributes to the "making" of modern women.[10]

round table
discussion

ellen lupton

ELLEN LUPTON *I want people to come into the museum and see objects and images that relate to their own life and think about how they have lived with these objects, and how their experiences fit and don't fit with media representations that tend to be normative and stereotypical and focus on a certain middle-class ideal of life. In* Mechanical Brides *we tried to create an atmosphere that invites people to think about their own experiences with machines, and sex, and money. The* Mechanical Brides *project is kind of a second chapter to* The Bathroom, the Kitchen, and the Aesthetics of Waste, *an exhibition I organized with Abbot Miller at MIT List Visual Arts Center in 1992. It is an attempt to introduce people to the research that historians have done on women's work and women's economic conditions and how that research relates to the world of objects, the everyday world of commodities and things that we work with, and buy, and enjoy, and hate, and so forth. So I see these books as small archeologies of particular objects.*

One of the things that I wanted to do in Mechanical Brides *is to focus on the users of objects rather than the makers and to focus on their importance in completing the object. So it's not a show about the fact that only men designed appliances in the 1950s. That's a straw dog, because men in the twentieth century basically have designed almost everything. But at the same time women have had*

this huge but unrecognized role in homes and in offices and so forth, using objects, being the consumers of objects.

ROUND TABLE There are few women in the field, and therefore their perspective isn't seen in product design. But I think that we're probably seeing a shift in design from the self-centered "I'm going to design something and give it to the world" attitude to a more user-centered approach. So I think that whether you're male or female, design is starting to come to the user.

EL *I think market research, which has been rising for decades, is a place where, in fact, women consumers do contribute to the design process in a very controlled way. One thing about looking at design in the context of a museum is trying to get people not to focus on the designer as the only force in creating objects and controlling their use and so forth. Consumers have a role to play. The objects can't dictate who uses them. The refrigerator of itself doesn't determine who is the main person in the family responsible for stocking it and cleaning it and throwing away every gross thing that you find in its depths. But there are lots of people involved in this world of objects, not just designers. I think the move towards market research and so called user-centered design is, in a way, the feminization of design in the sense that it presents the idea that the people who use the objects have needs, and that those needs vary, and they need to be accommodated.*

RT Don't you think we can be told we need something in an advertisement, because they want to sell something, whether we need it or not? I wonder how much designers really have to do with that. I would think unless you're a very well-known designer, those companies aren't coming to you and saying "Design this, and do whatever you want . . ." I would think the companies are working in parameters and with restrictions, and thinking "This is what we want to sell the public, this is what we want you to design."

EL *Yes, I mean domestic appliances. This is one thing that distinguishes industrial design from graphic design. You can really run a cottage industry as a graphic designer. I mean like all my books for example—it's a situation where the designer has complete control over the product. But product design, because of the huge amounts of capital that go into making a mass-produced object, the designer is just*

one tiny link in deciding what gets made and how many and in what colors. The designer's position is minor. And another point to be made is that one can revolutionize the process of work. For example, in the twentieth century massive changes in the way housekeeping is done—the introduction of the vacuum cleaner and the washing machine and automatic appliances, and so forth—changed completely the texture of the way that work is done. But at the same time the social frame in which it is done remains basically the same; it's done by women and it's done privately, within households. Everyone owns their own appliances. So on the one hand you have the revolution of the object and on the other, the complete conservation of the social frame in which the work is done. And major shifts, like changing that social frame, aren't going to happen just with objects. Technology is not a force with its own mind that does work without people manipulating it and paying the bill. So it's really important in any kind of study of objects to remember that it's the social frame that ultimately determines how things gets used.

RT As artists we are taught from day one that form is so important—the form, the design, the shape, the color, the texture of that thing, that's what it's about. It's difficult, I think, for people in art, and probably in design too, to really come to terms with seeing products/objects more as part of a social network than as discrete things.

EL *I am still fascinated with individual objects. A big part of the exhibition shows the evolution of the washing machine. I think they're beautiful. Especially the older ones. The Maytag from 1939 with the white legs and the red logo is a beautiful machine. It's not that I don't think the form of things is interesting, or even that form has no power, but you just can't think that all of the power resides in the object.*

RT You did show a few contemporary ads, and I was wondering how much of the show was on history and how much on contemporary advertising. I think 99 percent of advertising is still doing what it did then, but that advertising is so slick now we don't see what they're doing. It's not as obvious, but it's still there.

EL *Some things have gotten better. Advertising today is more diverse. There's a lot of pressure to show people of color in advertising. You look at the traditional women's magazines like* Ladies' Home Journal *and* Women's Day *and those mag-*

azines, they're much more diverse and much more culturally sophisticated than advertising in the sixties was, even though society was diverse then, too.

RT I do think there has been some change between men and women in certain circles. The fact was that certain people wouldn't be in certain rooms fifty years ago. So there have been some changes and I think those changes are going to have demographic effects throughout the whole society. My perception of a relationship, and sharing, is different from my father's.

EL *There is change, but it's not in the bag. Susan Faludi's book* Backlash *documents how journalism in the eighties promoted the idea that women were suffering because of feminism, and that women were losing their fertility, and that they were "burning out." The statistics were manipulated—by journalism, not advertising—by* Time *and* Newsweek *and the* Harvard Business Review *to get across the message that feminism a) had succeeded and equality had been achieved; and b) that women were hurting because of it.*

RT In contemporary advertising, I can't recall an ad where men are cooking in the kitchen, or cleaning the bathroom, etc.

EL *Women teach their own daughters to expect certain things from life and you know, it's not just men making women do the work. There is a wonderful book by Arlie Hochschild called* The Second Shift, *which studies this problem in the eighties. She went and lived with these families and studied who was doing the work. She's strictly concerned with double-income families, and reading her book is heart wrenching. She really gets involved in the relationships between the parents and children and the games people play in a manipulative way to do the work and not do the work and it's really wonderful and entertaining. It's like a novel. But she finds even in families where the woman is bringing home a salary, she is still expected to do 90 percent of the cooking, and grocery shopping, and cleaning. Whatever gets done, she ends up doing it. One of the reasons for that is that women still are paid less in the marketplace, so when they get home with the woman's $20,000 salary and the man's $35,000 or whatever, her time is simply worth less. Literally, it's worth less, so even though she worked the same eight hour day that he*

did, when she gets home her leisure has less economic value attached to it because she makes less money.

RT As a graphic designer, do you think screen icons and the way the whole computer interface works is male-centered, and if it's becoming a whole new language that might be a generational concern? For example, my mother doesn't interact with computers well. From cave paintings all the way through to making letterforms, I'm wondering if computers are actually a part of that evolution or if they're a fracture, and all of a sudden we're starting out with something new that most of the population, and the aging population, can't understand.

EL *Yes, I think it's really going to revolutionize—I mean it already has—the way a design is done. I don't think there is any sexual bias to those interfaces. I don't think so. But, I think it is true that men are dominating that field. Everyone should want to do it. The computer enables you to write and design at the same time, which is really fun. It's something, for example, that editors find perverse. I mean the way I'm doing the* Mechanical Brides *book is that I do the layout and then I write the text that fits. My editor at Cooper-Hewitt thinks that that's a problem, because it's putting design before a text, and that you should have your manuscript and your manuscript is everything that needs to be said, and then you force your design to accommodate it. I don't have that feeling about a text being more important than format and margins and illustrations. Text is just one part of the reading experience, and the writing experience.*

RT What about education, do you have ideas about teaching design? Mostly we still do a Bauhaus foundation in art schools.

EL *I think design is a cultural discipline and that designers are cultural players, and that design involves the history of society and the structure of it and literary concerns and so forth. I feel that the focus on basic geometric form and figure-ground relationships and all of that, which becomes the first thing that students learn when they come to college-level design programs, tends to limit the way*

people think about design. I think you look at contemporary art/architecture and that these fields are increasingly involved with study and understanding of culture, and sexuality, and all kinds of issues like that.

At invitation of the Center for Interdisciplinary Studies in Art and Design, Ellen Lupton spoke at the Wexner Center for the Arts about the exhibition, "*Mechanical Brides: Women and Machines from Home to Office,*" that she was curating for the Cooper-Hewitt, National Design Museum. This discussion took place on April 23, 1993, the day following her lecture, at a round table of graduate students and faculty; the transcript was recently edited by Ellen Lupton. Round table participants: B. Barnes, N. Belcher, L. Bly, K. Evenson, S. Huntsman, P. Mitchell, A. Olson, R. Roth, C. Shafer, L. Wolfe, K. Woodward, G. Wyrick.

stephen pentak

STEPHEN PENTAK My thought was to begin with some general questions that would provide a background. I would be interested in hearing a few words about your life as an artist and an educator, and your role in this Cheyenne Elk Warrior Society, and life on the Cheyenne Arapaho reservation.

EDGAR HEAP OF BIRDS *Well I moved back about ten years ago, I think in '80 or something. I had been on the east coast, had a studio space, finished graduate school in Philadelphia, kind of showing in New York a little bit in alternative spaces, and then had to just sort of get out of town, get back to the basics of nature in a way, and to learn some things that I couldn't learn in the city. And, of course, the tribe was instrumental in that too, but it was kind of getting back out of the city and exploring some things that I wanted to do, but just couldn't get the information, or feeling from where I was in Philadelphia. It was a pivotal time—I had a piece downtown at this gallery, and I came and took it out of the gallery and took it with me. They just freaked out. It was in the* SoHo Weekly News, *and people were going to come and see this piece, and I just said, "I'm going to move back to Oklahoma." And they thought, "Are you nuts?" They said you are supposed to move to Tribeca and get a loft and do this thing. Which I could have done, I mean*

I was interested in that too, but it didn't seem to be the prudent part of the plan. Anyway, I moved back and eventually moved into this old house on the reservation area.

SP This was about ten years ago or so?

EHB *Yeah, it was about '80 or '81 or so. Moved back. I rebuilt this old house that was just derelict. No bathroom, no road, no electricity, and just sort of started hammering out by hand, sawing with a bow saw, making a bathroom, and I have just been there ever since. I got more involved with learning from the tribe on the ceremonial level, pretty heavily into that, that's a big responsibility, and that's where the Warrior Society comes in. It's something you can join, if they will accept you and you can just decide to go into it and you get responsibilities from that, and also basic learning. So, I've been really involved with those things and then trying to work on my art too. I was artist-in-residence for about eight years for the Arts Council of Oklahoma, did gigs all around, little schools and little tiny towns, and worked with kindergarten kids, or third graders, or whatever, and made a living that way and kind of learned about the state also. It's a very strange way to learn about the state. You come into this little tiny town of insensitive people or whatever, and you've got to learn how to deal with them and they learn about me. So I learned about Oklahoma doing those jobs, and teaching kids. I also learned how to communicate with people, I think, teaching young kids.*

SP So you've been active in the Warrior Society for that period of time as well?

EHB *Yeah, just about. Maybe about eight years or so.*

SP And you've had an active career beyond the boundaries of Oklahoma for that same period of time, though. How were people finding you? It's not the same as you being in New York or Philadelphia, being able to meet people.

EHB *Yeah, that's a good question. Now they do. They come out to the studio. Curators fly out sometimes and look at the work. But, no, I had to work really hard*

at that, you know. And a lot of it wasn't very successful. I tried to have a show in Europe and it flopped, and I tried to have a show at PS1 and it flopped. And now I don't know if I'd take a show at PS1, but I tried and they said they lost my video tape, and they didn't call back, and whatever. But I kept plugging away. But it was more like being interested in just exchanging ideas, you know. That's how I look at careerism as not just about getting a good gig or getting well known but actually just...

SP My reason for asking was to find if there has been a sense of isolation.

EHB *I guess there were both things going on. And that's the strange thing about where I am, this very isolated place, yet if you catch an airplane every now and then you can be anywhere. Actually, I was teaching in Sweden for a while. I went to Europe two or three times and I was doing a show at the United Nations in Geneva. I did a large native group show that I curated. I took it to Geneva and I hung it. I was hanging out in Switzerland for a while and I met some people from Sweden who asked me to teach in the public school system in Sweden. Then my tribal business committee members' council, they paid the air fare for me to go to Stockholm and then I taught. So it was always these kinds of networks, coming out of that place and reaching out to different parts of the world.*

SP That must provide an interesting role model for your students at the University of Oklahoma to see how somebody can have their life the way they choose it to be and still connect to other communities.

EHB *What's been difficult now though, is that I have two children, two sons, you know. I think we're probably going to move off that place and move to the university town. We were there for the ten years and it was fine. We were lonely, there is no place to get a pizza, you can't buy anything. The store closes at six, there's no store open. You know the conveniences are zero. And then you're driving an hour to go anywhere.*

SP So then, the children are the motivation, in terms of meeting their needs.

EHB *I think so. You know the schools, and then how you're almost working more with raising your kids then you are anything else. There's nothing else, I mean you squeeze in things, but before you could kind of go off and hunt in the canyon for five hours and come back whenever you wanted to, which I used to do with my dogs, but, of course, that's not happening. We take walks everyday, but the access is a different story.*

SP Well that leads to the next thing I want to talk about. I think it would be good for you to have the opportunity to respond to this idea of a life in two worlds. So the first question is: do you see it that way, and to what extent do you feel distant from or connected to non-native artists?

EHB *Well, I'm really connected to non-native artists.*

SP You're talking about Vito Acconci?

EHP *Yeah, Vito Acconci. I exhibit a lot, like in this show here at the Wexner Center. I travel a lot and I see a lot of work. I teach a course about contemporary art, a videotaped interview course. I play video tapes of Hans Haacke, Barbara Kruger, Vito Acconci, all of these people, Juan Sanchez, Pat Ward Williams, you know all of the contemporaries of mine. I feel like I'm friends with them, basically, because I show with them. So I guess I'm very versed in the contemporary vein, but by choice, because I'm interested in the work.*

SP So the model of two worlds is not a model.

EHB *More like the country. I think that is a big division, like rural America maybe. Because I think anyone who lives in rural America, that's a whole other world in a sense, and not on an ethnic level, but just that pace and that kind of self-reliance and the kind of network you have to deal with, the farmers to get your car pulled out of the ditch or whatever, and those kinds of things. Or like, one farmer by me had a leak in his well, and he called me up and asked me to come pull this one hundred foot well out of the ground. And I had to go because he pulled my car out of the*

ditch. So we were working all day pulling this big hose out of the ground, and all of that. I mean that opposed to Norman, Oklahoma, even the University of Oklahoma, or New York City, those are very different places.

SP I'm interested in your thoughts about your education as an artist. Reflecting back on what you considered the most important aspect of your education. Because on the one hand you have studied in Philadelphia and England and on the other hand you have the education you received from the Warrior Society. Would you say just a few words about what you consider true education?

EHB *Well it's a blend of both. It's funny but it seems like the white education is more accessible in a way. That's held up as a better role model, I mean people have more respect for that. That's kind of what's hurting native America in a sense. Ceremonial leadership and traditional responsibilities—no one understands what that means, so no one respects it. There was a man who died a few years ago who I respected immensely. He was a janitor, but he was the priest of the ceremonial ways. I mean he could turn the world around, he could renew the earth, but he was a janitor at the hospital, the Indian hospital, and I would just shake my head. And I don't know if anybody minded him being a janitor, but the respect, he just didn't get the respect he deserved. So in terms of role models, when kids look at that, and you tell them "well you go with him because he's going to show you these things," and he's sweeping up or something, so it's a screwy deal. Whereas, long ago if there was a warrior, a native warrior, they would go with him, because he's, in the tribal context, a leader with respect. That's kind of how I grew up too. I thought that academia was the best model that I had discovered. Of course first was a good job. My father retired from Beech Aircraft in Kansas, twenty-eight years; my mother and father were excellent models on how to work and how to be committed to family. They still are, so I saw that, and then I learned later that you have college, because I didn't know that. That was an important thing, you know. Then I later became a graduate student to become a professional artist. But that was the first kind of goal. But then of course, after graduate school and after working in a studio for a while there was something missing. That's when the ceremonial knowledge kind of beckoned. I think it's led the work into the best direction, overall, but I can't divorce the two things from each*

other, they compliment each other. My friend Willie, the priest of the ceremonial ways, what he said, I totally believe. I mean I know what he's talking about and when things come down to very difficult circumstances, you know where you're gong to be. Which one you're going to pick. You're going to be with your pipe. You're going to be sitting on the ground, there's going to be a fire burning, and you're going to be humble before the spirits. There is no doubt what is most important.

SP What is the most irreducible.

EHB *Yeah. And I use that myself and my son does. He understands the priorities of that. And that's where you start and that's where you end, and that's always something you can count on.*

SP I want to read something, a passage from an article by Kay WalkingStick that was in *Art Journal* in fall of 1992 and I'd like to get your reaction to it. She says, "Curators have instead used issues such as gender or ethnicity as an opportunity to show artists who may then be left out of exhibitions dealing with more mainstream themes. Such a separation seems to reduce the possibility of serious critical discourse, and thus implies that there are different standards for different people—and, indeed perhaps there are. *Separate* is still not *equal*; it marginalizes the art, no matter how wonderful that art might be. Critical questions that would be raised in other venues simply are not considered in ethnic or gender-specific exhibitions. Not to receive serious critical review is a kind of disempowerment."

EHB *Well that's a real important observation. I'm very behind that thesis, because I came up through all of this multicultural whirlwind kind of thing with Group Material. Which I found to be very sort of fascist, basically. And I find a lot of liberal places fascist, basically, because they have an agenda. Even though it is very well meaning or whatever. And they'll phone you up and tell you what it is, and then you do it. And then you're in, but what did you do? What did you compromise? Or what is their interpretation of what you should do? Their fantasy of what fits the agenda. Actually, you probably know this, but I showed at Documenta in Kassel, West*

Germany, like the preceding one or something, and Group Material calls me up on the phone from Germany and said my piece wasn't "working." I'm on the reservation in Oklahoma and they call from Germany and say "Edgar, it's not working." I say, "Why did you take it on Lufthansa all the way over there then? Why didn't you just leave it in America? Didn't you look at it?" They said, "Well it's not fitting what we're trying to do." And we're the artist now. We're curators hanging the show so we're making our art. Well I hear that at the Museum of Modern Art. Any kind of dominating museum's going to tell you "Well we're in control. What you're doing is to serve us and we know best." And that was really a telling circumstance. Group Material didn't really respond to the work the way they hoped they would have. So maybe we should change it, see. And this is the catchall, liberal, activist group that's going to make everything right. They're just like everybody else, they had their agenda, they wanted you to fit into it, you didn't fit into it, they change it, or get someone else. So I find all of that stuff pretty problematic. It sets a foundation of knowing, like reference, but I'm hoping to move past the reference point—where we have these shows, gay show, lesbian show, whatever, Greenpeace show, all of these things, all of these politically active causes. But I don't really find myself relating to all of them, personally. Like the Decade show for instance. I don't find myself being in that book necessarily making any sense, because there are all of these divergent kinds of theories or ideas and here they are all caught together. I don't know what they have to do with each other. I don't know what a Cheyenne artist has to do with a gay activist/AIDS program or something, you know. Or if I'm antiabortion, you know that's not cool. You know that I'm supposed to be this liberal thing, and I'm not. I'm not, I'm just not that simplistic. So I find that to be a big problem.

SP We talked about that earlier, in terms of a simplistic reading where there may be some projection in terms of somebody wanting you to be their image of what they expect you to be, rather than going with where you really are.

EHB *Well that happens in a big way with the idea of the Warrior Society. I've had a lot of run-ins with liberal-thinking people in New York. They start asking you, "What does that mean?" and you start telling them. And they think, "Hey, wait a minute. That doesn't sound like you're doing your own thing out there," and this*

and that. And I say "Well, no. If you step into that circle, that means you carry the tribe on your back and everything you do is for that." You can't just go change the rules if you don't feel that way today. It's a pretty closed totalitarian system. It's not like a radical thing. So a lot of the readings are misinterpretations.

SP Well that gives us a chance to maybe shift over to talking about your work specifically and some of the questions I have about the pieces here in Columbus. In the Wexner Center there are the paintings of the *Neuf* series and then the three walls of wall lyrics. Could you talk about the concept of the installation as a whole briefly?

EHB *Well first of all, the whole thing is called* Is What Is, *and basically it relates back to what you asked earlier about this whole kind of liberal catchall kind of scheme going on about all of these disenfranchised people coming together again, exhibiting and stuff. And I was getting kind of weary of that years ago. It's come to pass now, but I was tired of it a long time ago. The thought of it being about the public art, which I am very heavily involved in, too, but how that kind of became the lightening rod for the work. The public persona, the provocativeness of it all.*

SP You're talking now in terms of the billboards?

EHB *Yeah, the billboard signage and stuff. And people really liked that a lot. And they sort of liked it before they even knew what it was. The one-liner, what it said, and everyone gets all happy about that instead of being subversive and whatnot. I sort of felt myself getting trapped a little bit in that, and I was interested in many more things than that—when it was at the Berkeley Museum before this, I didn't make a public piece there and wasn't truly interested in making one. And there is no public work in the show. Here I did billboards as another project, but there is none in the gallery. Often when I have an exhibition, we'll show everything. We'll show the public things, drawings, paintings, sketches, and whatnot, prints. But here I just eliminated all the public work.*

SP From within the Wexner Center?

EHB *Yeah.*

SP I am curious about the unity within the various aspects, and the distinctions within the various aspects of the work. For example, on the wall that has the four paintings, there's a distinction among four separate panels, although they come together as a cluster in juxtaposition to the wall lyrics. Yet the whole installation is one unit. In general, what might you say about the degree of unity and distinction between the individual elements of your work?

EHB *Well, that was based again on the need to do something four times. That was, I guess, my idea of how could I really sum up what I believed in without using the political kind of signage and playing into their hands that way. I wanted to be bigger than that, harder to describe than that, or what I thought the essence of all these things was really about. Because all of the things come from that place where I live, and all the ideas, so that's not a city and it's not an art community and all of that. So I just came upon that idea of the four.*

SP Those four paintings are the whole series, or were there others?

EHB *No, it continues on, but I usually paint them four at a time. I make four at a time and there's been, I don't know, sixteen or twenty-four or something of those. But the way that it sets up is that . . . that's sort of the principle wall where those four paintings are and I sort of find, in a way, that I feel more comfortable with their description than anything else, because they're less literal on a certain level.*

SP Now you said those point north and refer northward. Is it as specific as the Black Hills or someplace like that?

EHB *Well, no, there's actually a mountain that we make reference to all of the time in our renewal. Actually, I've never been to the mountain, but I've seen it many times, you know. So the kind of priority that that place has with the tribe was like a very ambitious theme to me to try and encounter, and I hope that the paintings get close to that in some way. Of how important that direction is from Oklahoma and*

how hard to describe that whole situation would be, what that mountain means, that the paintings tend to describe it more because they describe it less, in a way. That it's really almost like a ceremonial knowledge that you can't even talk about, but everyone knows what it is, and they honor it all of the time, but you can't just put it in a book and write about it. So I put the paintings in that direction because of the prominence of that place and then the rest is the east, west, and south, so it forms that kind of quadrant.

SP I found it interesting to try to absorb the content of the wall lyrics without prior knowledge of what each wall was supposed to indicate, I would like to give you some reactions. It's not naive because I certainly have some knowledge of what the sources are for them. I did find, for example, in the east wall that the flow through the words was very fluid. The one that refers to the "sons," and must have something to do with your children, that had a very flowing, lyrical sort of ring to it. Whereas the west wall, which as it turns out is a California wall, is kind of sharper, choppier, you know has a whole different pitch to it. I guess I'm saying that the wall lyrics accommodate a real range of emotions. One time maybe angry, another time maybe more gentle.

EHB *That's what I like about making the drawings. I make drawings about everything, from a stewardess I see, to a show I go to, or an opening I might go to, I mean all of these weird things. I'm pretty blatant about the whole deal. I write about anything. It's pretty revealing, really, if you look close enough at that stuff, it's kind of an indictment. But I made other drawings. There are maybe a hundred of those drawings, or a hundred and twenty or something, there's a lot of them. A lot of them do vary from being gentle to being aggressive. A lot of them are sort of sexual, I would think. I did that a couple of years ago. I did a whole show, a whole wall, a whole wall called the Sexual Wall where it's all about that. And that was a breakthrough I felt we needed to make in terms of native men being too noble and too ideal or something. There wasn't enough sexual energy in native art or it wasn't revealed. So I tried to stir a bunch in to my show, because I think it's in the native culture in a big way, and it's a very sexual culture. Like most cultures.*

sp But it's just not acknowledged?

EHB *Yeah. Not really revealed or let into the scheme of things. So that west wall has a lot of tension, back and forth, I would think.*

sp Yeah. It had a sense of being sharply critical to me. "Make my movie," or . . .

EHB *Yeah, make my movie.*

sp Whereas the east wall seemed almost like a celebration. It had that general tone about it. The east wall is not as specifically oriented towards a place?

EHB *Not really.*

sp There's California for the west wall, your experience in Peru for the south wall, but the east wall . . .

EHB *The east wall was kind of, I don't know, it just caught a lot of different ideas. But I couldn't limit it to one experience, I mean there were so many other experiences. I sort of picked them and put them together in that side, in a way.*

sp The use of language in the wall lyrics, seems frankly lyrical, and the use of language on the billboards seems to have a different use of language that I guess could be described as taking the power of language and turning it back upon the dominant culture. For example the piece that you did, *Sooners Run Over Indian Nations: Apartheid Oklahoma* and "Sooners" is in mirror lettering. That seems much more about addressing the power of language, to have power over people and turning that power around.

EHB *Well I see the distinction more like personal and public. Where the wall lyrics are all really personal, kind of hidden jokes or hidden stories that happen to me, and then I distill them down to three words and then I put them out there. I sort of wonder, or I want to see if anyone understands it, or if they catch on to what's happening. And it's like a little hidden, it's sort of like Vito stuff. It's sort of like a taboo thing going on, where you tell this secret out in public.*

sp Can you bring the personal into the public space?

EHB *Yeah. Will they know what happened in that room or whatever, this kind of scenario? I don't know if people can figure that out or not, frankly. But that's kind of interesting to me. But the billboards are really like getting even, in a way. I mean talking to people very directly and there's not much of a hidden agenda in the billboards, you know, they're pretty straightforward.*

sp They don't have the room for the kind of playfulness that the wall lyrics have. And speaking of playfulness, I find the wall lyrics invite a sort of participation in the viewer to say "What happens if I string all of the red words together, read diagonally rather than reading down?" and so it seems to invite that kind of involvement.

EHB *Well the color is all symbolic too. I mean the color in the wall lyrics is all kind of set. It's got to be whatever I say it was.*

sp So the bones would be whitish?

EHB *Kind of, and then sort of good things are green, you know, that grow, and pink things are about white people, for the pink skin. It's a way to see pink, it's about white people, most of the time. So all of that stuff is pretty much set up to interconnect in a way.*

sp And do you ever sabotage that system?

EHB *Not yet.*

sp Well that's a good insight, thanks for that.

EHB *I'm giving away too much here.*

sp I think the last question I want to ask returns to the general. Maybe you've already addressed it to a certain degree, but I want to give you one more crack at

it. I'd like to know how you feel about the current blossoming of interest in work of indigenous artists. Whether it is only a blessing or does it feel like another act of "discovery?"

EHB *Well, that's important. I talk about that and I write about that. I've written about the earth awareness, and I've written about robbery. There's been all kinds of land robbery everywhere, basically, but now because of the desperation of Western culture, there's been ceremonial robbery happening with new age religions and all of these things, where they synthesize. They go down this shopping list of what they want and they make this new thing out of it. I talked to some white women who were building sweat lodges together, and they had a Sioux man helping them, and they were so proud of this thing that was reaffirming themselves, which was good. But then I said, "What happens if those Sioux spirits come down in there? Are you going to call them?" and she said "Well, no." But I said, "Well you built the lodge a certain way, and did these certain things, and this Sioux man told you how to do that, right? So that's what you're doing, isn't it?" And they said "Well, no we're not intending to do that. We're doing our own little thing. We're doing what we want to do with it." But not really. They're making this Sioux sweat lodge, it seems to me, but they don't want the spirits to come see them. So it's pretty convoluted.*

SP It seems like it's a little bit of what Joseph Campbell might have talked about: when signifiers get used up, people start shopping around for other signifiers.

EHB *Oh yeah.*

SP But they may not really want what's signified.

EHB *Yeah, but I was serious. I wasn't trying to scare them, but I was serious in saying, "Do you want them to come see you? What are you going to do when they come, or did you even think of that."*

SP Well, you did talk about the janitor who also could teach children something very valuable, and you say academia generally does not accommodate

somebody like that. I have heard about a university that has created a center for creation spirituality. They have a professor of drumming there. Have you heard about this?

EHB *No. No, I haven't*

SP No? Well, another subject for another day maybe. But it's a part of something; a yearning of people.

EHB *Yeah, there's an absence there. But then again, the point would be you've stolen the wherewithall for these people to make their world, I mean their economic world, native America. You've taken all of that and now you're looking for their spirituality too. And so I caution young native artists as to what they're giving away. To be included in certain projects and do all of these things—what are you really trading and why are you being selected for these things? But if you can use it and turn it. In Documenta I made a piece about the violence suffered by the Jews and native people. And I wouldn't even go to Germany myself. I wouldn't even go to Germany probably ever, because Germany is a dangerous place, I think. It seems to be more and more today. But to show in Germany, I made a piece about Germany, rather than to make a piece about Cheyennes. I think if you can turn that around sometimes then it becomes an important opportunity. But just to report on yourself totally, almost like you're a piece of anthropology being milked, that's not good.*

Edgar Heap of Birds visited Columbus on the occasion of the Wexner Center for the Arts exhibition, *Will/Power*, in which his work was included. This interview took place during his visit, on October 16, 1992; the transcript was recently edited by Stephen Pentak and Edgar Heap of Birds.

design, aging, ethics and the law

joseph a. koncelik

introduction: understanding the aging human species

FOR THE GENERATION OF YOUNG DESIGN-
ers who have just graduated from design
programs—or are going to graduate
over the next several decades—designing
is a very different process than it was for
their predecessors. Past generations of designers were able to use themselves as a
measure for the devices, communications, and enclosures they developed. This
premise for design activity I will call designing for the "self." Simply put, this
axiom is based upon an assumption that if it's good enough for *me* it should be
good enough for other people. For several generations, from the end of World
War II through the fifties and into the sixties, this attitude, this premise for design
activity was a workable assumption. My generation of designers was a part of the
baby boom—a spike in a population curve of Americans that were buying homes,
products, entertainment, travel and all the things an increasingly productive
America could set forth on the table of America's movable feast. But, no more!

Today, the design professions cannot use the self as a measure of their design activity, as a premise for their judgment about wants and needs or as a starting point in the decision about *what* this thing should be. The young designer must understand how to design for "others." For the foreseeable future, well into the middle of the next century, older Americans—in fact, older people in any of the industrialized nations of the world—are the overwhelming majority of consumers, the critical mass of working people and the overwhelming recipients of care in every civilized, industrialized nation on the face of the earth. This is the most significant change that has occurred in design professions since they emerged from the cradle of industrialization in the early part of the twentieth century.

The "age wave," as Kenneth Dykwald has termed this phenomenon, will peak in the year 2030 and extend through to the middle of the next century.[1] Predicting what will happen beyond that point in time is impossible for any demographer, but it is likely that older people, especially older women, will dominate the consumer market for decades to come—if there is a consumer market to dominate. The appropriate response on the part of the design professions must be to turn away from the self as a premise for design and to move toward others as a focus for design activity. For the young designer, the "user" of design is someone older or someone younger. For behind those who are twenty to thirty years of age is a moderate baby boom, and in front of them is an aging thermonuclear explosion.

It is useful to observe the dramatic shifts in demographic relationships relating to aging that are global as well as local. In a recent *Scientific American*, Olshansky, Carnes and Cassel take a global evolutionary approach to the dynamics of an aging "of the human species."[2] They observe that—worldwide—the total population over the age of sixty-five was ten to seventeen million people, or less than 1 percent of the total world population. By 1992, there were 342 million people over sixty-five, or 6.2 percent, and by the year 2050 that number will be 2.5 billion, or about one-fifth of the world's total population. In their seminal article, the three authors go on to state that increasing the birth rate or increasing the death rate among older people will still leave the proportion of older to younger human beings in the same relationship.

In America, the current proportion of those over sixty-five is at 12.5 percent and is estimated to increase to 20 or 25 percent between 2030 and 2050. The demography of living in America is also quite interesting, especially for those among the oldest Americans over the age of eighty-five. According to the Census Bureau's 1990 analysis of the population, America's continuous mobility has left the highest proportion of older people in the most rural areas of the country—roughly in a vertical belt line stretching from Minnesota and Wisconsin to Texas. Younger Americans have migrated outward toward the coasts. However, some areas in Florida and California are exceptions, with the greatest number of people over eighty-five living in Los Angeles County, California.

Mobility, for a variety of reasons, is a critical aspect of American life. In the five years from 1985 to 1990, the Census Bureau reported that 21.6 million Americans moved from one state to another.[3] California is the most volatile in terms of population flux: it both gained and lost the highest number of residents of any state in the union. Florida is also a volatile state—but mainly due to an influx of population, with 2.1 million in growth (over 120 thousand from Ohio in a five-year period). The Midwest steadily and continuously loses population—including Ohio. Ohio lost over 750 thousand in population in the five-year period from 1985 to 1990, and gained just over 620 thousand—with the largest number coming from Michigan. This results in a net loss in population for Ohio of almost 150 thousand residents. These shifts are even more significant when one realizes that the greatest influx of the population to this state is coming to the central Ohio area and that the greatest losses are occurring in the rural areas—following the pattern of the nation as a whole. This means that older people are an increasing proportion of the population of rural counties and younger people are either leaving the state or moving to its center.

Ohio has ninety-thousand nursing home beds and the four-state region of Ohio, Michigan, Indiana and Illinois have more than 10 percent of all the nursing home beds in America. Even the movement of people to central Ohio is deceptive regarding age relationships. According to a 1990 report by Management Horizons, a leading retail marketing research group, 22 percent of the population of Columbus, Ohio is over the age of fifty-five. Further, this population, nationally, holds 58 percent of all the discretionary dollar buying power with people in the age

bracket of sixty-two to sixty-five, possessing the most amount of discretionary buying power of any age segment in our population. People over the age of sixty-five buy double the amount of sporting equipment and related paraphernalia such as clothing than do their counterparts under the age of twenty-five. Virtually every watercraft over twenty-five feet in length is purchased by a male over the age of fifty-five—with the average age being sixty. Sixty-four percent of all of the large domestic cars produced in this country are purchased by people over the age of sixty-five. The two largest groups of people learning to drive in America are women under the age of twenty-five and women over the age of seventy. The average age of the purchaser of a single-family dwelling unit is fifty-five, and the average cost of the purchase is $350 thousand. Logically, these home purchases have some impact upon the markets for home appliances, home entertainment systems, security systems, home illumination, furniture and all other product development for residential application. Forty-one percent of the total movie-going audience is over the age of fifty, according to a recent article in *USA Today*, and the lack of recognition of the demographics of this audience is largely to blame for a precipitous drop in cinema theater attendance.

Since women continue to outlive men, the balance of wealth is gradually being transferred to women and this is even more rapidly expedited by women working with greater and greater frequency and in greater numbers. In fact, women make most domestic purchases of food, clothing and durable goods. They either purchase the family car or influence its purchase. The reason for so many older women learning to drive is due to the death of a spouse who drove the family car exclusively. Women still do most of the child rearing and most of the housework regardless of the attempt in two-job families to share the burden of work in the home. The eldest daughters, according to the eminent gerontologist Elaine Brody, provide 90 percent of all health care to aging parents. In many instances, this is a sixty-year-old female providing care to an eighty-year-old mother—or in many cases, a mother-in-law.

The greatest economic impact relating to the growth of the aging population lies in health care. For every dollar spent on a child by the federal government, the government spends fourteen on someone over the age of sixty-five. Fifty-one percent of all Medicare expenditures are made on people between the

ages of sixty-five and seventy-four. Twenty-nine percent of those expenditures go to people between the ages of seventy-five and eighty-four. AIDS patients cost five billion dollars for care in 1990, while Alzheimer's disease patients, most of whom are over seventy, cost fifty-five billion dollars. According to Dr. Leopold Liss, the Alzheimer's disease expert, only 2 percent of the population suffering from the disease is under the age of sixty, and 47 percent is over eighty. Alzheimer's disease has an approximate twelve-year period of development and is always fatal. Thirteen thousand people suffer from Alzheimer's disease in the central Ohio area. To a greater or lesser degree, everyone is a "designer," because everyone plans, or attempts to, and everyone makes decisions about the acquisition of goods and services. It is evident to the experts studying gerontology that no nation, no government, no group of professionals, no industry has fully comprehended what the tremendous impact of an aging human population already means in terms of distribution and consumption of resources. Aging is the single most important change occurring to humanity on this planet.

Designers have a part to play in developing a sensitive approach to the needs of an aging population. While somewhat less significant than curing Alzheimer's disease, it is surely important that resources not be wasted or misapplied. The specific intent of this paper, then, is to set out the dimensions of the designing of products—appliances and furnishings—with respect to the process of aging. The essence of this discussion is to relate the human factors of aging to the design of these products, beginning with appliances—because the age changes that affect the design of appliances occur earlier in one's life span. Characteristic changes that affect the design of furnishings occur later in life, when there are significant changes in mobility, strength and flexibility.

In appliance design, high technology applications to products requires that attention be placed upon appropriate control and display design. The designer must understand age-related changes in sensory modalities—vision and hearing—in order to design consumer sensitive products. The design of furnishings requires an understanding of anthropometrics related to an aging population as well as physiological changes that come about as a result of higher incidence of arthritis and muscle/skeletal changes and disability.

Aging consumers are one of the most significant "market segments." Discretionary buying power and requirements for sensitively designed products makes the aging population a force to be reckoned with in the marketplace. Further, the technology available to industry is changing and new potential exists to serve a broader range of consumers than ever before. These changing aspects of design will help identify measures to provide more useful appliances and furnishings for an aging population.

legislating social change:
civil rights laws and the aged

In the five-year period from 1985 to 1990, some very important pieces of legislation were authored that affect older Americans in numerous profound ways. The landmark Americans with Disabilities Act of 1990 (or ADA) may not be perceived as directed at elderly Americans, but it will be shown to have an immense impact upon their lives—and older people will affect the implementation of the law. The ADA is a companion law to The Fair Housing Amendment of 1988 which protects the rights of disabled people in their quest for suitable housing. What that law—and Federal Legislation Number 506 accomplished for disabled people in their right to accessible residential and public space, ADA extends to the workplace. The act is ostensibly directed at ensuring equal rights to employment for disabled Americans.

Before exploring the possibilities and probabilities that may extend from this recent piece of legislation, it is useful to look at this nation's experience with legislating social change in the past. In the formative period of this nation's history, after colonial Americans had sent the British army home and the ink had dried on the Bill of Rights, state legislators began to ponder the mounting problem of care of the "poor" and indigent. In his book, *Nursing Home and Public Policy: Drift and Decision in New York State*, William C. Thomas argues that indecision in public policy and a lack of ability to accept responsibility for those who could not cope gave rise to the system of care America either supports or ignores today.[4] Thomas's thesis is that a plethora of community, state and federal legislation has created layers of legal confusion and many of our least able people have simply slipped between the cracks—or the seams of those layers.

One only needs to look at the plight of the homeless, the mentally ill, the elderly poor, and the even poorer women and children to see ample evidence of this tragic situation.

Our problems today with the care and support of homeless people, the mentally ill, and infirm dependent elders is nothing new. The debate about appropriate policy and financial support is largely the same today as it was just after the Revolution. The Poor Acts of the eighteenth century were an attempt to specify responsibility within "parishes" or townships, and they created almshouses that later became the scandalous boarding houses of the 1940s. Legislation in the nineteenth century specified that the indigent were to be supported on a countywide basis, which gave rise to the county poor house, and later the county home and farm system that spread across America. These environments were the early model for nursing homes until health care reform in the 1940s and 1950s mandated regulatory structures and applied the acute care or hospital model to nursing home care. The lack of local, state and federal support for any system of care for the elderly led to the rise of a profit-making nursing home care system. By the 1960s, 90 percent of all nursing home care was for profit. Today, that proportion is just less than 80 percent, with nonprofit homes being almost 20 percent of the total, and county run and/or public facilities being 2 percent.

This system of care is our heritage, whether we like it or not. In fact, over the last three decades, nursing home care has gradually improved. On the other hand, the population served in these facilities is growing older and more infirm. In the 1960s, the average age of nursing home residents was nearly ten years younger than it is today—with an average age of eighty-three. Nearly 1.5 million old and infirm adults live out their lives in facilities that range from excellent to deplorable. Many are very good, but many are outrageously bad. Our attention to this problem is given sporadically when a newsworthy (hopefully videotaped) incident makes it to "film-at-eleven" status. Then, after some sour disapproval and head shaking, the problem disappears beneath our consciousness and continues to languish unattended.

Our experience with Social Security is similar. The debate over maintaining independence among an older population that was not in the work force led to

state, and then federal, legislation. However, the state-enacted Old Age Security Acts of the 1930s that gave rise to federally mandated Social Security were based upon poor assessments of the need and even poorer predictions of the demands upon the system. Olshansky, Carnes and Cassel point out that in 1935 the estimated number of people accessing Social Security in the year 2030 would be fewer than twenty million. The current prediction is that nearly seventy million people will be accessing Social Security by that time.

In 1936, Paul H. Douglas wrote that the increasing dependency on Social Security support could be traced to a ". . . decrease in the proportion of persons who were self employed as agriculture, the handicrafts and small trade gave way to large-scale industrialism and the increasing speed of industry which made it more difficult for old people to be reemployed once they had lost their jobs." From 1900 to the 1930s, America had moved from an agrarian economy of small farms and small towns to urban living and industrialization. In 1900, 85 percent of the population lived on the farm. By 1960, 3 percent of the population was living on the farm and 40 percent of the workforce was employed in the production of hard goods. In other words, tumultuous change in the economy led to displacement of a workforce and a reliance upon a system that was underdesigned to support people in the way it had originally been intended to do.

America now faces another era of tumultuous socioeconomic change, and it is predicating its responses on an experiential base with industry, one that is equally erroneous as the predictions made at the turn of the last century. From 40 percent employment in industrial production in 1960, American industry declined to 11 percent employed in 1990—and will be 9 percent by the year 2000. America is moving to a fragmented, volatile, small business base and losing—or evolving away from—its large industrial base. Thirty percent of the Fortune 500 companies of 1960 no longer exist—that makes 167 companies that have either been bought and sold or gone belly-up. Major corporations in America are predicted to suffer a net loss of two million jobs between 1990 and 2000. Small business is expected to generate seventeen million jobs during that same period, with 90 percent of those jobs generated in firms with fewer than nine employees.[5] The recent law granting parental leave affects companies with thirty or more employees, and the ADA is binding only on firms with fifteen or more employees.

It is entirely possible that the ADA will have little effect upon the increasing employment of the disabled, but it may have a tremendous impact upon the preservation of jobs for older workers experiencing increasing disability. The reason for this unforeseen effect of the law is that the ADA is not precise on the subject of disability. In the October 26, 1992 issue of *The National Law Journal*, Paul Starkman correctly identified this ambiguity when he stated that "the statute includes within its definition of 'disability' a wide variety of physical and mental impairments providing that the impairment substantially limit one or more life activities."

In fact, if an employee declares that he or she is impaired and is unable to perform tasks that are part of the job, that person may be reassigned or have the task redesigned. In the first two cases of litigation against an employer under the aegis of the ADA—ironically against the federal government as the employer—two employees sued to have their jobs redesigned and eventually won their cases. Currently over one thousand lawsuits are pending under the ADA and the overwhelming majority of those suits are by persons already employed.

Starkman, however, incorrectly assessed the cost of compliance for the redesign of the workplace and design of public access as being "significant." After the first year of experience with the implementation of the ADA, requirements for clear passageways, elevators, lavatories, drinking fountains and other specified architectural features and architectural hardware have been readily and quickly adopted by many businesses. Somehow, the previous experience with Federal Legislation Number 504 mandating barrier-free design was not taken into account, and implementation of design is well underway.

Full compliance with the ADA is untenable and the costs ultimately prohibitive. This realization is fully understood by the U.S. Department of Justice, the agency of the federal government having the authority to execute, mandate and prosecute violations under the ADA. By 1993, "programmatic accommodation" had become the watchword for moving ADA compliance of physical facilities forward. Programmatic accommodation is a concept that permits movement or transfer of programs—not just renovation—to accommodate the needs of people with disabilities. One of the first and highly successful applications of pro-

grammatic accommodation was the renovation of the campus at the Georgia Institute of Technology for the 1996 Olympic and Paralympic Games. The process of programmatic accommodation was provided an assessment methodology by a team from the Center for Rehabilitation Technology in the College of Architecture at Georgia Tech. Their efforts saved the institution critical time in the process of change, and reduced the cost of compliance by 40 percent. As a result of their efforts, the State of Georgia Board of Regents commissioned the team to do assessments at the thirty-three other state-assisted institutions and, while the program is still in progress, initial estimates show similar savings. Programmatic accommodation is moving compliance forward where it would have been stalled for lack of funding in most states.

In a *National Law Journal* lead article from March 1, 1993, there were expressions of concern that too many cases were being settled voluntarily—without litigation—and the boon to "trial lawyers," as President Bush called them, seemed not to be materializing; 3,358 discrimination charges had been filed with state and federal authorities implementing the ADA, but of that number only one lawsuit had been filed at the time of the article. It has been the preference of the Equal Employment Opportunity Commission (EEOC) to achieve compliance voluntarily. In many cases, the businesses themselves request the investigation in order to know how to comply. This is, at face value, a successful law if the spirit of this legislation receives such continuous voluntary compliance.

Architects, industrial designers, interior designers and graphic designers all went through a period of alternating panic and jubilation in the early days just after the ADA went into effect. The panic came from designers who were not sufficiently grounded in the human factors of ADA implementation. The jubilation, as unwarranted as that of the lawyers, came from anticipation of the feast of design and redesign contracts that would pour out of the implementation of ADA requirements. While there have been product and architectural revisions and renovations, the problems of implementation—with respect to the well-defined portions of the law—are not as significant as originally thought: perhaps because of the long period of adoption of barrier-free design under Federal Legislation Number 504 there will be design work as a result of this legislation. However, much of this work may come in areas previously unanticipated, such

as product development of office furnishings, illumination, and way-finding inside commercial buildings, and in the high-tech world of computer hardware and software design. American designers, manufacturers, employers and our colleagues in law seem to be unaware of the unintended use of this legislation and the effect of layering that has occurred in various legislation protecting the rights of the disabled. Olshansky, Carnes and Cassel (1993) point out that increasing trends in fitness and healthfulness will bring about a higher quality of life longer into old age; but it will also increase the time older people spend in disability during their lifetime.

Layering of civil rights protection may occur because mandatory retirement has been abolished and the existing workforce in industry is older. Older workers are extremely motivated to stay with current employment because they are losing health care benefits and pension plans. David M. Walker, Assistant Secretary of Labor in the Bush administration and now with Andersen Consulting, stated that as many as 95 percent of all employers are either cutting employee health care benefits or are planning to do so. This is an area where litigation prevails. Of the retirees hit the hardest, most were encouraged to take early retirement—thus facing a lengthy period of life without adequate health care protection.

The Ohio State University's *On Campus* newspaper reported on December 5, 1991 that, "After growing for more than 25 years, the number of Americans covered by employer-sponsored pension plans dropped 4% between 1979 and 1987." Donald Parsons, Professor of Economics at Ohio State made several observations in his study, but of interest is the statement that, "More people are working in the relatively poorly covered service sector of the economy." He went on to say that the cause of this trend is "industrial restructuring." Indeed!

The dynamics at work in our culture are so immense and so much in flux that the intent of legislation and implementation of law is impossible to predict. All prediction in this situation is speculation and thus, discussion of eventual outcomes must be characterized in the framework of potential and possibilities. Having stated this, the impact of a growing aging population and the evidence of increasing need for health care support requires that regulation, financial institutions and entitlements, and industrial work roles be examined

with aging in mind. The so-called baby boomer cohort that is moving into the ranks of the aged is a well-educated and demanding group of adults. They are not likely to be passive in defense of their own welfare. They are likely to fight hard to retain the supports and benefits that they are likely to see as rights, not privileges. What American lawyers are currently losing in business with regard to compliance with the ADA they will more than make up in the defense of aging workers trying to fight against the loss of pension plans, health care benefits and even employment owing to gradually increasing infirmity.

Shifting from the younger group fighting to keep their jobs and benefits to the other end of the aging spectrum, very old and infirm adults, yet another area of recent legislation is in force that impacts upon the act of designing. The Omnibus Budget Reconciliation Act of 1987 (OBRA) mandated the Patient Bill of Rights. This legislation requires a restraint free environment; care of elderly patients without use of physical and chemical restraints. The implications of this law may require sweeping changes in facilities that care for older patients. Administrative and staffing policies will change, and use of drugs and physical restraining devices must be reduced or disappear entirely. Additionally, environmental and product supports must change and/or be devised to assist or back up these changes in policy and practice.

The use of physical and chemical restraints in nursing homes is a practice spawned from the inability to staff such facilities adequately. Minimum requirements for staff on duty are viewed as maximum staffing levels. This has become the rule because 80 percent of all nursing home residents are supported on Medicare and Medicaid, which provide variable (from state to state) but minimal financial support for patient care. Many nursing homes that exist owing to Medicare and Medicaid support are subsistence level in their operation—regardless of the fact that they are technically profit-making facilities. In essence, patients are tied up because there is no one available to watch them or supervise their care. The low end of cost in a nursing home is approximately $17 thousand annually, with average stays ranging from three to five years. The average cost of care is $22 thousand per year, and it does not take long to expend life savings as well as property in order to care for someone in a nursing home. With increased staff and redevelopment of product and environmental supports, costs will rise,

but it will be worth the cost to offset the greater financial burden of maintenance involved in the incidence of decubitus ulcers resulting from restraint use, urinary and fecal incontinence that is an outgrowth of the use of powerful management drugs such as diazepam; and litigation resulting from suffocation and strangulation deaths that occur when physical restraints are used.

As a side note, nursing home admission is an area of intensive mythology. The picture of a child dumping a parent in a substandard facility crowds out the facts about admissions. Urinary incontinence is one of the leading reasons for nursing home placement of older adults, with another being extended stays in hospitals which result in a decline in patient health. According to William Whitehead, Ph.D., ten million Americans (or from 15 to 30 percent of all elderly living at home) suffer from urinary incontinence, and that this figure could be as high as 50 percent for nursing home residents.

In a recent study by Dr. Morton Creditor of the University of Kansas Medical Center, he found that patients over the age of seventy-five experienced declines in health and function while in the hospital that were not due to the original illness; these declines frequently lead to nursing home admissions. Some of these declines included reduced amounts of blood flow resulting in dizziness and falls, accelerated bone loss leading to fractures, and sensory deprivation leading to confusion and apparent senility. "Hospitals," said Dr. Creditor, "should be avoided like the plague unless absolutely essential."

Further, the Safe Medical Devices Act of 1990 requires the Food and Drug Administration (FDA) to certify any product that is related to the treatment of a pathology or is useful in therapy or rehabilitation. If the product (device) is not directly related to pathology, therapy, or rehabilitation it falls under the jurisdiction of the Consumer Product Safety Commission. FDA certification of a product—after the appropriate 510K form is submitted—may take as long as two years, delaying market entry. Market entry without the appropriate approval is illegal, and may result in FDA investigation.

Most manufacturers and designers acquainted with this law view it positively rather than negatively, because this certification is necessary in order to sell to health care professionals. Some products that are not typically considered related to pathology or therapy have been evaluated for certification, anyway, to insure

marketability. The delays in approval are related to how many similar products are up for review, and atypical products often receive approval in a matter of months. Indeed, local FDA offices are extremely helpful with advice to manufacturers.

This law also brings with it the responsibility for the manufacturer and the designer to monitor or establish product surveillance during the life of the product. This surveillance tracks records of sales so that if there is litigation involving the product there is a trace that can be established during investigation. The implications of tracking products can also mean that there will be better product evaluation in the future—and responsibility on the part of manufacturers to release a product only when and if it has been thoroughly tested.

conclusions about
legislating social change

Americans have a dreadful tendency to isolate to a specific area of concern professional responses to human problems when, in fact, all such deliberation and response is interactive with other human problems. Laws cannot be viewed as exclusive; they are interactive, especially when they are supposed to be enabling of human or civil rights.

As an example, the ADA is vague in its definition of disability and the problems of compliance have been misunderstood. It is entirely possible that application of the law will occur in an entirely different province of human activity than originally intended. Americans have been poor social engineers because of the inability to accurately predict the impact of their actions over time. Experience with the earliest laws attempting to place responsibility for support of the poor have shown that. Experience with inaccurate predictions about the application of Social Security from the 1930s has provided further evidence of this myopia or limited view of the future. Now comes the age wave during a time of as much socioeconomic and cultural nativity as America experienced at the turn of the last century—and the problem of accurate prediction remains.

During the sixties, the Supreme Court of the United States ruled that in automotive safety, manufacturers and designers were responsible for intended and unintended use of a product—this precedent has now extended to all areas of

product and environmental safety, and will be applicable to products developed in response to the needs of the aging population. The safety issues for product development that relate to health and welfare are profound in this regard, and must be seriously considered when developing product responses. Designers must pay attention to the law—especially the new attempts at civil rights legislation and social welfare. The implications of cavalier treatment of product development for manufacturers and designers may be catastrophic.

With regard to the design fields, understanding the legal constraints placed upon product development is now more important than ever. In many instances, the law has actually provided new product opportunities—rather than restricting opportunities. There are areas of legislation that impede product development and there are other areas where designers and manufacturers are required to negotiate their position for product to market entry with appropriate executive agencies or authorities. Intended and unintended use of products also present areas of concern, and the design effort must anticipate uses that have not been the focus of design. Finally, the responsibility of design teams and manufacturers in tracking products to insure proper operation and continuous safety is a new and developing responsibility. On the surface, it adds cost and time to product development. When one looks deeper, products are improved and new product opportunities can often be perceived.

market segmentation within the aging population of the united states

Aging is not uniform in the onset of changes or in the continuum of change. The physiological processes associated with aging occur at different rates for different people and the overwhelming majority of adults are in—and will remain in—good health for almost their entire lives. Older people are no less capable than younger people, and will remain so. In the United States healthy, aging adults over the age of fifty-five constitute an $800 billion market. Adults over the age of forty-five constitute 51.3 percent of all households, 49.6 percent of all income generation and, most importantly, 58.5 percent of all discretionary

income. They are and will remain the most significant market for the design of goods for every designer and marketing professional born in the twentieth century, and this market will peak in 2030.

The aging population—especially the oldest among us—have a greater attachment to their personal environment than other age groups. The home environment means more to them; they spend more of their time in their residence. To a great degree, how the architectural plan of a home is designed and its product components are arranged are critical factors in the establishment of a sense of well-being and control.

Most residential environments in the United States and Canada have never had the hand of an architect or any of the other design professions involved in their creation. Indeed, with regard to what is commonly understood as "interior design," this is an act largely reserved for the individual resident. The choice of furnishings, decor and accessories are made by those who acquire and possess them. These personal artifacts of choice imbue an environment with personality, reflect the lifestyle of the residents and, more importantly, provide the aging with a sense of control over environment and their own existence. The presence or hand of the designer at this level of decision making about the personal environment can be an intrusion—offsetting the benefit of having maintained the shaping of the personal environment by the residents.

It would seem that a critical aspect of the design process—with regard to insuring control by an aging person over environment—is knowing when to pull back from making all of the design decisions, including the specification of what can and cannot fit in the domain of an aging individual. Environmental research in the late 1960s and 1970s illuminated our understanding of the differences between the environments of older people—and younger adults as well. Older adults naturally acquired many things during their lifetimes and seem to be living with "clutter." Display of personal objects—photographs, collections, assorted memorabilia and other "accessories"—was in evidence when initial research was conducted and remains in evidence today.

Older adults who moved from one environment to another usually experienced a "compression" of their belongings into housing plans that were decidedly smaller than their previous abode. Research of this era also demon-

strated high satisfaction with personal surroundings among the elderly. Therefore, living independently in the surroundings of choice with those personal belongings one has acquired through a lifetime is central to the concept of shaping the residence of the elderly.

More importantly, no designer should intrude upon personal choices made by elderly residents that shape this environment. It is appropriate that where residence is an architectural decision, such as in the building of congregate housing or a retirement community, most of the decision making about the configuration of that building be in the hands of designers. On the other hand, personal space is a sacred territory, the province of the occupant.

Gerontologists from many different countries have stated that personal space and control over that environment is a sign of control over one's own existence. Without that control, a sense of well-being may be lost and the elderly experience true physical—as well as psychological—decline. In this complex design milieu, the designer advises; the designer may present alternatives and the designer cooperates with the older resident to insure that decisions about surroundings are made to the complete satisfaction of the aging resident. The overarching responsibility of the designer is the safety, security, and sense of satisfaction of the elderly resident who, in the final analysis, must live with the designs others produce, whether or not the designers and manufacturers of those spaces, objects and pictures had any understanding of the dynamic impact of aging upon the design process. The following statements are subjective guidelines that designers should observe when they consider the aging dynamic in the criteria any design should meet.

Aging is not a uniform process, and occurs at different rates in different people. Aging is a complex blending of physiological, psychophysical, psychological and sociological change, and affects human personality by intensifying individual characteristics. People who have reached advanced years (seventy-five to ninety-five) will be a very diverse population, with far greater difference between individuals than younger populations. Older people are just like they were when they were younger . . . only more so!

While there is a higher rate of disability among elderly people, it is inaccurate to depict older people as disabled—or to link aging and disability. Disability

may happen at any time in one's life span so that the issue of "handicap" should be viewed separately—and treated separately as a design issue—from the issues relating to aging.

The overwhelming majority of aging adults are capable of normal functioning throughout their lifetime. While there are normal age changes affecting human performance, these changes should not be treated as a handicap or distinctive characteristics separating aging adults from a so-called normal population. It is normal to age. Hence, age-related changes should be treated as part of the normal spectrum of human factors in design criteria.

People age in "cohorts." In other words, each generation brings with it its own culture, capacity to function and understand, and other characteristics such as the ability to learn. Each generation reaching old age has progressively become a better educated, healthier, and wealthier group than the cohort that preceded it.

The overwhelming majority of aged individuals are living independently. Only 5 percent of the population over sixty-five resides in nursing homes—with a progressive proportional increase with each age segment over sixty-five (22 percent of the population over eighty-five resides in institutional settings).

Most of the elderly (people over the age of sixty-five) are fit and remain fit most of their lives. However, the aged population is largely a population of women. Women by and large outlive men and at the age of eighty there are three women alive for every man. However, we do well to remember that aging is not chronological, and just who will be considered elderly by the turn of the century may change.

Long-term memory and learning is actually better among older people than it is among the young. While older people take longer to learn, they retain knowledge better. Younger people have better short-term memory.

The consumer products industry around the world has no future if it neglects the aging market. Meeting their needs is not only essential, it is an economic necessity—designers have no future if they fail to understand the aging process in terms of human factors and the elderly as a market in particular.

The most important step in designing for this population is to identify those normal aging characteristics to be used as criteria for the design of all products

and environments. Aging is a process, not a state of being. The continuous change inherent in the aging process is a dynamic that complicates integration in design processes. Designers require a model that allows a maximum application of generalizable characteristics related to the development, production, and distribution of their product. If they do not receive this information in a usable form, aging is and will continue to be disregarded as applicable information in the design process.

The Age/Loss Continuum concept was developed by Leon Pastalan (1970) and meant for application to product and environmental development.[6] The continuum specifically pertains to sensory modality change and is the most general and widely distributed set of aging characteristics. These changes are the basis for developing products that are transgenerational. While the onset of these changes is the essential set of characteristics that define who is referred to as an aging adult, it is not common to depict people in the forty to fifty age range as aged.

the market related to age/losses: sensory modality changes

The market that is the first group of aging users is everyone over the age of 40. In the United States, designers and manufacturers may focus upon members of this group as having the following generalizable characteristics: they have high discretionary income, they are healthy and well educated. People in this group over fifty-five are the single most important buying group for single family homes, appliances, and large watercraft (according to a recent study in the Department of Industrial Design at the Ohio State University).

To address the needs of the young/old market segment, all forms of manufacturing—mass and batch production—are significant. This is the population reached by mass-marketing techniques and the national distribution of goods. Advertising has proven and will continue to prove effective as a tool in reaching this population—as long as the overture to this segment appeals to their intellect and not to their viscera. It is important to remember that this group is the most highly educated and inherently disciplined of all aging cohorts among the American generations. These people have excellent and

complex learning skills and will extend themselves to acquire what they need and want. They are computer literate; they have driven every form of vehicle ever produced; they are widely traveled. They are well educated in the arts and literature, and read for pleasure (something now virtually extinct as a habit among the very young). While they begin to experience the onset of sensory modality change (sometime around 40 years), they will experience thirty years of relative good health. Members of this group may lose twenty miles per hour off their tennis serve and fifty yards off their golf drive, but they will be more prevalent users of the courts and courses than other generations—well into their seventies.

characteristic changes in vision

The onset of vision changes will be marked by a loss of ability to see near images and the consequent use of reading glasses. Fatigue related to eye strain and the increased sensitivity to glare may follow. As reported by the American Color Marketing Group, in professions where color specification is critical, specifiers begin to demonstrate what is known as "red shift" at around fifty-five years of age. This normal age change is the onset of loss of sensitivity to blue light and a greater disparity in the ability to match the cool range of colors.

Noticeable loss of color sensitivity generally does not occur until much later in life. Color sensitivity loss is most noticeable in populations over the age of seventy. Women have greater difficulty using hair color and makeup. Men are less able to match clothing colors properly. It is wise to remember that these losses are not uniform and happen at varying times and to varying degrees among the general population.

Other aspects of vision that are critical changes with age are: a reduction in the transmittance of light through the fluid that supports the eye, unequal transmittance of different wavelengths of light, and pigmentation of the retina that transmits yellow while absorbing blue. With the yellowing of the eye's lens there is a lessening of sensitivity to blue light. This is the reason for a lessening of sensitivity to all color intensity and a requirement of greater brightness of luminance in general.

Cones in the retina provide sensitivity to color—and, as humans, we are red-green-blue (RGB) receivers.[7] But the photo pigment sensitivity of the eye is unequal in the cones: 64 percent of the cones contain red photo pigment, 32 percent contain green photo pigment, and 2 percent contain blue photo pigment (we are naturally less receptive to blue light).

The human eye is edge sensitive, and because of the distribution of rods and cones across the retina, the muscles must shift focus constantly to perceive form. The very center of the retina, while high in acuity, is practically devoid of blue sensitive cones. Blue-blindness is the disappearance of blue light objects when one fixates upon them. More importantly, the eye must continuously shift to "read" blue light, and thus, objects in blue fatigue the eye faster than other colors.

characteristic changes in hearing

Design professionals may not be able to conceive of a world for themselves without sight. However, a world without sound may be much more devastating to contemplate. Sound is first and foremost a warning device to let the organism know if danger is nearby. In the modern world, those individuals who isolate themselves with in-ear radios to screen out the environment are increasing the potential hazard of a threatening environment and—doubly injurious—hastening loss of hearing. Younger populations' hearing is testing more poorly with each generational cohort. Hearing is also a feedback mechanism that informs us about ourselves and our own ability. Most importantly, loss of hearing affects quality of speech. In order to speak distinctly, it is necessary to hear our own speech continuously; as hearing declines, speech is also negatively affected. Totally deaf people who have suffered trauma-induced or progressive hearing loss will speak less clearly. It is necessary to undergo speech therapy with hearing loss in order to maintain this vital method of communication. This interrelationship is a critical example of how human well-being and sense of self can be determined by physiological change.

Two important aspects of hearing loss are: 1) presbycusis, or selective frequency hearing loss, which is a progressive change whereby the aging person loses the ability to hear high-frequency sounds, often resulting in the confusion

of sounds, a mixing of conversation and background noise; and 2) amplitude losses, which are a lessening of the ability to hear low levels of "volume" of sound and are also common with aging but not inherent to the aging process, as environmental noise is playing an increasing role in debilitating a greater proportion of hearing the loudness of sounds among *all* populations.

Just three years ago, the hearing assistance industry did not have technologies that would provide prosthesis in hearing for anything but amplitude loss. This is no longer true. Frequency loss can now be addressed and technology in the hearing aid industry is developing rapidly. Aids can either be set to amplify sounds in specific frequencies or automatically adjust to "listen" for specific frequencies. Computer-controlled aids will allow the user to select hearing "channels" by pressing buttons on a microprocessor-controlled remote unit. This permits the user to adjust hearing to the environment and select sounds.

implications for consumer product design

The technology of product display and control design in appliances (the greater market share is adults fifty-five and over) has brought us the ubiquitous VCR and on-screen monitor with blue light emitted figures—the symbol of a technology gone wrong—and the evil remote control (RCA recently revised its horribly designed remote with fifty-one push-button controls), which must be operated in the dark with more controls than can be committed to memory. Black on black control markings that defy recognition and proper use must be eliminated.

The gaudy but meaningless displays that dazzle the eye but provide no meaningful information (the American automobile control and display panels of the 1980s) must be reconsidered by designers because in some instances they attract attention that should be focused on other activities. Internal research at General Motors Corporation conducted in the early 1960s proved conclusively that the time required to monitor automotive displays is negligible, yet over the years the nonessential information has increased. The shift of the eye from road to display surface is a tour de force in accommodation. However, as any individ-

ual ages, it is well documented that accommodation increases in length of time. For a person of seventy, the ability to accommodate from a high light level to a low one (or the reverse) is three times as great as for someone of twenty-five.

corrective measures

Redundant cueing—the provision of stimuli to more than one sensory modality or channel to convey a signal—is a concept that designers should employ for developing a control and a display. Most appliances and high-technology devices found in the consumer marketplace rely upon visual cues only. Appliances must be developed with control and display devices that signal the user through hearing, tactile sensitivity, and shape coding—as well as alphanumeric symbols, color, and visible position.

Current technology, including the implementation of integrated circuitry and computer chips, is now relatively inexpensive—but has been primarily used to extend the life of appliances and other consumer products. It could also be used to build in redundant cueing, and to monitor the sequence of actions taken by an elderly user.

Simple mistakes such as choosing the wrong figure-ground color and contrast relationship for displays must be either avoided or finally regulated. Figure displays should never be used. Due to the age of the appliance user, blue figures are harder to distinguish for an eye designed to be edge sensitive. Additionally, blue-lighted figures fatigue the eye more quickly and increase the chance for error.

Controls have also become a technological issue. Membrane switches, microminiaturization and stylistic concerns have diminished the recognition of a control and its specific position on a surface. Designers must make an extra effort to rethink control design in order to help position the hands and the fingers, give positive feedback that the control is actually working or has actuated the process desired of the product. Blending the control with the surface, a stylistic cliché of the eighties, and now the nineties, must be reversed and a new sensitivity developed to the requirements of a user who may be baffled by products—regardless of how old that person may be.

the independent/infirm elderly

It is interesting to note that this population falls outside of the concern of both the design community and manufacturing. There are many reasons why the independent infirm elderly have little or no appeal. There is a curious relationship between wealth and infirmity—disabled people have less money than other populations. Much of the support for this group comes in the form of private or public subsidy. In terms of age range, this not silent but quiet population consists of those who can be categorized as "middle-old" to "old-old" (from the sixtieth to the ninetieth years). It is a large segment consisting of 15 percent of the population of independent aging people. As stated, their resources are modest to low income. However, 70 percent own their own homes—and those homes are paid off. They are reliant upon transportation and are frequent drivers of automobiles. There is increasing heterogeneity among this population, with multiple physiological afflictions (at least two chronic afflictions for everyone over eighty—arthritis and related musculo/skeletal disorders). Michael Teague (1991) points out that "functional impairment is loss or abnormality of physical or psychological structure or function."[8] This potentially means that even without chronic disorder, many of the infirm aged are functionally impaired and require environmental, product, and service supports.

According to Teague, changes occur that can be called psychomotor aging, including changes to the nervous system, cardiopulmonary system, and the musculoskeletal system. Muscle mass declines by approximately 40 percent by the age of seventy. Losses in strength are specific and especially severe in the quadriceps (40 percent) and in the arm muscles. This has important ramifications for the design of chairs and other furnishings because transferring weight successfully and lifting away from a chair becomes significantly more difficult after the age of seventy. Flexibility and closure of the joints in the extremities is also decreased. Knee closure combined with losses in strength mean that the foot cannot be moved rearward under the center of gravity of the body as easily.

The picture of manufacturing is also an interesting one for this population. The independent infirm aging rely upon self-help for the important modifications they must make to the homes they own. This population forms networks

among their peers and trades or barters services. Prosthetic and supportive aids are manufactured and sold through specialized product manufacturers with low visibility and limited distribution, such as the *Sampton Products Catalog*; the major service for the distribution of products to this population in the United States is the Sears *Special Products Catalog*.

The most successful product of any type available through a national distribution channel of manufacturing and marketing for this population is the "lift chair." This is an industry in the United States with $26 million in sales, having the advantage of marketing to a population with 80 percent Medicare reimbursement for the purchase of the product. However, claims about the benefits of lift chairs are now under dispute. The action of the chair actually places the infirm person in a stand leg position without proper transfer of the center of gravity over the heels of the feet. The potential for falls is significant and numerous falls and injuries have resulted from this highly questionable method of chair egress.

As stated previously, this population relies upon the automobile, in spite of the difficulty there may be in driving a car. A great number of infirm elderly live in the rural areas of the United States and do not relate to a specific town or hamlet. They drive to get what they need. For those without cars, there is a compression of home range due to environmental barriers. Venturing out may be dangerous for the urban infirm aged, and they may become reliant upon service brought to them, such as the well-known Meals on Wheels system. It is interesting to note that when the characteristics of nursing home populations and independent infirm elderly are matched, there is double the number of independent infirm elderly with the same characteristics as those who are institutionalized. The debate over whether it is cheaper to deliver services rather than place these independent aged in institutions is moot. There has been little construction in the institutional sector for the past ten years—except to build specialized facilities related to dementia or so-called Alzheimer's disease skilled care settings. At this time in the history of medical care in the United States, it is not possible to contemplate the expansion required to house all infirm aged in an institutional setting, nor would it be desirable. Independence is a valued commodity among this population, and as a national heritage in the United States. Unfortunately, demographic patterns will show many more aged infirm living

alone with less family to care for them as time goes on. A complex design/human factors problem is the development of supportive products for the population over eighty. This population has physical chronic conditions which can incorporate between two and thirty afflictions. Many of the so-called old-old in the United States are receiving eight different medications with little evidence of effectiveness. Some nursing home patients enter the institutional setting having acquired—and habitually taking—as many as 30 medications.

Some other considerations are that the federal government spends fourteen dollars on the care of aged adults for every dollar it spends on the care of children; that 40 percent of all federal medical and social service supports went to people over sixty-five in 1970, and the percentage is rising; and that 50 percent of all acute care patients are over the age of sixty-five, with 50 percent of that population coming for drug/drug interrelationship detoxification.

characteristic changes in human strength, flexibility and mobility

Arthritis and osteoporosis are pathological conditions that afflict older adults in greater numbers than other age groups. Treatments and therapies are available to offset the effects of these conditions. Most male adults contract arthritis in the lower spine in their early forties, which exacerbates the problem of lower chronic back pain. Thirty out of every one hundred adults—randomly chosen—show evidence of a herniated disk. This makes lower back pain a significant issue in the design of seating and issues relating to work.

Normal age changes in the musculoskeletal system affect human performance of tasks and activities of daily living regardless of the problems of pathological conditions. After the age of thirty-five, a half pound of muscle tissue is converted to fat every year. Weight maintenance, regular exercise and proper diet are critical aspects of healthfulness and fitness—not only in youth, but in all ages.

Recently, free-weight training has been introduced in nursing homes with carefully administered programs designed for very old people. Exercise physiologists have demonstrated that cardiovascular health can be improved at any age and some adults over sixty-five have increased their lung capacity, with regular exercise, by over thirty percent. A pioneer in this field, Sidney Robinson M.D., was the first to study the relationship of exercise to aging and established

that healthfulness and fitness cannot be "banked." Fitness is a continuous process of health maintenance throughout life.

Aspects of strength and fitness that impinge upon product design include:

- Loss of strength in the lower extremities—40 percent in the quadriceps, causing a "drop" to chair surfaces when assuming a seated position and increasing difficulty when rising from a chair.
- Less ability to bend the knee joint to an acute angle in order to position the center of gravity (CG) over the heels for egress from the chair.
- Greater reliance upon arm strength to lift the CG from the seated surface and stabilize the body for transition from standing to sitting.
- Longer seating durations, yet earlier onset of discomfort owing to tissue loss over the ischial tuberosities (load bearing points on the base of the hips that press against muscles of the buttocks).
- A gradual transition from normal walking gait to a "shuffling" gait whereby the aged adult thrusts feet forward out from under the CG.
- Aged adults experience "tremor" in the early morning and at the end of day.
- Loss of grip strength in the palm—from ninety-five pounds of pressure in youth to a low limit of five pounds for some aged adults.
- Loss of "pinching" or tip prehension strength in the fingers, from thirty pounds of force to none for some aged adults.
- A greater need to use whatever appendage of the environment presents itself for stability when walking, climbing, or changing position—especially important when considering the design of tables.
- Early onset of fatigue on inclined walkways or ramps.
- The so-called kick space around sofas, low base tables and other household furnishings should be raised to a height of eight inches from the standard three-inch level.
- Dining chairs should not be armless and should integrate with the tabletop in such a way that the arms fit below the table surface. Aged adults do not lean forward when dining, but utilize the backrest of their chairs for support.

implications for home appliance and furnishings design

Manufacturing is specialized in the arena of production of furnishings for the infirm elderly. The most successful among the special equipment manufacturers

match quality products with a reputation for service. New manufacturers enter this market warily. Manufacturers face very high research and development costs for new products—up front—with long-term production cycle testing and on-site product evaluations before market penetration. Additionally, because the user of the furniture is characteristically infirm, there is the threat of increased liability. It is difficult for many manufacturers to muster the staying power to develop and market special products for this population.

That segment of the market of infirm aged that lives independently has less discretionary income than their able counterparts. As stated previously, many live in rural settings. They network to support one another and frequently develop necessary modifications to environment on their own—or with the assistance of someone else.

Special product manufacturers do not operate through standard retailing channels. As stated, there are special product catalogs. Much of the specialized product distribution of this type in the United States is available through home medical equipment dealers (HMEs). These dealers combine the sale of products with intensive service to individual consumers who are frequently reimbursed through medical insurance plans (Medicaid) to purchase specialized furnishings. Additionally, hospitals, outpatient geriatric facilities and senior day care centers can also assist in the specification of special furnishings.

In essence, design solutions are frequently the least difficult part in the chain of related events that must occur to provide better furnishings to the elderly, especially the aged infirm. Herman Miller Corporation recently abandoned research and development of residential products for this population, not because product design and development was so difficult, but because they did not have the marketing capability, distribution network and service expertise to be successful.

At best, manufacturers, dealerships and distributorships find success when they are able to make sales directly to large-budget facilities upon opening or when they decide to refurbish interiors. This would include senior centers, retirement communities, congregate housing facilities, apartments and housing for the elderly, and other nonmedical settings that disburse funds in sufficient quantity for the manufacturer or dealership to deal "direct" (without field representatives or retail outlets).

corrective measures

A manufacturer or designer contemplating the development of furnishings designated for a "special user" market should formulate a careful marketing plan that takes into account: 1) how the product will be handled beyond manufacturing; 2) an effective sales strategy with carefully trained sales specialists who are in constant communication with design/marketing/engineering staff; 3) a careful plan for the servicing of all products on-site or through returns; and 4) an extended time allowance for market development, as short-term expectations for success will likely prove to be unrealistic. The design team should be fully acquainted with the human factors of aging and be willing to work with dimensional and proportional characteristics—especially in seating design—that are atypical in the design of most furnishings. Dimensions cannot be altered to suit aesthetic considerations.

There have been significant advances in materials and production methods that allow for small-quantity production of goods. At least four manufacturers of fabrics in the United States are producing odor-eliminating fabrics. The fabrics that can be acquired are easily cleaned and resist bacterial growth.

The chair, or one special chair, becomes a very important design element in the environment of the aging—especially the infirm aging. That special chair has been referred to as a "control center" by the eminent gerontologist, M. Powell Lawton. From that place in the environment, the chair occupant exerts both passive and active control over the immediate surroundings. From this chair, television is accessed, books read and the phone used. The length of time any elderly person may remain seated increases with age and infirmity.

Designers and manufacturers must develop a sensitivity for those populations left out of the typical marketing effort. These segments are "special users"—as any population ages, their physical, psychological and sociological characteristics diversify. The population becomes heterogeneous. This makes uniformity in design unworkable—one size will most definitely *not* fit all. Product lines must be responsive to this diversity by emphasizing variability to meet differentiating needs.

the institutionalized
infirm elderly

The characteristics of this group of aged individuals is the most complex design/human factors model with the least population. The average age among this segment of the population is eighty-three and rising. In the United States, this constitutes 5 percent of the population over the age of sixty-five and 22 percent over the age of eighty. This population of very infirm people, as I have noted, has a range of between two and thirty pathological afflictions.

Nearly 40 percent of the population of institutional settings suffers some form of dementia. The most widely known of these psychological afflictions that affects the brain is Alzheimer's disease. Surprisingly, Alzheimer's, a disease named for the man who identified it, has been known to the medical profession since 1929. The disease has a significant relationship to aging: up to sixty years of age the incidence of the disease afflicts 2 percent of the population of the United States. At eighty-five, the disease afflicts nearly 65 percent of the "old-old" population.

Alzheimer's disease progresses over time and longevity with the malady range from eight to twelve years. In many ways, this disease is symbolic of the problems in caring for the aged when they become profoundly infirm. The costs are staggering and denude the resources of many families who pay for the care of their older parents. However, many infirm institutionalized elderly are quite alone—without family—and their care falls to the public domain and government support. In spite of the fact that medical research in the United States and elsewhere has had more time to deal with Alzheimer's, the research community is no closer today to a treatment or a cure than it was at the time the disease was identified. Cohen and Weisman produced a thoughtful treatise on the subject of designing to meet the needs of the aged who suffer dementia.[9] In their guidelines, they mention four important design criteria. Specifically orientated to facility design, they are: 1) redundant cueing (a concept that transcends all design for the aging); 2) contrast—accentuating cues in the environment for those who require additional sensory stimulation; 3) anthropometric fit—understanding the differences between older populations and the other generations regarding body dimensions; and 4) self-correcting

design—that the environment and products within the environment can be designed so that movement and overall negotiation of that environment is directed or guided.

One of the most controversial areas of institutionalization is the profound use of medications. In the United States, the variation between facilities regarding their policy on drugs is astounding. It is possible to find a facility where no drugs are administered. On the other hand, the average nursing home patient is receiving eight different medications, sometimes regardless of evidence of effectiveness. Some institutions count an average of fourteen medications per day and "polypharmicological" patients may take and/or receive thirty medications per day.

Marketing strategy that focuses upon the provision of goods and services to the institutional population is a complex issue. The design of products for the population is less complicated than the mechanism of delivery that provides useful products to these infirm aged in need. Joseph Callifano, the Secretary of Health, Education, and Welfare in 1980, projected a budget of $600 billion in health care costs for the government of the United States for the institutionalized elderly by the year 2030—higher than the current defense budget. While the numbers of individuals to be served are small in terms of total population and percentage, the cost of their care and the support-product needs are tremendous.

It is essential to keep in mind that the institutionalized infirm are the recipients of care—and of product development—provided by others. Yet this population is more reliant upon personal possessions than any other population for establishing a sense of well-being and personal control over environment. Many nursing home resident/patients make purchases of personal objects and furnishings while they reside in such settings as patients. Sales will be made through the exhibition of products and services at statewide health care conferences and by direct one-on-one meetings with purchasing agents.

Manufacturing of products for the institutional population is also a complex issue. There are numerous regulatory agencies in the United States that must be satisfied in order to secure approval to sell such devices. Most manufacturing that services this area of the market is specialized with a high relationship to reputation for service. New manufacturers should enter this market warily. There are

very few national distributors of goods to this population. Those that have succeeded in this market (Hil-Rom, Lumex, et al.) have invested heavily in their reputation and do not release a product without long-term product evaluation.

Most special product manufacturers are localized, dealing with specific statewide regulations. Medicare/Medicaid certification for reimbursement of cost of products is essential for many product lines since, without this certification, the cost of the items would not be affordable to the aging consumer.

There are significant risks in developing products for the institutional market. Product liability and the issue of unintended use of products cannot be dismissed and must be thoroughly evaluated prior to the onset of a sales program. Manufacturers may anticipate very high research and development costs for new products up front with long term evaluations before market penetration.

Distribution of goods and services to the institutional market has evolved over the years through trial and error. Lumex, a very successful company dealing in the production and distribution of geriatric chairs and other furnishings has linked service with sales. Representatives for Lumex will frequently either repair products on site or report directly to the factory any malfunctions to be corrected. This technique of fast feedback insures the loyalty of the buyer and creates a trust that any product received will be carefully monitored through representation and direct sales from the manufacturer.

The buying of products takes place at the facility level through someone designated to purchase goods by the facility administration. However, in the case of facilities that are owned by companies controlling several institutional settings, purchasing will be centralized. There is a wide variation in expertise about products in facilities. In addition, pricing frequently dominates consideration of a product and service longevity is not always considered. Lack of knowledge about pricing has frequently meant that purchases have been made that are not cost effective—sometimes initial purchases have been overpriced.

conclusions

Much has been stated and printed about design approaches to the aging market in the United States. New buzzwords have emerged, such as "universal design"

and "transgenerational design." These terms are useful philosophic devices that act to proselytize designers and force them to consider an expanded range of users that need design attention. James Pirkl coined the term "transgenerational design."[10] It is perhaps the more useful of the two terms because it is a very specific philosophy of design that seeks to incorporate a wider range of normal users of products. Pirkl's intent has been to increase the awareness of industrial designers and of the industry they serve as to a potential marketing opportunity they may miss. This market has the need and the money to acquire.

Universal design, as a philosophy, is a less useful term. It is largely a remnant of the now anachronistic concept of mass marketing. Understanding that as people age they diverge in characteristics means that there is further market segmentation necessary to address their needs properly. Industrial production allows the designer to batch produce even the highest forms of technology so that old concepts of mass marketing are outmoded. Indeed, no ordinary product consumer requires a geriatric chair or a wheelchair. They do not require special beds or toilet equipment to assist in the performance of tasks of daily living. These are all special products that are designed to meet the needs of people with special requirements.

Marketing professionals must take a proactive, as opposed to reactive, approach to developing information about aging. Marketing research and sales strategy should precede product development—not the typical relationship in the experience of designers. The product itself is only part of a total marketing conceptual framework that must be in place as research and development begins. A company without experience in health care, for example, must either acquire the necessary expertise to sell and service the product as well as produce it, or that company will fail.

Designers should not mix aging with infirmity. Aging is inexorable but varies in rate. Infirmity happens at any time in life, with higher susceptibility in infancy and in the "old-old" population. Most people will never be infirm; many who are infirm have been afflicted for very long periods of their lives, perhaps all of their lives. Unfortunately, our language and our literature has blended these two aspects of life and people together in a way that does a disservice to both.

Developing an applied human factors model requires consideration of the acceptability of the information on the dynamic characteristics of aging. If a high degree of diversity of characteristics is misapplied to design projects that are meant for general production, distribution, and use, the information will go unheeded. Likewise, if designers compress diversity into a mold of uniformity in developing responsiveness in environments and products, the resulting effect is a neglectful and ultimately inhumane design.

It is also wise for the design community to remember that the field of human factors is an eclectic amalgamation of information from a very wide ranging base of resources. Anthropometrics alone is an area of content that emerged from World War II and developed independently. The need for this information forced the expansion of data collection to the general population and then to aging cohorts. Likewise, the human factor of aging is even more diverse, with many more considerations than the somewhat tighter and homogeneous characteristics of younger age groups. No label, no umbrella, no buzzword truly describes the diversity among the elderly.

Designers must continually look to other fields—a task that is difficult because it is not always possible to determine where critical information may be generated. For example, the fields of sports medicine, exercise physiology and physical therapy are now conducting important research on the capabilities of the aging adult. This research is not just focused upon existing capability, but also points toward potential capability as well. Nursing home residents are now involved in weight lifting to improve strength and flexibility—a potential that just two years ago would have been thought to be fruitless. Michael Teague's work lies in this area, as does the important work of Dennis Zacharkow on the relationship of posture, sitting, standing, and exercise to chair design.[11] This work will become an essential ingredient of the design of work stations and concepts for office settings as many more older workers pass up retirement for extended roles in the workforce.

Finally, the model for most designers is themselves. Designers, regardless of discipline and degree of artistic or scientific inclination, tend not to externalize design process and look at others as the ultimate users. This is no longer an acceptable process. What any individual designer may prefer does not tell that

individual what others may need. The self has become a less usable model for the development of design, and intuitive creativity is no longer untouchable as an unimpeachable arena of activity for the design professions that have sprung from the arts based disciplines. Designing for an aging population means, in essence, creating new forms or disciplines of designing. In reflection, the dynamic of aging has already changed the design disciplines even more than designers have changed products to address their needs. Somewhere in the future, possibly as the world becomes increasingly populated with older adults, new design disciplines will not only be necessary, but will be the only means by which the complexity of designing for an aging world can be accomplished.

ethical design

The Industrial Designers Society of America (IDSA) publishes its ethical standards with its directory every year. Article I of the Code of Ethics and Professional Practices for Industrial Designers states that "Responsibility to the Public for their safety and for their economic and general well-being is our foremost professional concern. We will participate only in projects we judge to be ethically sound and in conformance with pertinent legal relations; we will advise our clients and employers when we have serious reservations concerning projects we have been assigned."[12] This statement is clear and well conceived. The problem is knowing when the actions a designer may take will have a negative impact upon the public safety and welfare. In essence, ignorance of the "age wave" is an ethical issue for designers in all areas of work; and for manufacturers as a matter of profitability, and for design educators who use the model of the self to present design problems and concepts. Designers use their intuition to decide design direction and rely upon creativity as an essential ingredient in their problem solving approach. Information is used to support assumptions rather than to formulate approaches. In the final analysis, designers use themselves as a measure of acceptability. Further, self concept is fraught with vanity, ego and age avoidance, making a serious and effective approach at problem solving with real users in mind a very distorted and biased process right from the beginning.

If the first article of ethical behavior posed by IDSA were to be truly observed, the entire process of designing would require a revolutionary approach. Designers would be required to subdue their intuition while they learned enough about the users of design and what the real issues were about safety. Form giving, the service that lends distinction to design professions, would not be an ultimate goal of design action but a byproduct of the act of problem solving.

Academic education of designers is still woefully lacking in areas of aging or gerontology after three decades, during which ample information has been available to prepare designers. Students in product design or industrial design who believe that in-line skating, bungee jumping, sky diving, base jumping, surfing and other thrill-seeking lifestyles of the young and reckless are areas of unlimited design opportunity have not been properly prepared for their own future—nor are they acting responsibly about their own future. Graphic designers who see type as a massing of figures to be placed in aesthetic juxtaposition to an image, ignoring the problem of 8-point type printed in blue on a glossy gray background have not been adequately prepared for their own future and cannot legitimately refer to themselves as visual communicators. Additionally, the interior designer who cannot specify appropriate illumination for a public space with adequate glare limits and sensitivity to specular surfaces has not been adequately prepared as an interior designer. The aging consumer of products, information and spaces is not just another market, they are *the* market.

Design professions have other ethical problems that must be addressed— and soon, or they may not have time to address them and play no role in better design in the twenty-first century. Designers have always considered themselves generalists, not specialists. Today, the adage goes, I design a Bic lighter and tomorrow, a sports car. Critical human problems cannot be solved by design professionals without developing expertise. General capability must give way to long-term study of problems, cross-disciplinary relationships with other professions working in the same problem areas, and a long-term research focus. This conceptualization should provoke much discussion in the academic design community regarding graduate and advanced study—even raising the potential of doctoral studies in design that do not now exist.

intuition versus information and
universal design versus transgenerational design

Students have heard me say that industrial design can be seen as having two distinct eras within the twentieth century: one from 1920 to 1960 and the other from 1960 to the year 2000. Many different things define each of these two eras. However, one significant division between the way designers have practiced design is that, in the earlier era, designers used an intuitive approach: design first and support your assumptions with positive information (discounting the negative). This is the intellectual equivalent of shoot first and ask questions later. In the latter half of this history, we see increasing emphasis on research prior to the act of design; proactive marketing strategies; understanding user capabilities and performance; production, material and ecological concerns, and so on.

The thesis that design begins with information is a conceptual framework having its roots in the work of L. Bruce Archer, J. Christopher Jones, Christopher Alexander and others. They were pioneers in pressing the belief that designers were missing the mark more frequently than hitting it because they were insufficiently informed about the conditions surrounding the design task.

With regard to design problems that are related to aging and infirmity, there are currently the two approaches, universal design and transgenerational design, mentioned earlier. They are not one and the same and they represent the two different intellectual constructs that compete for attention in design service today. Universal design has become the bandwagon of the intuitive approach to serious human problems; it is a curious new bandwagon that has picked up tremendous steam within design professions. It is a "one size fits all" concept of meeting human problems. At a time when products can be made with infinite variations, sold profitably in batch quantities to discrete market segments or niches and are usually developed by innovative small companies, why would any designer assume that any given product must suit all people no matter what their capabilities? Reversing the theme that what works for one should work for all, consider a wheelchair designed for the able-bodied. It is an absurd conception. Why then should a telephone be designed with the same functions that make it suitable for those who hear normally as those who may be hearing disabled or deaf? The key is in product variation, not product universality.

Transgenerational design is an information-based design approach. James Pirkl defines the philosophy as one in which the normal age-related changes common to all elderly people should influence design of products for all adults. He excludes the specialized design necessary for the infirm in this approach and does not really slide the concept so far back that it includes children. Pirkl makes the one key observation that all research gerontologists make: adult human beings change with age and aging is a normal human factors dynamic that must be accommodated in general product development.

There is a critical ethical issue involved in the distinction between the two approaches: is it permissible for designers to approach critical human problems with the same intuitive approach they would use to design rollerskates, perfume bottles and the host of inconsequential but attractive products found in the *Sharper Image* catalog? The answer is that any designer who blithely uses such an approach is acting unethically. Is this an indictment of a very large segment—if not the majority—of my design colleagues? Designers would be required to examine their own conscience regarding an approach to problem solving and answer for themselves. The belief that all one needs to solve a problem is intuition and creativity is now not only unacceptable, it has become unethical.

selected bibliography for "design, aging, ethics and the law"

Aging Services Department, Lutheran Hospital and Homes Society, *Minimizing Physical Restraints*. N.p.: Lutheran Health Systems, 1987.

Dube, Arthur H. and Erik K. Mitchell. "Accidental Strangulation from Vest Restraints." *JAMA* 256, no. 19 (1986).

Evans, Lois K. and Neville E. Strumpf. "Tying Down the Elderly: A Review of the Literature on Physical Restraint." *Journal of the American Geriatric Society* 36, no. 1 (1989).

Koncelik, Joseph A. "Human Factors and Environmental Design for the Aging: Aspects of Physiological Change and Sensory Loss as Design Criteria," in *Environments and Aging: Concepts and Issues*, edited by M. Powell Lawton. Princeton: Grovenor Press, 1979.

———. Aging and the Product Environment. Stroudsburg, Pa.: Dowden, Hutchinson and Ross, 1982.

———. "Applications of Human Factors of Aging to Environmental Design for the Aging Infirm," in *Housing the Aged*, edited by V. Regnier and J. Pynoos. Princeton: Grovenor Press, 1986.

National Citizen's Coalition for Nursing Home Reform. *Restraints Packet A*. N.p.: National Citizens' Coalition for Nursing Home Reform, 1992.

distributive
protocols
residential
formations

keller easterling

THE BUILT ARTIFACTS OF DEVELOPMENT systems, the highway interchange or the suburban tract house may be described formally or scrutinized aesthetically, but their dominant architecture may be best identified by *protocols* expressing the constraints governing timing, organization and interactivity. For instance, the process of assembling residential fabric has often resembled that of agricultural production, where large numbers of houses are executed simultaneously in uniform fields. And it is the *architecture* or format of that process which may be the chief determinant of spatial and material consequences, not the appearance or shape of a residential subdivision.

Suburbia is a distributive protocol, a code of procedures which usually shapes infrastructure, markets, construction techniques, financing, etc. into more uniform networks of organization. Despite generic subdivision models, the variable architectures of financial arrangements, ownership, development and building methods *potentially* establish a differential system of housing production. However, one common approach to community building is to fuse these

variable fronts into a streamlined organization which fashions the house and lot as a repeatable phenomenon in the realms of banking, real estate, prefabrication and mass production. For instance, at mid-century in America, not just the house but the entire site was considered to be a kind of assembly-line product, with the tasks of cutting streets, pouring foundations, framing, roofing, and the like executed simultaneously and sequentially over the whole of the site. Since subdivision development was also the vehicle of new mortgage formulations designed to bolster failing depression-era banks, houses became a kind of currency or economic indicator, valued for the sheer numbers that could be produced. Influenced by banking and marketing, many of the sources of differentiation in the subdivision (e.g. changes over time, separate layers, different designers, etc.) were fused and neutralized into an ecology where the aim was equivalent, high-volume coverage in large fields of development. Adjustments to that market field were like giant *summations* across many similar elements within a distributed market.

This kind of residential engineering was created in part by the planning establishment's willingness—even eagerness—to systematize its formulations. Perhaps because they thought they would be given the job of implementing planning proposals, planners attempted to convince their business or government "clients" that subdivision design was a kind of science. Technical expertise was useful in galvanizing legislation. However, when housing became not a planning effort, but a major American industry not unlike the automobile industry, only the systematizing aspects of more complex planning proposals were lifted from their context and used by the federal government to create uniform development guidelines. Consequently, many planning methods were turned to entirely different purposes as they were transferred to the real architects of suburbia—that is, the various branches of private industry associated with building homes and subdivisions. Discriminatory banking and real estate practices had also become bureaucratized and centrally controlled through the statistical division of the Federal Housing Administration. These too were merged with the subdivision, making it an implement of continued racial segregation, a trend exacerbated by the large volumes of decentralized housing under construction. It was not the

architects and planners, but the manufacturers of building materials and the designers of household accoutrement who were operating within real contours of suburbia's spatial arrangements. As the residential environment was formatted into a field for distributive merchandising, the actual sites of adjustment perhaps had little to do with variations in the architecture of the buildings or the curvatures of the streets. The active sites were really the fittings, finishes, gadgets, and appliances that exploited the power of the small, tactical design repeated across a large field of elements.

Within the formatting of most repetitive residential formations, tactical designs have strategic implications. Indeed, in many spatial organizations, tactic and strategy are really two points on a continuum. Architects and planners historically begin with a desire for some kind of strategic control, a stance which, as in the case of the subdivision, may make a sophisticated practice vulnerable to unintentional political associations. Ironically, the most effective *strategy* might involve both working *tactically* on smaller sites which have some radiating effect and adjusting the more ephemeral protocols that format organization and timing. While most of suburbia's finishes and accessories remain inert within the larger organization of repetitive dwellings, the design of fittings, details and gadgets holds significant power to retool and recondition those environments.

As a laserdisc, *Call it Home* by Richard Prelinger and Keller Easterling considers *in parallel* the protocols of various industries that were the effective architects of suburbia during the period from 1934–1960. Protocols for financing, merchandising, advertising, home building, publishing, and the like are traced through the ephemera, planning materials and government documents of the period. The disc contains fifty-five minutes of running footage, three thousand still frames and three separate sound tracks. The nonlinear format of the disc matches its content about a distributive development environment. The following images are from the trade journal *Architectural Record*. They demonstrate how almost every industry in America converted some of its efforts to home-building production at the time, and how those industries understood patterns of consumption.

Include CRANE QUALITY in the Homes You Are Planning

Quality Plumbing
NOW AVAILABLE

The bathroom and kitchen fixtures shown here are typical of the many non-critical plumbing items you may obtain now without priority for today's construction projects. Orders will be filled as rapidly as production facilities permit.

Crane Hanover Closet

Crane Cottage Sink

Crane Norwich Lavatory

Crane Conservor Bath

EVERY indication points to a rapid expansion of home construction when conditions permit the release of men and materials.

Already on the drafting boards of architects are plans for these homes of tomorrow. Many are of the low-cost group. Others will cost much more. But no matter what type houses you are designing, you will find plumbing equipment exactly suited to the taste and desires of your clients in the complete Crane line of tomorrow.

Specifications on the homes you are planning should include Crane plumbing. To help you with your planning, we will gladly furnish you information on styles and dimensions of fixtures that will be available when war conditions permit their manufacture.

CRANE

CRANE CO., GENERAL OFFICES, 836 SOUTH MICHIGAN AVENUE, CHICAGO

VALVES · FITTINGS · PIPE
PLUMBING · HEATING · PUMPS

NATION-WIDE SERVICE THROUGH BRANCHES, WHOLESALERS, PLUMBING AND HEATING CONTRACTORS

FROM A PILOT SEAT...AND RUBBER-LIKE SAFLEX...SOLID COMFORT, MASS PRODUCED?

William Lescaze, architect, is credited with the first modern skyscraper (for the Philadelphia Savings Fund Society), and the first use of glass brick in a facade. Outstanding examples of his work include Columbia Broadcasting's Hollywood Studios, the Ansonia (Conn.) High School, and Longfellow Bldg., Washington, D. C.

STRONG, lightweight pilot seats of plastics-bonded plywood now in quantity production for the U. S. Air Forces were the principal inspiration for this interesting suggestion for 194X by well-known, New York Architect William Lescaze.

Wartime success, however, in converting Monsanto's Saflex from its original function as a tough, resilient interlayer for safety glass into what amounts to a new and promising synthetic rubber,

also interested Mr. Lescaze and led him to include Saflex in his "specifications".

Making use of war-stimulated bag-molding techniques, the chair Mr. Lescaze visualizes would be quickly and easily formed on inexpensive molds with little or no waste of material. It would be upholstered with a resilient, sponge-like Saflex and covered with a waterproof, washable, Saflex-coated fabric.

The sketches below illustrate details.

Formed plys, coated with a Resinous phenolic bonding resin, would build up on simple, inexpensive wood molds, tacked in place.

Molds would be covered with rubber bag and air evacuated to form snug fit. Entire assembly then goes into pressure chamber.

Removed from mold, chair is one tough, resilient, monolithic piece. Sponge-Saflex cushion would be slipped on frame like an envelope.

The Broad and Versatile Family of Monsanto Plastics

These names designate Monsanto's exclusive formulations of these basic plastic materials.

LUSTRON (polystyrene) · SAFLEX (polyvinyl acetal) · NITRON (cellulose nitrate) · FIBESTOS (cellulose acetate) · OPALON (vinyl and phenolic resin) · RESINOX (phenolic compounds)

Sheets · Rods · Tubes · Molding Compounds · Coatings · Vuepak Rigid Transparent Packaging Materials

MONSANTO PLASTICS
SERVING INDUSTRY...WHICH SERVES MANKIND

FACTS TO HELP *YOU* SHAPE THE FUTURE

No one can say today with certainty that a chair such as Mr. Lescaze has suggested will ever be produced. It *is* certain, however, that wartime advances in plastics materials and techniques *will* exert a strong influence over the shape of many things to come. That is why it will pay you to add "The Family of Monsanto Plastics, A Guide for Product Designers," to your postwar file now. Its 24 pages are packed with facts on one of the largest and most versatile groups of plastics produced by any one manufacturer. Simply write: MONSANTO CHEMICAL COMPANY, Plastics Division, Springfield, Massachusetts.

WINDOWALL specified by Humphrey & Hardenbergh, Inc., Architects

ANDERSEN
Windowalls*
COMPLETE WOOD WINDOW UNITS

OPERATING WALLS of Andersen Gliding Window Units give extra meaning to the architect's open planning of this dining area. For each window opens.

These are WINDOWALLS...windows that admit pleasant breezes in addition to a view and a flood of light...walls that keep unpleasant weather from disturbing the owner's comfort. Hundreds of combinations are possible with these beautiful wood window

units—combinations which give lasting satisfaction to both architect and client.

See Detail Catalog in Sweet's Architectural and Builders' Files, or write us for further information. The complete WINDOWALLS Tracing Detail File will be sent on request to architects and designers at no charge. Andersen WINDOWALLS are sold by lumber and millwork dealers.　*TRADEMARK OF ANDERSEN CORPORATION

Andersen Corporation
BAYPORT · MINNESOTA

The BARCOL OVERdoor

BIG "FRONT DOOR"

with Smartness and Utility Combined

Today's design trend places the garage door *out in front*. Thus, it can be looked at as a big "front door" that must necessarily be a handsome, harmonious part of the house. Barcol OVERdoors answer this need both in standard and in special design models.

In addition to their decorative aspects, Barcol OVERdoors are known for easy operation, snug fit without sticking, weathertightness, and many distinctive mechanical features which contribute to satisfactory use and long service life. Installation is by factory-trained crews.

Specify Barcol OVERdoors . . . worthy of the overall investment in the home.

RADIO CONTROL

For maximum convenience and safety, open and close the garage door by Barcol RADIO CONTROL . . . just press a button *in your car*.

Factory-Trained Sales and Service Representatives in Principal Cities

BARBER-COLMAN COMPANY
102 MILL STREET, ROCKFORD, ILLINOIS

painting
and ethics
(or looking
for painting)

laura lisbon

THE RELATIONSHIP OF PAINTING AND
ethics is at once oblique and obvious. If,
as Emmanuel Levinas claims, ethics
arises from the "epiphany of the face,"
the obvious fact is that we all have faces
and have faced others. Gerhard Richter's painting *Betty* shows the shoulders
and head of a blond-haired girl from the back, turned away from us and the face
of the painting.[1] How peculiar it is to show someone from behind, to make a
portrait that is revealed in the back of the head and in the turning away. Perhaps
as Levinas suggests, it is in the nape of the neck that one is lured to see the *under*
of the face-to-face or to find the *other* in truth.[2] It is a meeting place that bears
its face from behind as an obscured view. The nape is literally the back of the
neck, but it is the back that is the front we wish the face to be. The nape pro-
vokes an erotics that loosely composes a turning of thought around a spot that
is a meeting of its subject. In this way *Betty* is really a turning toward an ethics,
which is painting.

Painting is behind and prior to itself; as yet to be known and performed; as
located in an obscure space beneath or *through* its surface; as evident only in its

self-evidence, and thus concealed. If the question of self-evidence is a question of the subject, of the *what*, then Richter approaches that question obliquely through the use of photographs. Subjects for paintings chosen from photographs seem to enable him to shift the question toward a relationship with painting that is behind the foil of the picture (expression); a facade of sorts whose opacity shows his own "helplessness."

> What shall I paint? How shall I paint? 'What' is the hardest thing because it is the essence. 'How' is easy by comparison. To start off with the 'How' is frivolous, but legitimate. Apply the 'How' and thus use the requirements of technique, the material and physical possibilities in order to realize the intention. The intention to invent nothing—no idea, no composition, no object, no form—and to receive everything: composition, object, form, idea, picture. Even in my youth, when I somewhat naively had 'themes' (landscapes, self-portraits) I very soon became aware of this problem of having no subject. Of course, I took motifs and represented them, but this was mostly with the feeling that these were not the real ones, but imposed, dog-eared, artificial ones. The question 'What shall I paint?' showed me my own helplessness . . .[3]

A difficult negotiation of the question of the subject is a kind of erotic relationship of helplessness in the face of the other. It is an obliterating of the known for an engagement with the unknown.

Painting on photographs is a clear effacement of sorts, a covering. Painting *from* photographs effaces the photograph, as well, in order to reveal the painting. One can imagine looking for paintings in photographs in order to find a subject, only to lose the subject to painting. In this way, looking for the subject is looking for painting.

eye

Imagine for a moment a detailed view of the right eye of the 1525 painting, *Judith with the Head of Holofernes*, by Lucas Cranach. Its determined brown iris is precisely rimmed by a thin upper lash and the barest hint of an eyebrow. The pale milky flesh modeled in light pinks with gentle umber shadows is seamless beneath the web of cracked varnish that spreads across the surface of the whole painting. The eye peers through this net, out of the painting, concealed in a way

by the evidence of its age. It stares straight ahead without acknowledging the severed head of Holofernes, dripping with blood in a lower corner of the painting.

Looking into sections of a painting like this, handling it as a conservator does, is understanding painting from a register in which it appears in all of its material specificity as a coating to be preserved uninterrupted. That the original state must be restored is the demand that dictates the ethical debate in the field: does one let the retouch show as such, camouflage the retouch so that the experience of the painting might be similar to the *original* experience, or paint cracks back into the work to simulate the look of aged varnish after that layer has been removed?

House painters understand painting in similar terms as conservators. Paint exists as pure coating: image free, material laden. Conservators understand the painting as house. Both need to be maintained. Paint is a protective coating. Varnish is identified, distinct from its connectedness to image as blemish, bloom, obstruction when it is aged, and it brings the work to a conclusion when it is new. To remove the varnish of a painting is to remove the painting of its privacy.[4] An unvarnished painting is an unprotected painting, vulnerable and transparent in its unpreserved state. Varnish blocks the view.

Restoring the crackelure in the varnish of the Cranach makes the look of age unfractured, so that the eye recedes behind the web of cracks untroubled, replaced seamlessly within its field. Conservation has a code of ethics in the traditional sense of ethics, as a prescription for the "good" and the "ideal." Most importantly, the conservator must remain faithful to the "original." Though conservation sets rules for its relationship to painting by locating those rules in relation to the preservation of the object, is the object where the painting resides? And if not, where then does one locate its ethics?

Conservators photograph their work as if to better show the painting. Details from the front reveal the seamlessness of the surface. A shot from the side shows the smoothness of the surface, and from the back, the integrity of the weave. The painting photographed from every angle convinces us of the same thing, the work of preservation, not that of painting.

Despite the rewoven pattern of the crackelure, the conserved face of painting dislocates an ethics from itself toward a nostlagia for the preserved. Preservation

serves a social standard. Perhaps, then, there is not an ethics proper to conservation. Perhaps the practice is all surface. Or, instead, the "epiphany of the face" can only be found in the raising of questions about maintenance and commentary, as might museology.

Museums photograph their installations to show the housing of paintings. If conservators, museums or otherwise, photograph their paintings, why don't house painters as conservators of houses photograph *their* paintings? This raises a question about what painters do when they photograph their paintings. Evidence of the subject of paintings is maintained in photographs, but the subjects themselves are elided.

A certain critique of conservation as maintenance only, as memory, past, or archive is raised by a critique of the museum understood as conservator. Jean-François Lyotard suggests, in the essay entitled "Conservation and Colour," that the status of paintings conserved or in the museum can be read not only as maintenance or "reserve," but also as ". . . essentially expenditure rather than reserve and that if it is exhibited or exposed, it is rather to the uncertainty of its future than to its perpetual right to a place in the cultural heritage."[5] This definition relieves the pressure put on authenticity and the politics of the museum and places an emphasis on the experience of the work as that which can exceed the limits of the museum walls. He cautions however that museums must be attentive to "new technologies" and that the method of exhibiting works ought not block the work which is ". . . ceaselessly exposed to the event, to the question, to the taking up again . . .".[6] Exposure in this way, as an opening toward an inherent future that the object holds, is an ethics derived from the turning of the present toward its presuppositions and its *posts*, a dislodged present and a freeing of the preserved.

flag

Imagine now that we are asked to look through transparent stripes 8.7 cm in width to see the city of Paris, as in one of Daniel Buren's photo-souvenirs of a 1977 piece, *Les Couleurs: sculptures*. The fabric flags are positioned upon several public and private rooftops where they are viewed through telescopes situated

on the top floor of the Centre Pompidou. The photo-souvenir recalls the experience of looking for the painting in relation to the network of cracks in the Cranach detail. Stripes have replaced the cracks and the obvious stitching, which seams the stripes together, does the job of obstructing the view similar to the way the cracked varnish did. The flags have been cut from the striped fabric that Buren uses to signal painting, the stripe as his signature. We are encouraged by the photo-souvenir, like the experience of looking through the telescopes, to recognize the work of painting somewhere other than the surface of the piece, other than the signaled object.

The fifteen rectangles of cloth that dot the skyline of Paris in the view from the top of the Centre Pompidou are suspended from flagpoles that mark government buildings and department stores, as well as private residences. They conflate these categories as they simultaneously conflate the categories of flag and painting as signals. The fabric that constitutes both the flags and the paintings is the transparent material evidence of that conflation. Both flag and painting are looked *for* and *through*, standing obliquely for what is sought.

The "institutional critique" that is part of Buren's work complicates the notion of the limits of the work, but the work is also the way that the view from afar, the view through the telescope, radicalizes a notion of the oblique manner with which we encounter painting.[7] Buren's practice, if one understands it to be fundamentally painting, reveals its ethics from the side, so to speak. Yet the questions painting can raise about its limits are seen clearly as Buren binds surface and structure in the telescopic view. It is impossible to see Paris or the flags as separate from one another. Painting masks itself, ceasing to be a field upon which material stratifies.[8]

support

The later work of Daniel Dezeuze from the 1980s is a body of large irregularly shaped gauze pieces that adhere to the wall. Bits of tape rim the forms, which are hybridized mechanical and figurative silhouettes. Often there is a hole of some sort cut into the upper central parts of the shapes. Bits of drawing and/or staining are visible both on and through the gauze. Overall, the forms feel as if they

have been cut for a purpose prior to their showing as art, perhaps as stencils. The remnants of the markings and tapings that remain on the edges of the forms encourage this strange presentness as something belonging to an extension of itself–not a fragment, really, but an evidence of something congruent; the future or past of the shape presented.

The central holes, like keyholes, promise a view. But the view is the hold that the space of the hole and its threadbare gauze perimeter expose. The hole is not cut to reveal the support (wall) of this work. The support of a work does not literally live behind its surface in this way, but through it as an entity obliquely implicated. Dezeuze's painting in this context may be seen as a form of "oblique utterance."

Maurice Merleau-Ponty touches on these matters in "Eye and Mind," writing of the ways that "no thought ever detaches itself completely from a sustaining support; that the sole privilege of speaking thought is to have rendered its own support manageable; that the figuration of literature and philosophy are no more settled than those of painting and are no more capable of being accumulated into a stable treasure . . ."[9] "Rendering a support manageable" is literally developed in the early lattice pieces by Dezeuze. His work and that of the Supports/Surfaces group, a group of artists working in France between 1966 and 1974, raises questions about painting through a reduction toward the material and structural limits of painting. In the seventies, for example, Dezeuze exhibited lattice-like strips that explicitly recall the stretcher bars of painting. Christian Prigent, in his book about Dezeuze, *Like Painting*, writes that "The object is chosen for its formal proximity to the technical (stretcher) and intelletual (the orthogonic grid) substructure of the western pictorial tradition. It is not a matter of relegating the question of art to a sort of tiresome derision (and moving on to chess) but of establishing a light displacement permitting the perversion of the 'formal' effects in order to evince what is 'intellectually' at stake."[10]

The "perversion" of the formal seems to suggest something akin to the reverse side of a canvas—the side not evident that holds all of the (dirty) secrets. Dezeuze cuts through the canvas or screen to reveal painting and in this way affirms that ". . . painting has no other subject than the definition of the space thus cruelly exposed."[11]

The support is harder to find in the later gauze work. Support in the gauze work does show itself through the work as a question about the parameters of the work—painting, drawing, installed shaped things. If ethics arises from the "epiphany of the face" and that face is tied somehow to a signification that is the managing of a support against an unsettling, the gauze works pose themselves as pieces whose support is constitutive, less the wall and more the "cruelly" revealed question of their identity. As Prigent writes, "the aesthetic delectation is here the condition of the emergence of a certain thought of a 'joyful wisdom' of painting. A resolutely 'ethical' demand programming asceticism and irony, severity and silence, subtlety and violence, underlies the invention of forms that make Daniel Dezeuze a 'painter,' a 'producer-killer' ('produtueur') of art object[s]. (I meant to write 'producer'—'product-tueur': the slip, as often happens, works better.)"[12] Somehow this work raises in its own demands a movement away from *expression*, an evidence that plays on the turn toward a question of the self-supporting subject. But self-criticism in the end may reveal work that is merely an evidence of painting, bringing to the surface that which it can know, not turning us away but turning us restrictively toward the face. This might be what it means to kill painting; to produce an enunciation of itself that is already its face, instead of inviting an utterance that requests a second, more intimate, look.[13]

name

The condition of the subject and object negotiation that drives contemporary criticism and philosophy happens in the practice of painting. Names for ethics that describe the complexity of the notion seem to plausibly include not only the "epiphany of the face" but the "sublime." Each of these names describes some form of internal recognition and fundamental misrecognition. Names are what we are called and call others, but exist unsupported as some form of lifelong tag. Yet they produce associations despite their status. Naming a child is a negotiation of family history and how the name really does or does not (may or may not) suit the little one. Painting and ethics are simultaneously a negotiation of their names, of finding the right fit, of enacting or discovering the proper tag

and maybe insisting on a naming activity that dismantles itself necessarily throughout life. "It seems to me, that the aim of painting, beyond and by means of all the plots with which it is armed, including the museum, is to render presence to demand the disarming of the mind. And this has nothing to do with representation. Painting multiplies technical and theoretical plots to outplay and play with representation."[14]

To be disarmed means that something has been allowed to happen, and one is conscious of the happening and themselves having been "happened to." The ethics of the face-to-face resides somewhere in here. "The struggle this face can threaten presupposes the transcendance of expression."[15] The presupposition of the face and its implication of a future is analogous to the complicated way the sublime is characterized within the phrase "is it happening?", which Lyotard describes in relation to Barnett Newman's essay, "The Sublime is Now." "Here and now," Lyotard says, "there is this painting, rather than nothing, and that's what is sublime. Letting go of all grasping intelligence and of its power, disarming it, recognizing that this occurence of painting was not necessary and is scarcely foreseeable, a privation in the face of *Is it happening?* guarding the commentary, guarding the occurrence 'before' any defence, any illustration, and any commentary, guarding before being on one's guard, before 'looking' [regarder] under the aegis of *now*, this is the rigour of the avant-garde."[16]

Levinas's face-to-face is here as the bare address; the before-one-is-prepared; a disarming due to an inability to expect the unexpected or to reconcile the happening and the now. To hold someone in high regard is to hold them at a distant respect for what they are and what they will presumably continue to be.

Not only does the sublime presuppose a present and a future like the face-to-face, but it also provokes a recognition of oneself through the process. "In this way the sublime is none other than the sacrificial announcement of the ethical in the aesthetic field."[17] A certain helplessness is central here. The sacrificial announcement of the ethical comes in the form of the thing that produces an inability to join with nature, unlike the Kantian beautiful, where imagination and understanding wed. But marriage is not ultimately a mutual knowing, but rather a recognition of a productive unsettling toward truth that being intimately faced by an *other* might produce. That is what marriage is in its most

ethical, or one might say, sublime form. The ethical arrives as self-recognition and as the awareness that the facing of one's self remains to be done. The urgency of that facing is suggested by Richter when he comments: "I don't paint just to paint. I seek the object and the image, not painting or the image of painting, but our image, our aspect and appearance, binding and total."[18]

subject

As Gerhard Richter repeatedly claims, an ethics for painting is the complicated approach to truth, inspite of ideology. The subject of or for painting is the rapport between the truth and its approach. Asking about the subject of painting (what to paint) deflects an approach to truth away from the surface that is merely the image, toward an effort to experience the ethical stance painting takes.

The question of the subject of painting becomes complicated against a subject understood merely as painting's own structures or supports. An inquiry into the supports of painting can end up as a mere analysis of painting, the object. Another danger is an approach that stays too close to an aspect of self-recognition, which can destroy the fundamental asymmetry of the Levinas' face-to-face. The approach can collapse into a kind of knowing prior to the event that is painting, a fitted "known-ness" like the promise of a face-to-face settling of differences. But what is it that unsettles the approaching of a subject?

John Rajchman opens his book, *Truth and Eros: Foucault, Lacan and the Question of Ethics*, with what he refers to as "one of the great questions of ancient philosophy: What is the eros of thinking? What is the eros of the peculiar sort of truth of which philosophy is the pursuit? What is the passion that drives one to philosophize, and that philosophizing requires of one? . . . In our great debates over what is good for us and what is right for us to do we have rather lost the sense in which to do philosophy is to entertain such passionate relations with ourselves and others."[19]

The question of ethics is imbedded in philosophical writing as a difficulty in style. Style, for painting, proceeds from a difficulty over questions of where painting is, of what supports painting, of what signals painting as such, of what *is* painting, and what for painting is its subject. "Perhaps to start to think,"

Rajchman writes, "is to find oneself in a peculiar difficulty one knows not yet how to define. And the problem of style in a philosophy is the problem of finding the words and the acts appropriate to the difficulty one thus discovers or brings to life."[20] The most mundane aspects of painting: placing paint on a support, choosing a color, selecting an application method, combined with the question of the subject, constitutes an erotics of thought that is its ethics.

This notion of an erotics of thought as central to a practice of ethics, sustained by the temporal dimension of the sublime and the epiphany of the face, opens painting as a practice that operates forcefully toward itself. Looking for painting is painting's ethics. It is as oblique as the nape of the neck, as a site for raising questions of truth and being in the world. It must be approached before it is known, with the utmost attention to its utterance. Painting is there, at the nape, an utterance to touch on. As Richter describes it, "Scraping off. For about a year now, I have been unable to do anything in my painting but scrape off, pile on and then remove again. In this process I don't actually reveal what was beneath."[21]

the politics of
the artificial

victor margolin

introduction

IF WE CONSIDER DESIGN TO BE THE
"conception and planning of the artifi-
cial," a definition which I developed
with my colleague Richard Buchanan,
then its scope and boundaries are inti-
mately entwined with our understanding of the artificial's limits. That is to say,
in extending the domain within which we conceive and plan, we are widening
the boundaries of design practice. To the degree that design makes incursions
into realms that were once considered as belonging to nature rather than cul-
ture, so does the conceptual scope of design practice widen.

Until recent years, the distinction between nature and culture appeared to be
clear, with design, of course, belonging to the realm of culture. The concept of
design, as it was initially developed by early theorists such as Henry Cole, one of
the chief promoters of the British Crystal Palace Exhibition of 1851, was a static
one that was inextricably bound to the object. Cole thought the purpose of
design was to improve the appearance of products, and he hoped to confront the

confusion and profusion of historic styles that were being loaded onto Victorian objects, from furniture to steam engines, by promoting a closer collaboration of artists and industry.

With Cole begins a discourse about objects, particularly about how they should look, that continues well into the twentieth century. It is echoed in Charles Eastlake's exhortations for simple forms and honest representations of materials, Herman Muthesius's call for a language of industrial forms, and Adolf Loos's antagonism to ornament. Closer to home, we can see it at work in the products of the American consultant designers of the 1930s such as Walter Dorwin Teague and Raymond Loewy and in the resistance to those products by the design staff at the Museum of Modern Art.

Although the modernist belief in simplicity was turned on its head by the expressive furniture of such groups as Studio Alchymia and Memphis in the late 1970s and early 1980s, the terms of the discourse were still focused on objects. It was this emphasis that gave rise to the profession of industrial design we have known until recently.[1] But this project has been implicitly and explicitly challenged by various theorists such as Herbert Simon and John Chris Jones who have argued that a process of design underlies everything in our culture, both material and immaterial. Simon has gone so far as to call design a new "science of the artificial."[2]

Where Simon and Jones proposed a broadening of design's subject matter to embrace all that which we might call the artificial, other theorists have questioned design's meaning. In the discourse of the modernists the locus of meaning was twofold: *form* and *function*, for which we might substitute the theoretical terms *esthetics* and *pragmatics*. Early modernist designers believed that meaning was embedded in the object rather than negotiated in the relation between the object and a user. Objects were considered to be signs of value with uncontested referents such as clarity, beauty, integrity, simplicity, economy of means, and function. The reductive slogan "form follows function" assumed that use was an explicit unambiguous term. Thus, the meaning of objects was to be found in their relation to a value that was grounded in belief. Poststructuralism challenged that idea of grounded belief, as well as our right to use "meaning," as if

it were a term that itself did not raise questions about the possible conditions of its use.

Besides the slippery subject matter of design and the questions regarding the conditions under which we can talk about its meaning, we must also confront a more difficult problem at the heart of the politics of the artificial; and that is the nature of reality. For the "first modernity"—and here I will use Italian theorist Andrea Branzi's distinction between two modernities—reality was an uncontested term.[3] It was the stable ground for the attribution of meaning to objects, to images, and to acts. Today, this is no longer the case and any mention of "reality" must be qualified by conditions, just as the use of the term "meaning" must be; hence we are unclear as to how or whether boundaries can be drawn around the real or authentic, as a basis of meaning.

When Herbert Simon called for a new science of the artificial in 1969, he described nature as the ground of meaning against which a science of the artificial or a broadly conceived practice of design would be defined. "Natural science," he wrote, "is knowledge about natural objects and phenomena."[4] The artificial, on the other hand, was about objects and phenomena invented by humans. The difference between the two was clear to Simon although his implicit positivist construction of the natural was also the model for his explicit methodology of design.

The critique of scientific discourse mounted by Paul Feyerabend, Donna Haraway, Stanley Aronowitz, and others has since called into question the way we claim to know nature as real. This critique has at least succeeded in contesting the easy equation of the natural with the real and has thus made references to nature more difficult without qualifications. By focusing on scientific thought as a linguistic construct, critics have attempted to challenge a previous faith in scientific truth. Hence we have two contested terms, "meaning" and "reality" that severely undermine the certainties on which a theory and practice of design was built in the first modernity.

Since we can no longer talk about design as if these terms were not in question, a new discourse is needed, although the way that discourse will develop as a reflection on design practice is not yet clear. However, I believe the central theme to be addressed in this new discourse is the artificial and its boundaries.

the boundary problem

In the first of his Compton Lectures on "The Science of the Artificial," delivered at the Massachusetts Institute of Technology in 1969, Herbert Simon characterized natural science as descriptive, as concerned "solely with how things are," while he defined a science of the artificial as "normative" in its engagement with human goals and questions of how things ought to be. The two were differentiated by the term "should," which marked the task of humans to invent the artificial world in order to achieve their own goals while honoring the parallel purpose of the natural world.

Simon defined four indicia to distinguish the artificial from the natural. Three of these define the artificial as the result of human agency. Simon said that artificial things result from an act of making, which he called synthesis, while the act of observing—analysis—is the way humans relate to nature. Furthermore, he characterized the artificial by "functions, goals, adaptation," and discussed it "in terms of imperatives as well as descriptives."[5]

When Simon compared the artificial to the natural, he posited the natural as an uncontested term, arguing that the artificial "may imitate appearances in natural things while lacking, in one or many respects, the reality of the latter."[6] As I have already mentioned, the equation of the natural with the real has been heavily contested in recent years, most notably by poststructuralists and deconstructionists. Roland Barthes's and Michel Foucault's challenge to authorial intentions in literature and art, Jean Baudrillard's claim that simulacra are signs without referents, and Jean-François Lyotard's refusal to acknowledge any metanarratives or *grands recits* that shape social values all exemplify this tendency as does Donna Haraway's discourse on cyborg culture.

While these attacks on the "real" legitimately challenged implicit assumptions of positivist thought that closed out many of the voices that now constitute our cultural community, they also strove to abolish any presence, whether we call it nature, God, or spirit, that might exist beyond the frame of a socially constructed discourse.

Hence, Donna Haraway, in her 1985 essay "A Manifesto for Cyborgs," could argue for the cyborg, a hybrid of human and machine, as "a fiction mapping

our social and bodily reality"[7] and Gianni Vattimo, the Italian philosopher who has postulated *il pensiero debole* (or "weak thought") as the appropriate philosophy for the postmodern era, can claim that "only where there is no terminal or interrupting instance of the highest value (God) to block the process may values be displayed in their true nature, namely as possessing the capacity for convertibility and an indefinite transformability or processuality."[8] Vattimo concludes from his readings of Nietzsche and Heidegger that "Nihilism is thus the reduction of Being to exchange-value."[9] He does not mean this in the mercantile sense of selling the self but in terms of the self's convertibility without a ground such as nature or God against which it can be defined.

We also find evidence of this in William Gibson's cyberpunk novel *Neuromancer*, where the artificial is unbounded by any presence outside it. Gibson's characters have no grounding in the real; they are constructed of motives and impulses that are facilitated by the manipulation of artificial products. While some characters are more human than others, none possess any inherent resistance to the incursion of the artificial in their bodies or their lives, and some, like the AI Wintermut (an Artificial Intelligence that intervenes in social life) are totally artificial. Part of the fascination with *Neuromancer* outside the cyberpunk milieu is Gibson's portrayal of a world in which the artificial is dominant and where the ability to manipulate it is the most potent human activity.[10]

Neuromancer offers us a scenario of design triumphant in a world where the real is no longer a point of reference. Simon's postulation of the artificial as an imitation of the natural carries no weight in this context. In the world portrayed by Gibson, being is convertible into infinite forms, and values of identity are constituted primarily through the manipulation of technology. The materials which constitute the substance of design have already gone through so many transformations that their locus in nature is no longer evident.

If design in *Neuromancer* is victorious at the expense of reality, how do we reflect on the issue of meaning in Gibson's world? We first need to question what meaning is in a world where reality is no longer the ground on which values are formed. Meaning then becomes a strategic concept that exists pragmatically at the interface of design and use. Its value is determined by operational,

rather than semantic, concerns. The characters in *Neuromancer* have even designed themselves, but without an external ethical imperative or an inner sense of self to guide them.

Neuromancer is a fictional depiction of Jean Baudrillard's world of the simulacrum. As in Gibson's novel, the real for Baudrillard "is nothing more than operational."[11] The simulacrum, according to Baudrillard, is a sign for the real that substitutes for the real itself. The result is what he calls the "hyperreal." Baudrillard believes there can be no representation since "simulation envelops the whole edifice of representation as itself a simulacrum."[12]

The world of *Neuromancer* is a reflection of Baudrillard's own nihilism. He sees the West as having lost what he calls the "wager on representation." This wager was based on the belief that signs could exchange for depths of meaning and that something external to the exchange—he mentions God—could guarantee it. However, Baudrillard himself expresses no faith in God or a metanarrative of equivalent power. He expresses his doubt, asking, "But what if God himself can be simulated, that is to say, reduced to the signs which attest his existence? Then the whole system becomes weightless, it is no longer anything but a gigantic simulacrum—not unreal, but a simulacrum, never again exchanging for what is real, but exchanging in itself, in an uninterrupted circuit without reference or circumference."[13]

Although Baudrillard is a prophet of doom, his ability to explore the implications of a world without the presence of the real is useful. As in *Neuromancer*, meaning only exists for Baudrillard in the operation of exchange rather than in a reality outside it.

In his book *Simulations*, Baudrillard discusses the difficulty of finding meaning in a world without a metanarrative, which Jean-François Lyotard defines as any large idea or presence that exists as an uncontested phenomenon outside the realm of human social action. And yet postmodern theorists, led by Lyotard, have insisted that metanarratives are no longer possible. As Lyotard states in *The Postmodern Condition*, "I define *postmodern* as incredulity toward metanarratives."[14] He believes that knowledge may be accepted as legitimate for reasons other than its inherent truth and he wants to guard against the hegemonic dominance of knowledge that in his perception may be illegitimate. I use qual-

ifiers to account for Lyotard's interpretation of legitimate and illegitimate knowledge to insure that we relate his thought to his own perception of truth, rather than to anything that is or isn't inherently truthful.

Although Lyotard's scepticism has usefully stimulated a critical analysis of how social discourses are constructed, it has also reinforced the belief of many that social life has no ground of meaning. The disbelief in metanarratives, particularly among prominent cultural theorists, is an essential factor in the argument that the postmodern is a rupture with the modern. Although meta-narratives of the modern have been variously defined, the belief in progress animated by instrumental reason is a central one, as is the belief in universals rather than differences.

expanding the discourse

The collapse of a particular modernist paradigm has opened the space of social discourse to many voices that were formerly marginalized or suppressed. But the recognition of difference has also led to a widespread refusal to postulate the world in terms of shared values. Lyotard refers to the situation of difference as "a pragmatics of language particles."[15]

However, many people, including myself, are unhappy with the postmodern condition as Lyotard and other scholars, critics, and artists have defined and elaborated it. But this does not mean that it has to be countered by sustaining a modernist position that is no longer valid. In the most profound sense, the specter of instrumental reason, with its increasing technological power, let loose on what remains of nature—without any moral or ethical imperative to govern it—is terrifying.

Mark Sagoff has described the potential impact of advances in biotechnology on the environment. "The goal of biotechnology," he says, "is to improve upon nature, to replace natural organisms and processes with artificial ones, in order to increase overall social efficiency and profit. . . . That is why we spend more to produce economically valuable engineered species than to protect economically useless endangered ones. And that is also why we continually turn whatever natural and wild ecological systems we may have—from rain forests to savannas to

estuaries—into carefully managed and engineered (and therefore predictable and profitable) bioindustrial productive systems."[16]

The issues raised here are similar to those previously referred to in *Neuromancer* and thus justify the critic Peter Fitting's reading of Gibson's world as "not so much an image of the future, but the metaphorical evocation of life in the present."[17] The technical possibilities of biotechnology, as described by Sagoff, have already blurred the boundaries between the artificial and the real. Rather than an imitation of nature, the managed biosystem becomes a replacement of it.

These biosystems still maintain the appearance of the natural in that they draw their energy from the earth, but their transformation from natural to managed systems may disengage them from a larger ecological balance that their managers are either unaware of or do not wish to take into account. Such biosystems might be simulacra of nature without our even knowing it. Instrumental reason continues to alter species and biosystems for human use, particularly for economic profit. This is design but, as in *Neuromancer*, it flourishes only at the expense of the natural.

The confusion between the artificial and the natural that the capabilities of biotechnology have engendered exists because both realms have been reduced to exchange value. When they are seen as interchangeable, as biotech managers prefer to do, one can be substituted for the other without any sense of loss. The only way to distinguish between the two is to identify one with a value that is missing in the other.

Extreme views of biotechnologists and ecologists who collapse the distinction between the artificial and the natural can be contrasted with another set of views that regard nature as sacred. According to James Lovelock's *Gaia* principle, the earth is a living being with whom we must cooperate. Ecofeminists who have adopted the triadic values of feminism, ecology, and spirituality also share the belief that the earth is alive. As Paula Gunn Allen writes, "The planet, our mother, Grandmother Earth, is *physical* and therefore a spiritual, mental, and emotional being. Planets are alive, as are all their by-products or expressions, such as animals, vegetables, minerals, climatic and meteorological phenomena."[18]

Both the Gaia metaphor and the Goddess narrative, which is at the core of ecofeminist spiritual belief, have generated a strong critique of instrumental reason which the ecofeminists identify with patriarchy. Carol Christ, also an ecofeminist, believes that "the preservation of the Earth requires a profound shift in consciousness: a recovery of more ancient and traditional views that revere the profound connection of all beings in the web of life and a rethinking of the relation of both humanity and divinity to nature."[19]

For ecofeminists the narrative of Goddess spirituality has been a powerful impetus to political action. They have led and participated in demonstrations against acid rain, the destruction of the rain forests, the depletion of the ozone layer, and the proliferation of nuclear weapons and have, as well, been involved with numerous other causes related to a healthy environment. Their aim, as Starhawk, another ecofeminist says, is not simply to oppose patriarchal power but "to transform the structure of power itself."[20]

The accomplishments of ecofeminists on two fronts—opposing groups that damage the earth's ecology and creating actions to draw women together to collaborate positively with the life forces of the Earth—signify the power of a narrative in changing human action. From the position of ecofeminism, the postmodern philosophy of Vattimo and Lyotard has little to offer those who wish to act together constructively. It can only acknowledge an absence of meaning.

Ecofeminism has also made a valuable contribution to the understanding of discourse formation through its resistance to a patriarchal narrative that has closed out earlier matriarchal cultures in which women maintained roles of authority. Starting from a marginalized position, the ecofeminists have, through cooperative intellectual activity, made a place for themselves within contemporary cultural discourse.

They have simply begun from a different position than either positivists or nihilistic poststructuralists with a project that could be consistently and cooperatively pursued within the framework of a new narrative. They have also demonstrated the power of spiritual conviction and experience in generating positive action. Where they have been less effective is in establishing a rhetorical stance from which to engage postmodern theories in both a critical and an affirmative way. They have, however, implicitly challenged Lyotard's dismissal

of metanarratives by producing a narrative of their own that is clearly empow-
ering. While it might be seen as marginal because so few people embrace it, the
Goddess narrative can nonetheless form part of a more inclusive metanarrative
of spirituality within which difference can be asserted just as the postmodernists
argue it must be done socially.

Spirituality as a metanarrative—and I interpret spirituality here as a con-
nection to the Divine—can serve as a basis for addressing the problems of
meaning and reality that have arisen from the expansion of the artificial. If a
broad discourse on the spirit can become as compelling for other social groups
as the Goddess narrative has been for ecofeminists, then it has the capacity to
empower large numbers of people to find meaning and fulfillment in action
directed to the well-being and life enhancement of themselves and others. It is
difficult to say what form this action would take, particularly as regards design,
but it would certainly be characterized by the quest for meaning and unity in
relations with others.

A recognition of the Divine, as neither exclusively matriarchal or patriarchal,
can overcome the breach between the modern and the postmodern in several
ways. It can acknowledge the value of a social narrative in modernist thought
while recognizing the shortcomings of the first modernity's faith in universal
categories and instrumental reason. It can also recognize the significance of the
many incisive critiques of contemporary culture and the attention they have
brought to the problem of the artificial.

There is much that design and technology have to gain from a metanarrative
of divinely inspired spirituality, particularly as a ground of meaning that testi-
fies to the limits of the artificial. While I trace spirituality to a transcendent
source, I refer to it here as it is manifested in human action. What characterizes
the spiritual is both its immanence and transcendence, its capacity to animate
humans from within themselves while also existing as a presence outside them.

simulacra and the real

I realize that spirituality, whether we link it to God, the Goddess, or some other
transcendent source, is one of the most contested terms in our contemporary

vocabulary, but we have had little chance to explore its meaning because it has been suppressed by a powerful intellectual discourse of materialism. Hence, Donna Haraway states, in "A Manifesto for Cyborgs," that "late twentieth-century machines have made thoroughly ambiguous the difference between natural and artificial, mind and body, self-developing and externally designed, and many other distinctions that used to apply to organisms and machines."[21] Haraway claims that we are moving to a "polymorphous information system" in which "any objects or persons can be reasonably thought of in terms of dis-assembly and reassembly; no 'natural' architectures constrain system design."[22]

Whereas *Neuromancer* is a dystopic narrative of self-interest and power played out through design and the control of technology, Haraway proposes her view of this new polymorphous flexibility as a vehicle for positive social change. However, the lack of a metanarrative that can serve as a source of nor-mative values compels her to emphasize power and economics as primary in determining the boundaries of the artificial and the real. Such an absence also makes resistance to technology more difficult. A principal theme of technolog-ical discourse is that innovative devices will enable us to do things we have not done before. We are told that new experiences made possible by technology will be expansive. Measured against a reductive understanding of "natural" experi-ence, this certainly appears true. But the power of lived spirituality can enlarge the experience of being and thus provide a stronger position from which to sup-port or resist new technologies.

Let's take virtual reality (or VR) research as an example.[23] Brenda Laurel has described the many experiences that VR will make possible as has Jaron Lanier, one of the medium's founders and early spokespersons. In a 1989 interview, Lanier spoke euphorically about the new possibilities of VR: "The computer that's running the Virtual Reality will use your body's movements to control whatever body you choose to have in Virtual Reality, which might be human or might be something quite different. You might very well be a mountain range or a galaxy or a pebble on the floor. Or a piano . . . I've considered being a piano. I'm interested in being musical instruments quite a lot."[24] Needles to say, nei-ther Lanier nor others involved in VR research privilege personal fantasy as the primary justification for what they do, but it is certainly a strong element and

one that promises extensive economic payoff. Surely virtual reality, which has already become a site for virtual sex, will continue to develop into a powerful entertainment medium.

While it promises numerous advantages as a simulation device for training surgeons or pilots, or for manipulating machines electronically at a distance, the primary issue raised by virtual reality technology relates to whether we experience simulation as a mark or a mask. This distinction was made by Dennis Doordan in an article on simulation techniques in museum exhibits.[25] When the designer marks the edge of simulation, it is distinguished as a second-order experience whose referent is more authentic. When the edge is masked, the simulation becomes a simulacrum, as Baudrillard has pointed out, with no reference to an experience outside itself. Thus the boundary between the simulated and the real collapses and the simulated becomes the new real.

The counterbalance of perceived constraints in corporeal society and the envisioned freedom of an electronic self raises questions about how physical reality is valued in relation to its virtual counterpart. Virtual reality enthusiasts sometimes speak of VR as an alternative to the physical world, a place where constraints can be overcome and new freedoms can be discovered. On one level, this is classic techno-rhetoric. New technology always promises more. For some, virtual reality suggests that electronic identity offers something greater or more fulfilling than bodily existence. Recall the comment of Case, Gibson's antihero in *Neuromancer*: "The body is meat."[26]

For Case, jacking into cyberspace is a life-enhancing experience that is more meaningful than being in his body. In cyberspace, Case, a marginal figure in real life, displays a shrewd intelligence in breaking through barriers to crack information codes, and he shows considerable courage in maneuvering his way through nets of electronic opposition. In a world of collapsed boundaries between the artificial and the real, the symbolic world of the Net becomes for Case a more intense and expansive reality than his corporeal one.

For Bruce Sterling, a cyberpunk writer and libertarian, cyberspace is a political frontier where the world can be invented anew without constraints. But the expectation that this new symbolic territory will be immune to the same tendencies to regulate life that characterize the corporeal world is unrealistic.

Lawyers are already at work on cases where electronic events have threatened or violated constitutional rights and have resulted in psychological or even physical harm to individuals. However, legal codes will not be applied to virtual action without great difficulty. As attorney Ann Branscomb states, "The ease with which electronic impulses can be manipulated, modified and erased is hostile to a deliberate legal system that arose in an era of tangible things and relies on documentary evidence to validate transactions, incriminate miscreants and affirm contractual relations."[27]

As we know from the many accounts of hacker behavior and from novels such as *Neuromancer*, psychic engagement with electronic communication can be intense. What is possible, as virtual reality research makes the visualization of electronic identities more palpable, is that the potential for boundaries between corporeal and virtual identities to become blurred will increase. In Baudrillard's sense, electronic identity for some may no longer be a representation of a self but may become the self against which life in the body is poor psychic competition.

Cynicism about the constructive possibilities of the American political system leaves a vacuum of meaning in civil society which offers little or no resistance to the artificial. In fact the artificial as entertainment, from video games to interactive VR environments, may become even more engaging than corporeal life.[28] It may also become such a powerful diversion that incursions into the natural by aggressive biotech corporations will go unnoticed.

The images of becoming as explorations of fantasy are a far cry from the discourses on human development embodied in the different strands of the spiritual metanarrative. Within this metanarrative, becoming is part of a continuity of development that results in a self which understands its purpose within a larger framework of spiritual evolution. For those who hold this belief, spiritual evolution is the ground of reality against which the virtues of the artificial must be assessed.

The late Jesuit theologian and scientist Pierre Teilhard de Chardin related the motivation to embrace spiritual evolution to the force with which it is experienced: "In any morality of movement, on the contrary, which is only defined by relation to a state or object to be reached, it is imperative that the goal shall shine with enough light to be desired and held in view."[29]

For Teihlard the Jesuit priest, it is the love of the Divine that animates human beings to strive together toward a higher unity. Yet, as a paleontologist, he realized that humans need to think about spirituality in a new way that does not oppose the realm of the spirit to that of science. As he wrote in an unpublished text of 1937, "What we are all more or less lacking at this moment is a new definition of holiness."[30]

spirituality and the future of design

We are now challenged to take up Teilhard's question at a moment when the capabilities of technology are outstripping our understanding of what it means to be human.[31] As artificial beings like cyborgs or replicants more closely represent what we have always thought a human is, we are hard pressed to define the difference between us and them. This is the problem that Donna Haraway addressed in her myth of the cyborg, which draws humans into a closer relation with machines. "No objects, spaces, or bodies are sacred in themselves," she argued in "A Manifesto for Cyborgs"; "any component can be interfaced with any other if the proper standard, the proper code, can be constructed for processing signals in a common language."[32] The film *Blade Runner* plays with this idea of interchangeability, leaving ambiguous the relation of the bounty hunter, played by Harrison Ford, to the female replicant, whose feeling for him may or may not be the equivalent of human love.

To move toward a self that is more *differentiated from* rather than *similar to* artificial constructs we need to understand the connection to the Divine as a force of evolution that is not in opposition to technology but at the same time offers some of the equivalent fulfillments we currently seek in the realm of the artificial.[33] We are living in a moment that Teilhard de Chardin could not have conceived in 1937, a moment where the real cannot be taken for granted but must be wrested from the artificial. This is not an easy task, but it is one in which we need to engage if we are not to be engulfed by simulacra. It means finding a way of talking about the spiritual that does not present it in opposition to the artificial but instead recognizes particular forms of the artificial as fruitful man-

ifestations of spiritual energy. The task is difficult because of the plurality of human experience and the lack of a discourse that can accomodate the presence of spirituality even for those who resist it or marginalize it.

The first step, however, is to reintroduce the concept of spirituality into the current philosophic debates from which it has been excluded. As a rhetorical move, spirituality must be brought from the margins of contemporary thought to a more central position. By considering its place in our reflections on the artificial, we can raise questions about design and technology that would otherwise go unasked. For example, we would have to wrestle with questions of whether particular forms of artificiality—a genetic mutant, an artificial-life environment, or an expert AI system, for example—were appropriate replacements for equivalent phenomena we have designated as natural. In short, we would have to manage the boundaries between the artificial, which is human-made, and the natural, which exists independent of human design.

While this distinction is more problematic than it may have appeared to Herbert Simon in 1969, it nonetheless empowers us to stake out a different territory for design, one that does not attempt to completely replace the natural but instead to complement it. This view is in opposition to the thrust of techno-rhetoric that always argues for the superiority of the artificial.

The Australian design theorist Tony Fry addressed this problem in a lecture on eco-design given at Notre Dame University in 1993. While Fry was referring to the effects of too much design on the natural environment, I find his words germane to the larger issue of boundaries for the artificial: "Designers have to become more informed about the environmental impact of what they do; they have to be more critical, more responsible. They/l have to fully recognise, that whatever they/l design goes on designing. It/I/they also have to discover how to stop designing, which implies learning how to let essential systems be, or designing mechanisms of artificial support that render future design action redundant."[34]

A metanarrative of spirituality can help designers resist techno-rhetoric that sanctions the continuous colonization of the natural. It can provide instead a more profound and conscious reflection on the artificial as a subject which has yet to be explored with any depth by designers and technologists. Such reflection

can resist the reduction of the artificial to simulacra, on the one hand, or violations of nature, on the other.

To the degree that a metanarrative of spirituality is articulated as a discourse on human purpose, it can enable technologists and designers to make decisions about what research directions to pursue and what to design.[35] I don't want to make grandiose claims for spirituality as the source of an entirely new design paradigm when in fact many of our products already fully satisfy human needs. But I do want to suggest that the more a designer or an engineer can conceive of a user as a person of depth and worth, the more likely he or she is to design a valuable product.[36]

Design, understood in a deeper sense, is a service. It generates the products that we require to live our lives. To the degree that our activities are enabled by the presence of useful products, spirituality can be a source for cultivating a sense of what is worthwhile. As manifested in product design and technological devices, spirituality is the attention to human welfare and life enhancement seen both in relation to the individual self and to humanity as a whole. As designers and technologists develop a more caring feeling for how people live, they may also generate new products that respond to previously unimagined human activities. A discourse on human purpose generated independently of the market is not utopian; it can have an effect on what the market produces.

A greater attentiveness to questions of human welfare and purpose can also help us weigh the merits of new technologies as well as the possibilities they offer for the design of products. Bruce Sterling has characterized virtual reality as the "ultimate designable medium," which can absorb infinite amounts of human ingenuity.[37] The design of cyberspace, for example, could become a parallel economy where electronic analogs of corporeal experience are bought and sold. This activity could absorb vast amounts of capital and concentrate it in the hands of a few corporations that control the technology to make it happen. We need to ask ourselves whether the construction of such analogs is where designers can most usefully concentrate their talent and the economy its capital? I think not.

While ecological concern is no substitute for the spiritual, eco-design has nonetheless generated a discourse in which the natural, and human cooperation with it, are central. In recent years ecology has become important to prod-

uct designers and the public. Thus, we are now rethinking the construction and purpose of many products in terms of materials, longevity, maintenance, and other factors.[38]

A metanarrative of spirituality can empower designers and technologists to better understand design as a form of action that contributes to social well-being. It can link design to a process of social improvement that becomes the material counterpart of spiritual evolution. Here a sense of continuity with the modern period can reinvigorate the idea of a larger project for design that needs to be thought anew in relation to contemporary conditions. Most importantly, a spiritual metanarrative can empower individuals to act confidently and forcefully in the face of a widespread cultural nihilism.

This metanarrative can also reunite design with the two contested terms, "meaning" and "reality," in a way that resists their collapse. There is clearly a need to understand the meaning of products within a larger set of issues about the artificial, but no theory has thus far addressed this problem.

To consider the question of the artificial in the way we need to, I want to return to Herbert Simon's 1969 Compton Lectures. I don't think we can accept Simon's assumption that either "nature" or "science" hold uncontested claims to truth. What I believe is important in Simon's work, particularly in terms of my own call for a new metanarrative, is his delineation of the natural and the artificial as distinct realms. Although the natural can be transformed into the artificial through human action, and Simon acknowledges that "the world we live in today is much more a man-made, or artificial, world than it is a natural world,"[39] the natural is not interchangeable with the artificial.

Today we recognize that the artificial is a much more complex phenomenon than postulated by Simon in 1969. We therefore need to address it as a problem in a new way. The various critiques of positivism and patriarchy, the deconstruction of scientific discourse, and the multiple new voices that now fill the space of social debate are all part of a different situation within which the artificial must be rethought. Among those heavily invested in the artificial as a replacement for the natural, resistance to this challenge is strong. And yet, as the artificial's incursion into the natural domain of our lives advances, we may lose part of our humanity. In the face of such a prospect, there is no choice but to fight back.

the violence
of public art
do the right thing

w. j. t. mitchell

IN MAY, 1988, I TOOK WHAT MAY WELL
be the last photograph of the statue of
Mao Tse Tung on the campus of
Beijing University. The thirty-foot
monolith was enveloped in a bamboo
scaffolding "to keep off the harsh desert winds," my hosts told me with know-
ing smiles. That night, workers with sledgehammers reduced the statue to a
pile of rubble, and rumors spread throughout Beijing that the same thing was
happening to Mao statues on university campuses all over China. One year
later, most of the world's newspaper readers scanned the photos of Chinese
students erecting a thirty-foot styrofoam and plaster "Goddess of Democracy"
directly facing the disfigured portrait of Mao in Tiananmen Square despite
the warnings from government loudspeakers: "This statue is illegal. It is not
approved by the government. Even in the United States statues need permis-
sion before they can be put up."[1] A few days later the newspaper accounts told
us of army tanks mowing down this statue along with thousands of protesters,
reasserting the rule of what was called "law" over a public and
its art.

The Beijing Massacre, and the confrontation of images at the central public space in China, is full of instruction for anyone who wants to think about public art and, more generally, of the whole relation of images, violence, and the public sphere.[2] "Even in the United States" political and legal control is exerted, not only over the erection of public statues and monuments, but over the display of a wide range of images, artistic or otherwise, to actual or potential publics. Even in the United States, the "publicness" of public images goes well beyond their specific sites or sponsorship: "publicity" has, in a very real sense, made all art into public art. And even in the United States, art that enters the public sphere is liable to be received as a provocation to or an act of violence.

This juxtaposition of the politics of American public art with the monumental atrocities of Tiananmen Square has struck some readers as deeply inappropriate. Zhang Longxi has argued that it is a "rather casual use of the Chinese example," one that "seems to trivialize the momentum of a great and tragic event" and "verges on endorsing the Chinese government's view" while failing to understand the "true meaning of that phrase"—"even in the United States"— "coming out of government loudspeakers."[3] My aim, of course, is not to endorse the Chinese government's massacre of its people, but to see what might be learned from its manner of legitimating that massacre. The government's verbal pretensions of legality and public civility coupled with the most transparent visual representations of brutal violence effectively dismembered and disarticulated the smooth suturing of the television news imagetext. But the spectacle does more than undermine the phrase, revealing it as a cynical alibi for state repression; it also puts the phrase into a new orbit of global circulation and connects it, albeit anachronistically and a-topically, with other public spectacles of monumental violence and violence against monuments. "Even in the U.S." comes home to roost, as it were, and the question is how. This sort of juxtaposition and circulation is what it means to live in a society of spectacle and surveillance, the world of the pictorial turn. Zhang Longxi is right to worry that such specular linkages risk trivializing great and tragic events. But the ability to differentiate and connect the trivial and the tragic, the insignificant and the monumental, is precisely what is at issue in the critique of art, violence, and the public sphere. Above all, the relations of literal and figurative violence, of vio-

lence by and against persons, and violence by and against images, can only be measured at the risk of trivializing the monumental and vice versa.

Our own historical moment in the United States has seemed especially rich in examples of public acts and provocations that cross the boundaries between real and symbolic violence, between the monumental and trivial. The erosion of the boundary between public and private spheres in a mediatized, specular society is what makes those border crossings possible, even inevitable. Recent art has carried the scandals previously associated with the cloistered spaces of the art world—the gallery, the museum, and the private collection—into the public sphere. And the public, by virtue of governmental patronage of the arts, has taken an interest in what is done with its money, no matter whether it is spent on traditional public art—in a public place as a public commission—or on a private activity in a private space that just happens to receive some public support or publicity. The controversy over Richard Serra's *Tilted Arc* sculpture in a public plaza in New York City marks one boundary of this phenomenon. Serra's is a traditional work of public art; it provoked another engagement in what Michael North has called the "tiresome battle, repeated in city after city . . . whenever a piece of modern sculpture is installed outdoors."[4] But now the battle has moved indoors, into the spaces of museums and art schools. The privacy of the exhibition site is no longer a protection for art that does symbolic violence to revered public figures like the deceased mayor of Chicago or to public emblems and icons like the American flag or the crucifix.

The erosion of the boundary between public and private art is accompanied by a collapsing of the distinction between symbolic and actual violence, whether the "official" violence of police, juridical, or legislative power or the "unofficial" violence in the responses of private individuals. Serra's *Tilted Arc* was seen as a violation of public space, was subjected to actual defacement and vandalism by some members of the public, and became the subject of public legal proceedings to determine whether it should be dismantled.[5] The official removal of an art student's caricature of Mayor Washington from the School of the Chicago Art Institute involved, not just the damaging of the offensive picture, but a claim that the picture was itself an "incitement to violence" in black communities. A later installation at the same school asking *What Is the Proper Way to Display*

the American Flag? was construed as an invitation to "trample" on the flag. It immediately attracted threats of unofficial violence against the person of the artist and may ultimately serve as the catalyst not simply for legislative action but for a constitutional amendment protecting the flag against all acts of symbolic or real violence. The response to Andres Serrano's *Piss Christ* and the closing of the Mapplethorpe show at the Corcoran Gallery indicate the presence of an American public, or at least of some well-entrenched political interests, that is fed up with tolerating symbolic violence against religious and sexual taboos under the covers of "art," "privacy," and "free speech" and is determined to fight back with the very real power of financial sanctions.[6] The United States is nowhere near to sending tanks to mow down students and their statues, but it has recently endured a period when art and various partial publics (insofar as they are embodied by state power and "public opinion") have seemed on a collision course.

The association of public art with violence is nothing new. The fall of every Chinese dynasty since antiquity has been accompanied by the destruction of its public monuments, and the long history of political and religious strife in the West could almost be rewritten as a history of iconoclasm. The history of communism, from Eisenstein's *October* to CNN's coverage of the collapse of the Soviet Union, has been largely framed by images of the demolition of public monuments. There is also nothing new about the violent opposition of art to its public. Artists have been biting the hands that feed them since antiquity,[7] and even the notion of an "avant-garde" capable of scandalizing the bourgeoisie has been dismissed, by a number of critics, to the dustbin of history. The avant-garde, in Thomas Crow's words, now functions "as a kind of research and development arm of the culture industry."[8] Oppositional movements such as surrealism, expressionism, and cubism have been recuperated for entertainment and advertising, and the boldest gestures of High Modernism have become the ornaments of corporate public spaces. If traditional public art identified certain classical styles as appropriate to the embodiment of public images, contemporary public art has turned to the monumental abstraction as its acceptable icon. What Kate Linker calls the "corporate bauble" in the shopping mall or bank plaza need have no iconic or symbolic relation to the public it

serves, the space it occupies, or the figures it reveres.[9] It is enough that it serve as an emblem of aesthetic surplus, a token of "art" imported into and adding value to a public space.

The notorious "anti-aesthetic" posture of much postmodern art may be seen, in its flouting of the canons of High Modernism, as the latest edition of the icon-oclastic public icon, the image which affronts its own public—in this case, the art world as well as the "general" public. The violence associated with this art is inseparable from its *publicness*, especially its exploitation of and by the appara-tuses of publicity, reproduction, and commercial distribution.[10] The scan-dalousness and obtrusive theatricality of these images holds up a mirror to the nature of the commodified image and the public spectator addressed by adver-tising, television, movies, and "Art" with a capital A. If all images are for sale, it's hardly surprising that artists would invent public images that are difficult (in any sense) to "buy." Postmodern art tries, among other things, to be difficult to own or collect, and much of it succeeds, existing only as ruined fragments, or photographic "documentation." Much of it also "fails," of course, to be unmar-ketable and thus "succeeds" quite handsomely as an aesthetic commodity, as Andy Warhol's work demonstrates. The common thread of both the marketable and the unmarketable artwork is the more or less explicit awareness of "mar-ketability" and publicity as unavoidable dimensions of any public sphere that art might address. "Co-optation" and "resistance" are thus the ethical maxims of this public sphere and the aesthetic it generates.

The violence associated with this art may seem, then, to have a peculiarly desperate character and is often directed at the work itself as much as its beholder. Sometimes a self-destructive violence is built into the work, as in Jean Tinguely's self-destroying machine sculpture, *Homage to New York*, or Rudolf Schwarzkogler's amputation of his own penis, both of which now exist only in photographic documentation.[11] More often, the violence suffered by contem-porary art seems simultaneously fateful and accidental, a combination of mis-understanding by local or partial publics and a certain fragility or temporariness in the work itself. The early history of Claes Oldenburg's monumental *Lipstick* at Yale University is one of progressive disfigurement and dismantling. Many of the works of Robert Smithson and Robert Morris are destroyed, existing now

only in documents and photographs. The openness of contemporary art to publicity and public destruction has been interpreted by some commentators as a kind of artistic aggression and scandal-mongering. A more accurate reading would recognize it as a deliberate vulnerability to violence, a strategy for dramatizing new relations between the traditionally "timeless" work of art and the transient generations, the "publics," that are addressed by it.[12] The defaced and graffiti-laden walls that Jonathan Borofsky installs in museum spaces are a strategy for reconfiguring the whole relation of private and public, legitimate and "transgressive" exhibition spaces. Morris's 1981 proposal to install the casings of nuclear bombs as monumental sculpture at a Florida VA hospital was both a logical extension of a public sculpture tradition (the public display of obsolete weapons) and a deadpan mimicry of the claim that these weapons "saved American lives" in World War II.[13]

The question naturally arises: Is public art inherently violent, or a provocation to violence? Is violence built into the monument in its very conception? Or is violence simply an accident that befalls some monuments, a matter of the fortunes of history? The historical record suggests that if violence is simply an accident that happens to public art, it is one that is always waiting to happen. The principal media and materials of public art are stone and metal sculpture not so much by choice as by necessity. "A public sculpture," says Lawrence Alloway, "should be invulnerable or inaccessible. It should have the material strength to resist attack or be easily cleanable, but it also needs a formal structure that is not wrecked by alterations."[14] The violence that surrounds public art is more, however, than simply the ever-present possibility of accident—the natural disaster or random act of vandalism. Much of the world's public art—memorials, monuments, triumphal arches, obelisks, columns, and statues—has a rather direct reference to violence in the form of war or conquest. From Ozymandias to Caesar to Napoleon to Hitler, public art has served as a kind of monumentalizing of violence and never more powerfully than when it presents the conqueror as a man of peace imposing a Napoleonic code or a *pax Romana* on the world. Public sculpture that is too frank or explicit about this monumentalizing of violence, whether the Assyrian palace reliefs of the 9th century B.C., or Morris's bomb sculpture proposal of 1981, is likely to offend the sensibilities of a public

committed to the repression of its own complicity in violence.[15] The very notion of public art as we receive it is inseparable from what Jurgen Habermas has called "the liberal model of the public sphere," a pacified space distinct from economic, private, and political dimensions. In this ideal realm disinterested citizens may contemplate a transparent emblem of their own inclusiveness and solidarity and deliberate on the general good, free of coercion, violence, or private interests.[16]

The fictional ideal of the classic public sphere is that it includes everyone; the fact is that it can only be constituted by the rigorous exclusion of certain groups—slaves, children, foreigners, those without property, and (most conspicuously) women.[17] The very notion of the "public," it seems, grows out of a conflation of two very different words, *populo* (the people) and *pubes* (adult men). The word *public* might more properly be written with the "l" in parentheses to remind us that, for much of human history political and social authority has derived from a "pubic" sphere, not a public one. This seems to be the case even when the public sphere is personified as a female figure. The famous examples of female monuments to the all-inclusive principle of public civility and rule of law—Athena to represent impartial Athenian justice, the Goddess of Reason epitomizing the rationalization of the public sphere in revolutionary France, the Statue of Liberty welcoming the huddled masses from every shore— all presided over political systems that rigorously excluded women from any public role.[18]

Perhaps some of the power associated with the Vietnam Veterans' Memorial in Washington, D.C., comes from its cunning violation and inversion of monumental conventions for expressing and repressing the violence of the pub(l)ic sphere. The VVM is anti-heroic, anti-monumental, a V-shaped gash or scar, a trace of violence suffered, not (as in the conventional war memorial) of violence wielded in the service of a glorious cause.[19] It achieves the universality of the public monument, not by rising above its surroundings to transcend the political, but by going beneath the political to the shared sense of a wound that will never heal, or (more optimistically) a scar that will never fade. Its legibility is not that of narrative: no heroic episode such as the planting of the American flag on Iwo Jima is memorialized, only the mind-numbing and undifferentiated

chronology of violence and death catalogued by the 57,000 names inscribed on the black marble walls. The only other legibility is that of the giant flat "V" carved in the earth itself, a multivalent monogram or initial that seems uncannily overdetermined. Does the "V" stand for Vietnam? For a pyrrhic "Victory"? For the Veterans themselves? For the Violence they suffered? Is it possible, finally, to avoid seeing it as a quite literal anti-type to the "pubic sphere" signified in the traditional phallic monument, the Vagina of Mother Earth opened to receive her sons, as if the American soil were opening its legs to show the scars inscribed on her private parts?

Even as this monument seems to invert the symbolic valences of the traditional war memorial, however, it reinscribes them at a more subtle level. The privates of Mother Earth are all men (Frederick Hart's "supplement" to the VVM, a traditional sculptural group of three male GIs, makes this exclusion of women visible). And although the authorship of the VVM design by a Chinese-American woman is sometimes adduced to explain its pacifist form, the ethnicity of Maya Lin seems mainly an ironic footnote to a memorial that (unsurprisingly) has no place for the suffering of the Vietnamese. If the VVM is a successful work of public art, it is not because it manages to "heal" the wounds of the past or to re-open them with forms of critical violence: it succeeds only in keeping the space between these possibilities open, in the way an indelible scar provokes an indefinite series of narratives and counternarratives.[20]

It should be clear that the violence associated with public art is not simply an undifferentiated abstraction, any more than is the public sphere it addresses. Violence may be in some sense "encoded" in the concept and practice of public art, but the specific role it plays, its political or ethical status, the form in which it is manifested, the identities of those who wield and suffer it, is always nested in particular circumstances. We may distinguish three basic forms of violence in the images of public art, each of which may, in various ways, interact with the other: (1) the image as an *act* or *object* of violence, itself doing violence to beholders, or "suffering" violence as the target of vandalism, disfigurement, or demolition; (2) the image as a *weapon* of violence, a device for attack, coercion, incitement, or more subtle "dislocations" of public spaces; (3) the image as a *representation* of violence, whether a realistic imitation of a violent act, or a mon-

ument, trophy, memorial, or other trace of past violence. All three forms are, in principle, independent of one another: an image can be a weapon of violence without representing it; it may become the object of violence without ever being used as a weapon; it may represent violence without ever exerting or suffering it. In fact, however, these three forms of violence are often linked together. Pornography is said to be a representation of and a weapon of violence against women which should be destroyed or at least banned from public distribution.[21] The propaganda image is a weapon of war which obviously engages with all three forms of violence in various ways, depending on the circumstances. The relation of pornography to propaganda is a kind of displaced version of the relation of "private" to "public" art: the former projects fetishistic images confined, in theory, to the "private sphere" of sexuality; the latter projects totemistic or idolatrous images directed, in theory, at a specific public sphere.[22] In practice, however, private "arousal" and public "mobilization" cannot be confined to their proper spheres: rape and riot are the "surplus" of the economy of violence encoded in public and private images.

These elisions of the boundary between public and private images are what make it possible, perhaps even necessary, to connect the sphere of public art in its "proper" or traditional sense (works of art installed in public places by public agencies at public expense) to film, a medium of public art in an extended or "improper" sense.[23] Although film is sometimes called the central public art of the twentieth century, we should be clear about the adjustments in both key terms—"public" and "art"—required to make this turn. Film is not a "public art" in the classic sense stipulated by Habermas; it is deeply entangled with the marketplace and the sphere of commercial-industrial publicity that replaces what Habermas calls the "culture-debating" public with a "culture-consuming" public.[24] We need not accept Habermas's historical claim that the classic public sphere (based in the "world of letters") was "replaced by the pseudo-public or sham-private world of culture consumption" to see that its basic distinction between an ideal, utopian public sphere and the real world of commerce and publicity is what underwrites the distinction between public art "proper" and the "improper" turn to film, a medium that is neither "public" nor "art" in this proper (utopian) sense.

This juxtaposition of public art and commercial film illuminates a number of contrasting features whose distinctiveness is under considerable pressure, both in contemporary art and recent film practice. An obvious difference between public art and the movies is the contrast in mobility. Of all forms of art, public art is the most static, stable, and fixed in space: the monument is a fixed, generally rigid object, designed to remain on its site for all time.[25] The movies, by contrast, "move" in every possible way—in their presentation, their circulation and distribution, and in their responsiveness to the fluctuations of contemporary taste. Public art is supposed to occupy a pacified, utopian space, a site held in common by free and equal citizens whose debates, freed of commercial motives, private interest, or violent coercion, will form "public opinion." Movies are beheld in private, commercial theaters that further privatize spectators by isolating and immobilizing them in darkness. Public art stands still and silent while its beholders move in the reciprocal social relations of festivals, mass meetings, parades, and rendezvous. Movies appropriate all motion and sound to themselves, allowing only the furtive, private rendezvous of lovers or of auto-eroticism.

The most dramatic contrast between film and public art emerges in the characteristic tendencies of each medium with respect to the representation of sex and violence. Public art tends to repress violence, veiling it with the stasis of monumentalized and pacified spaces, just as it veils gender inequality by representing the masculine public sphere with the monumentalized bodies of women. Film tends to express violence, staging it as a climactic spectacle, just as it foregrounds gender inequality by fetishizing rather than monumentalizing the female body. Sex and violence are strictly forbidden in the public site, and thus the plaza, common, or city square is the favored site for insurrection and symbolic transgression, with disfiguration of the monument a familiar, almost ritual occurrence.[26] The representation of sex and violence is licensed in the cinema and it is generally presumed (even by the censors) that it is re-enacted elsewhere—in streets, alleys, and private places.

I have rehearsed these traditional distinctions between film and public art not to claim their irresistible truth but to sketch the conventional background against which the relations of certain contemporary practices in film and public art may be understood—their common horizon of resistance, as it were.

Much recent public art obviously resists and criticizes its own site, and the fixed, monumental status conventionally required of it; much of it aspires, quite literally, to the condition of film in the form of photographic or cinematic documentation. I turn now to a film that aspires to the condition of public art, attempting a similar form of resistance within its own medium and holding up a mirror to the economy of violence encoded in public images.[27]

. . .

In May of 1989 I tried unsuccessfully to attend an advance screening of Spike Lee's *Do the Right Thing* at the University of Chicago. Students from the university and the neighborhood had lined up for six hours to get the free tickets, and none of them seemed interested in scalping them at any price. Spike Lee made an appearance at the film's conclusion and stayed until well after midnight answering the questions of the overflow crowd. This event turned out to be a preview not simply of the film, but of the film's subsequent reception. Lee spent much of the summer answering questions about the film in television and newspaper interviews; the *New York Times* staged an instant symposium of experts on ethnicity and urban violence; and screening of the film (especially in urban theaters) took on the character of festivals, with audiences in New York, London, Chicago, and Los Angeles shouting out their approval to the screen and to each other.

The film elicited disapproval from critics and viewers as well. It was denounced as an incitement to violence and even as an *act* of violence by viewers who regarded its representations of ghetto characters as demeaning.[28] The film moved from the familiar commercial public sphere of "culture consumption" into the sphere of public art, the arena of the "culture-debating" public, a shift signaled most dramatically by its exclusion from the "Best Picture" category of the Academy Awards. As the film's early reception subsides into the cultural history of the late eighties in the United States, we may now be in a position to assess its significance as something more than a "public sensation" or "popular phenomenon." *Do the Right Thing* is rapidly establishing itself not only as a work of public art (a "monumental achievement" in the trade lingo), but as a film *about* public art.[29] The film tells a story of multiple ethnic public spheres, the

violence that circulates among and within these partial publics, and the tendency of this violence to fixate itself on specific images—symbolic objects, fetishes, and public icons or idols.

The specific public image at the center of the violence in *Do the Right Thing* is a collection of photographs, an array of signed publicity photos of Italian-American stars in sports, movies, and popular music framed and hung up on the "Wall of Fame" in Sal's Famous Pizzeria at the corner of Stuyvesant and Lexington Avenues in Brooklyn. A young bespectacled man named "Buggin' Out" (who is the closest thing to a "political activist" to be found in this film) challenges this arrangement, asking Sal why no pictures of black Americans are on the wall. Sal's response is an appeal to the rights of private property: "You want brothers up on the Wall of Fame, you open up your own business, then you can do what you wanna do. My pizzeria. American-Italians only up on the wall." When Buggin' Out persists, arguing that blacks should have some say about the Wall since their money keeps the pizzeria in business, Sal reaches for a baseball bat, a publicly recognizable emblem of both the American way of life and of recent white-on-black violence. Mookie, Sal's black delivery boy (played by Spike Lee) defuses the situation by hustling Buggin' Out of the pizzeria. In retaliation, Buggin' Out tries, quite unsuccessfully, to organize a neighborhood boycott and the conflict between the black public and the private white-owned business simmers on the back burner throughout the hot summer day. Smiley, a stammering, semi-articulate black man who sells copies of a unique photograph showing Martin Luther King and Malcolm X together, tries to sell his photos to Sal (who seems ready to be accommodating) but is driven off by Sal's son Pino. Sal is assaulted by another form of "public art" when Radio Raheem enters the pizzeria with his boom box blasting out Public Enemy's rap song, "Fight the Power." Finally, at closing time, Radio Raheem and Buggin' Out re-enter Sal's, radio blasting, to demand once again that some black people go up on the Wall of Fame. Sal smashes the radio with his baseball bat, Raheem pulls Sal over the counter and begins to choke him. In the riot that follows, the police kill Radio Raheem and depart with his body, leaving Sal and his sons to face a neighborhood uprising. Mookie throws a garbage can through the window of the pizzeria, and the mob loots and burns it. Later, when the fire is burning

down, Smiley enters the ruins and pins his photograph of King and Malcolm to the smoldering Wall of Fame.

Sal's Wall of Fame exemplifies the central contradictions of public art. It is located in a place that may be described, with equal force, as a public accommodation and a private business. Like the classic liberal public sphere, it rests on a foundation of private property which comes into the open when its public inclusiveness is challenged. Sal's repeated refrain throughout the film to express both his openness and hospitality to the public and his "right" to reign as a despot in his "own place" is a simple definition of what his "place" is: "This is America." As "art," Sal's wall stands on the threshold between the aesthetic and the rhetorical, functioning simultaneously as ornament and as propaganda, both a private collection and a public statement. The content of the statement occupies a similar threshold, the hyphenated space designated by "Italian-American," a hybrid of particular ethnic identification and general public identity. The Wall is important to Sal not just because it displays famous Italians but because they are famous *Americans* (Sinatra, DiMaggio, Liza Minelli, Mario Cuomo) who have made it possible for Italians to think of themselves as Americans, full-fledged members of the general public sphere. The Wall is important to Buggin' Out because it signifies exclusion from the public sphere. This may seem odd, since the neighborhood is filled with public representations of African American heroes on every side: a huge billboard of Mike Tyson looms over Sal's pizzeria; children's art ornaments the sidewalks and graffiti streaks subversive messages like "Tawana told the truth" on the walls; Magic Johnson T-shirts, Air Jordan sneakers, and a variety of jewelry and exotic hairdos make the characters like walking billboards for "Black pride"; and the sound-world of the film is suffused with a musical "Wall of Fame," a veritable anthology of great jazz, blues, and popular music emanating from Mister Señor Love Daddy's storefront radio station, just two doors away from Sal's.

Why aren't these tokens of black self-respect enough for Buggin' Out? The answer, I think, is that they are only tokens of self-respect, of black pride, and what Buggin' Out wants is the respect of whites, the acknowledgment that African-Americans are hyphenated Americans too, just like Italians.[30] The public spaces accessible to blacks in the film are *only* public and that only in

the special way that the sphere of commercial-industrial publicity (a sphere which includes, of course, movies themselves) is available to blacks. They are, like the public spaces in which black athletes and entertainers appear, rarely owned by blacks themselves; they are reminders that black public figures are by and large the "property" of a white-owned corporation—whether a professional sports franchise, a recording company, or a film distributor. The public spaces in which blacks achieve prominence are thus only sites of publicity or of marginalized arts of resistance, the disfiguring of public spaces epitomized by graffiti, not of a genuine public sphere they may enter as equal citizens. The spaces of publicity, despite their glamour and magnitude, are not as important as the humble little piece of "real America" that is Sal's Pizzeria, the semiprivate, semipublic white-owned space, the threshold space that supports genuine membership in the American public sphere. The one piece of public art "proper" that appears in the film is an allegorical mural across the street from Sal's, and it is conspicuously marginalized; the camera never lingers on it long enough to allow decipherment of its complex images. The mural is a kind of archaic residue of a past moment in the black struggle for equality, when "Black Pride" was enough. In *Do the Right Thing* the blacks have plenty of pride; what they want, and cannot get, is the acknowledgment and respect of whites.

The film is not suggesting, however, that integrating the Wall of Fame would solve the problem of racism, or allow African Americans to enter the public sphere as full-fledged Americans. Probably the most fundamental contradiction the film suggests about the whole issue of public art is its simultaneous triviality and monumentality. The Wall of Fame is, in a precise sense, the "cause" of the major violence in the narrative, and yet it is also merely a token or symptom. Buggin' Out's boycott fails to draw any support from the neighborhood, which generally regards his plan as a meaningless gesture. The racial integration of the public symbol, as of the public accommodation, is merely a token of public acceptance. Real participation in the public sphere involves more than tokenism: it involves full economic participation. As long as blacks do not own private property in this society, they remain in something like the status of public art, mere ornaments to (or disfigurations of) the public place, entertaining statues and abstract caricatures rather than full human beings.

Spike Lee has been accused by some critics of racism for projecting a world of black stereotypes in his film: Tina, the tough, foul-mouthed sexy ghetto babe; Radio Raheem, the sullen menace with his ghetto blaster; "Da Mayor," the neighborhood wino; "Mother Sister," the domineering, disapproving matriarch who sits in her window all day posed like Whistler's mother. Lee even casts himself as a type, a streetwise, lazy, treacherous hustler who hoards his money, neglects his child, and betrays his employer by setting off the mob to destroy the pizzeria. But it is not enough to call these stereotypes "unrealistic"; they are, from another point of view, highly realistic representations of the public *images* of blacks, the caricatures imposed on them and (sometimes) acted out by them. Ruby Dee and Ossie Davis, whom Lee cast as the Matriarch and the Wino, have a long history of participation in the film proliferation of these images, and Dee's comment on the role of black elders is quite self-conscious about this history: "When you get old in this country, you become a statue, a monument. And what happens to statues? Birds shit on them. There's got to be more to life for an elder than that."[31] The film suggests that there's got be more to life for the younger generation as well, which seems equally in danger of settling into a new image-repertoire of stereotypes. It is as if the film wanted to cast its characters as publicity images with human beings imprisoned inside them, struggling to break out of their shells to truly participate in the public space where they are displayed.

This "breaking out" of the public image is what the film dramatizes and what constitutes the violence that pervades it. Much of this violence is merely trivial or irritating, involving the tokens of public display, as when an Irish yuppie home-steader (complete with Larry Bird t-shirt) steps on Buggin' Out's Air Jordans; some is erotic, as in Tina's dance as a female boxer, which opens the film; some is subtle and poetic, as in the scene when Radio Raheem breaks out of his sullen silence, turns off his blaster, and does a rap directly addressed to the camera, punctuating his lines with punches, his fists clad in massive gold rings that are inscribed with the words "Love" and "Hate." Negative reactions to the film tend to obsessively focus on the destruction of the pizzeria, as if the violence against property were the only "real" violence in the film. Radio Raheem's murder is regularly passed over as a mere link in the narrative chain that leads to the climactic spectacle of the burning pizzeria. Spike Lee has also been criticized for

showing this spectacle at all; the film has routinely been denounced as an incite-
ment to violence or at least a defense of rioting against white property as an act
of justifiable violence in the black community. Commentators have complained
that the riot is insufficiently motivated, or that it is just there for the spectacle, or
to prove a thesis.[32] In particular, Spike Lee has been criticized for allowing
Mookie's character to "break out" of its passive, evasive, uncommitted stance at
the crucial moment, when he throws the garbage can through the window.

Mookie's act dramatizes the whole issue of violence and public art by staging
an act of vandalism against a public symbol and specifically by smashing the
plate glass window that marks the boundary between public and private prop-
erty, the street and the commercial interest. Most of the negative commentary
on the film has construed this action as a political statement, a call by Spike Lee
to advance African-American interests by trashing white-owned businesses. Lee
risks this misinterpretation, of course, in the very act of staging this spectacle
for potential monumentalization as a public statement, a clearly legible image
readable by all potential publics as a threat or model for imitation. That this
event has emerged as the focus of principal controversy suggests that it is not so
legible, not so transparent as it might have seemed. Spike Lee's motives as writer
and director—whether to make a political statement, give the audience the spec-
tacle it wants, or fulfill a narrative design—are far from clear. And Mookie's
motivation as a character is equally problematic: at the very least, his action
seems subject to multiple private determinations—anger at Sal, frustration at his
dead-end job, rage at Radio Raheem's murder—that have no political or "pub-
lic" content. At the most intimate level, Mookie's act hints at the anxieties about
sexual violence that we have seen encoded in other public monuments. Sal has,
in Mookie's view, attempted to seduce his sister, Jade (whom we have seen in a
nearly incestuous relation to Mookie in the opening scene), and Mookie has
warned his sister never to enter the pizzeria again (this dialogue staged in front
of the pizzeria's brick wall, spray-painted with the graffiti message, "Tawana
told the Truth," an evocation of another indecipherable case of highly publi-
cized sexual violence). Mookie's private anxieties about his manhood ("Be a
man, Mookie!" is his girlfriend Tina's hectoring refrain) are deeply inscribed in
his public act of violence against the public symbol of white domination.

But private, psychological explanations are far from exhausting the meaning of Mookie's act. An equally compelling account would regard the smashing of the window as an ethical intervention. At the moment of Mookie's decision the mob is wavering between attacking the pizzeria and assaulting its Italian American owners. Mookie's act directs the violence away from persons and toward property, the only choice available in that moment. One could say that Mookie "does the right thing," saving human lives by sacrificing property.[33] Most fundamentally, however, we have to say that Spike Lee himself "does the right thing" in this moment by breaking the illusion of cinematic realism and intervening as the director of his own work of public art, taking personal responsibility for the decision to portray and perform a public act of violence against private property. This choice breaks the film loose from the *narrative* justification of violence, its legitimation by a law of cause and effect or political justice, and displays it as a pure effect of *this* work of art in this moment and place. The act makes perfect sense as a piece of Brechtean theater, giving the audience what it wants with one hand and taking it back with the other.

We may call *Do the Right Thing* a piece of "violent public art," then, in all the relevant senses—as a representation, an act, and a weapon of violence. But it is a work of *intelligent* violence, to echo the words of Malcolm X that conclude the film. It does not repudiate the alternative of nonviolence articulated by Martin Luther King in the film's other epigraph (this is, after all, a film, a symbolic and not a "real" act of violence); it resituates both violence and nonviolence as strategies within a struggle that is simply an ineradicable fact of American public life. The film may be suffused in violence, but unlike the "Black Rambo" films that find such ready acceptance with the American public, it takes the trouble to differentiate this violence with ethically and aesthetically precise images. The film exerts a violence on its viewers, badgering us to "fight the power" and "do the right thing," but it never underestimates the difficulty of rightly locating the power to be fought or the right strategy for fighting it. A prefabricated propaganda image of political or ethical correctness, a public monument to "legitimate violence" is exactly what the film refuses to be. It is, rather, a monument of resistance, of "intelligent violence," a ready-made assemblage of images that reconfigures a local space—literally, the space of the black ghetto, figuratively,

the space of public images of race in the American public sphere. Like the Goddess of Democracy in Tiananmen Square, the film confronts the disfigured public image of legitimate power, holding out the torch of liberty with two hands, one inscribed with *Hate*, the other with *Love*.

We may now be in a position to measure the gap between the tragic events of spring 1989 in China and the impact of a Hollywood film that just happened to be released at the same moment. The gap between the two events, and the images that brought them into focus for mass audiences, may seem too great for measurement. But it is precisely the distance between the monumental and the trivial, between violence in the "other country" and our own, that needs to be assessed if we are to construct a picture, much less a theory, of the circulation of visual culture in our time. The Goddess of Democracy imaged a short-lived utopian and revolutionary monument that seems to grow in stature as it recedes in memory. It brought briefly into focus the possible emergence of a democratic, civil society in a culture and political order that has endured the violence of state repression for centuries. *Do the Right Thing* deploys its utopian, revolutionary rhetoric on a much smaller stage (a street in Brooklyn), and its challenge to established power is much more problematic and equivocal. If the Goddess claimed to symbolize the aspirations of a majority, an all-inclusive public sphere, Spike Lee's film articulates the desperation of a minority, a partial public, calling on the majority to open the doors to the public sphere promised by its official rhetoric. The violence in *Do the Right Thing* may be local, symbolic, even "fictional" in contrast to the Tiananmen Square massacre, but it refers unequivocally to the widespread, unrelenting, and very real violence against African Americans in the United States, both the direct physical violence of police repression instantiated by Radio Raheem's murder and the long-term economic violence perpetrated by the white majority.

Perhaps the most obvious contrast between the Goddess and *Do the Right Thing* is the sense (doubtless inaccurate)[34] that the former is an image of revolutionary "purity," the latter a highly impure image-repertoire of compromises, trade-offs, and sell-outs. The harshest criticism that has been made of Spike Lee is the claim that he is merely another "corporate populist," franchising his own celebrity as a star and director, trading in his progressive principles for adver-

tising contracts with the Nike Corporation.[35] The advantage of this *ad hominem* attack is that it saves a lot of time: one needn't actually look at *Do the Right Thing* (or at Spike Lee's witty, ironic commercials for Nike), because one already knows that he is a capitalist.

On the other hand, if one is willing to grant that corporate capital constitutes the actual, existing conditions for making movies with any chance of public circulation, then one actually has to look at the work and assess its value.[36] *Do the Right Thing* makes abundant sense as a film *about* corporate populism, a critique of the effects of capital in a multi-ethnic American community. The film shows what it is like to live in a community where no utopian public image or monument is available to symbolize collective aspirations, a community where personal identity is largely constituted by commodity fetishism—from Air Jordan sneakers to Magic Johnson jerseys to designer jewelry and elephantine boom boxes.

The meaning of these fetishes, however, is not confused with the labeling of them as fetishistic. They are treated critically, with irony, but without the generalized contempt and condescension generally afforded to "mere" fetishes. Radio Raheem's blaster is as important to him as Sal's pizzeria (and the Wall of Fame) is to him. Both are commercial objects *and* vehicles for the propagation of public statements about personal identity. Even the image in the film that comes closest to being a sacred, public totem, the photograph of King and Malcolm X shaking hands, has been turned by Smiley into a commodity. The affixing of this image, with all of its connotations of love and hate, violence and nonviolence, to the smoldering remains of the Wall of Fame, is the closest the film comes to the sort of apotheosis achieved by the Goddess of Democracy as she faced the disfigured portrait of Mao.

If *Do the Right Thing* has a moral for those who wish to continue the tradition of public art and public sculpture as a utopian venture, a "daring to dream" of a more humane and comprehensive public sphere, it is probably in the opening lines of the film, uttered by the ubiquitous voice of Love Daddy: "Wake up!" Public art has always dared to dream, projecting fantasies of a monolithic, uniform, pacified public sphere, a realm beyond capitalism and outside history. What seems called for now, and what many contemporary

artists wish to provide, is a *critical* public art that is frank about the contradic-
tions and violence encoded in its own situation, one that dares to awaken a
public sphere of resistance, struggle, and dialogue. Exactly how to negotiate
the border between struggle and dialogue, between the argument of force and
the force of argument, is an open question, as open as the two hands of the
Goddess of Democracy or the two faces of revolution in Smiley's photograph.

> *Violence as a way of achieving racial justice is both impracti-
> cal and immoral. It is impractical because it is a descending
> spiral ending in destruction for all. The old law of an eye for an
> eye leaves everybody blind. It is immoral because it seeks to
> humiliate the opponent rather than win his understanding; it
> seeks to annihilate rather than to convert. Violence is immoral
> because it thrives on hatred rather than love. It destroys com-
> munity and makes brotherhood impossible. It leaves society in
> monologue rather than dialogue. Violence ends by defeating
> itself. It creates bitterness in the survivors and brutality in the
> destroyers.*—Martin Luther King, Jr., *"Where Do We Go from
> Here?"* Stride toward Freedom: The Montgomery Story
> (*New York:* 1958), p. 213

> *I think there are plenty of good people in America, but there are
> also plenty of bad people in America and the bad ones are the
> ones who seem to have all the power and be in these positions to
> block things that you and I need. Because this is the situation,
> you and I have to preserve the right to do what is necessary to
> bring an end to that situation, and it doesn't mean that I advo-
> cate violence, but at the same time I am not against using vio-
> lence in self-defense. I don't even call it violence when it's
> self-defense, I call it intelligence.*—Malcolm X, *"Communication
> and Reality,"* Malcolm X: The Man and His Times, *edited by*
> John Henrik Clarke (*New York,* 1969), p. 313

notes

notes for the foreword

1 For these essays by Derrida, Rorty, and Leclau, see Chantal Mouffe, ed., *Deconstruction and Pragmatism* (New York: Routledge, 1996).

2 *Music/Ideology: Resisting the Aesthetic* is the title of another book in the Critical Voices series. Its editor is Adam Krims.

notes for introduction

We thank Jon Erickson and Stephen Pentak for previewing a draft of this introduction.

1 *Zen Flesh, Zen Bones: A Collection of Zen and Pre-Zen Writings,* compiled by Paul Reps and translated by Nyogen Senzaki (Garden City, N.Y.: Anchor Books, n.d.), 35–36.

2 Elaine Scarry, *The Body in Pain: The Making and Unmaking of the World* (New York: Oxford University Press, 1985), 291–92

3 Yi-fu Tuan, *Landscapes of Fear* (New York: Pantheon Books, 1979), 6.

4 Aristotle, *Nicomachean Ethics,* trans. W. D. Ross, in *The Basic Works of Aristotle,* ed. Richard McKeon (New York: Random House, 1941), 957–59.

5 Jean Dubuffet, "Anticultural Positions," a lecture given at the Arts Club of Chicago, 1951, from the exhibition catalogue, *Dubuffet and the Anticulture* (New York: Richard L. Feigen and Co., 1969).

6 Ibid.

7 *Zen Flesh, Zen Bones*, 32.

8 *The New York Times*, "Law Students Buy and Hold Pollution Rights" (March 31, 1995).

notes for toward the spiritual in design

1 The first poster for the Bauhaus in 1919 carried Gropius's invitation to prospective students to help build the Bauhaus as 'the new cathedral of socialism'.

2 This useful coinage by Kirkpatrick Sale describes the results when we judge the past using only the standards of our own period and culture.

3 'All beauty that has not a foundation in use, soon grows distasteful, and needs continual replacement with something new. That which has itself the highest use, possesses the greatest beauty.' From the *Shaker Millennial Laws*, 1795.

4 Freud wrote of the relationship between horror and beauty in *Civilization and its Discontents* (New York, 1961 edn); 'terrible beauty' is in Siva as both creator and destroyer. A fighter-bomber, however, has no such ambivalence.

notes for political space part I: moonmark

1 Hence my reservations about the term *political*. Throughout its entire history, the term and its relations (*community, party, citizen, city,* etc.) have accommodated difference only in its dialectical or categorical forms. As such, the term has always operated in service of one or another philosophy of unity. All philosophies of unity necessarily privilege similarity over difference and therefore subsume any respect for difference under the auspices of an aspiration to achieve greater unification. It seems that a program whose aspiration is to propose social aggregations based on the constructive potential of difference-as-such must eventually abandon the term/discourse of the political without lapsing into a discourse of the individual or individualism.

notes for sex objects

1 On design, streamlining, and the machine, see Richard Guy Wilson, Dianne Pilgrim, and Dickran Tashjian, *The Machine Age in America, 1918–1941* (New York: Brooklyn

Museum, 1986). See also Donald J. Bush, *The Streamlined Decade* (New York: George Braziller, 1975) and Jeffrey L. Meikle, *Twentieth Century Limited: Industrial Design in America, 1925–1939* (Philadelphia: Temple University Press, 1979). On car design, see Karal Ann Marling, "America's Love Affair with the Automobile in the Television Age," *Design Quarterly 146* (1989): 5–19.

2 J. Gordon Lippincott asserts the primacy of the female consumer in *Design for Business* (Chicago: Paul Theobold, 1947).

3 For a general history of working women, see Alice Kessler-Harris, *Out to Work: A History of Wage-Earning Women in the United States* (New York: Oxford University Press, 1982).

4 Betty Friedan revived the women's movement with *The Feminine Mystique* (New York: Dell Publishing, 1963).

5 Marshall McLuhan helped found modern media studies with his book *The Mechanical Bride: Folklore of Modern Man* (New York: Vanguard Press, 1951).

6 On cultural studies, see Daniel Miller, *Material Culture and Mass Consumption* (Oxford: Basil Blackwell, 1987).

7 On commodity fetishism, see Karl Marx, *Capital*, Vol. I (New York: International Publishers, 1966), 35–41, 71–79; and Wolfgang Fritz Haug, *Commodity Aesthetics, Ideology, and Culture* (New York: International General, 1987).

8 On the sexual fetish, see Sigmund Freud, "Fetishism," *Sexuality and the Psychology of Love* (New York: Collier Books, 1963), 214–19.

9 Gayle Rubin analyzes the "sex/gender" system in relation to anthropology and psychoanalysis in "The Traffic in Women: Notes on the Political Economy of Sex," *Toward an Anthropology of Women*, ed. Rayna Rapp Reiter (New York: Monthly Review, 1975), 157–210.

10 Feminist histories of technology include Ruth Schwartz Cowan, *More Work for Mother: The Ironies of Household Technology from the Open Hearth to the Microwave* (New York: Basic Books, 1983); Christina Hardyment, *From Mangle to Microwave: The Mechanization of Household Work* (Cambridge: Polity Press, 1988); and Susan Strasser, *Never Done: A History of American Housework* (New York: Pantheon, 1982).

Design history is considered from a feminist viewpoint in Dolores Hayden, *The Grand Domestic Revolution* (Cambridge: MIT Press, 1981) and *Redesigning the American Dream: The Future of Housing, Work, and Family* (New York: W. W. Norton, 1984); Adrian Forty, *Objects of Desire* (New York: Pantheon, 1986); and Penny Sparke, *Electrical Appliances: Twentieth-Century Design* (New York: E. P. Dutton, 1987).

Critical overviews of feminist approaches to design history include Judy Attfield, "FORM/female follows FUNCTION/male: Feminist Critiques of Design," in *Design History and the History of Design*, ed. John A. Walker (London: Pluto Press, 1989), 199–235; Cheryl Buckley, "Made in Patriarchy: Towards a Feminist Analysis of Women and Design," *Design Issues 3* (1987): 3–15; and Barbara Oldershaw, "Developing a Feminist Critique of Architecture," *Design Book Review 25* (Summer 1992): 7–15. See also *Sexuality and Space*, ed. Beatriz Colomina (New York: Princeton Architectural Press, 1992).

notes for design, aging, ethics and the law

1 Dykwald, Kenneth, *Age Wave* (Los Angeles: Age Wave, 1987).

2 Olshansky, S. Jay, Bruce A. Carnes and Christine K. Cassel, "The Aging of the Human Species," *Scientific American* (April 1993).

3 U.S. Department of Commerce, Economics and Statistical Administration, *Statistical Abstract of the United States 1992* (Washington, D.C.: U.S. Government Printing Office, 1992).

4 Thomas, William C., *Nursing Homes and Public Policy: Drift and Decision in New York State* (Ithaca: Cornell University Press, 1969).

5 Birch, David, *Job Creation in America* (New York: Macmillan, 1987).

6 Pastalan, Leon A., "Privacy as an Expression of Human Territory," in Caron and Pastalan, eds., *Spatial Behavior of Older People* (Ann Arbor: University of Michigan Press, 1970).

7 Murch, Gerald M., "Human Factors of Displays," in *Colors in Computer Graphics: Course Notes* (published notes of the SIGGRAPH Conference, 1987).

8 Teague, Michael A., "Leisure Product Development: Outlining the Need," in *Independent Living Environments for Seniors and Persons with Disabilities: Proceedings and Directions '91* (Winnipeg, Manitoba: 1991).

9 Cohen, Uriel and Gerald Weisman, *Environments for People with Dementia: Design Guide* (Milwaukee: The Center for Architecture and Urban Planning Research, University of Wisconsin-Milwaukee, 1988).

10 Pirkl, James J. and Anna L. Babic, *Guidelines and Strategies for Designing Transgenerational Products: A Resource Manual for Industrial design Professionals* (Syracuse: The Center for Instructional Development, Syracuse University, 1988).

11 Zacharkow, Dennis, *Posture, Sitting, Standing, Chair Design and Exercise* (Springfield, Ill.: Charles C. Thomas, 1988).

12 Industrial Designers Association of America, *Directory of Industrial Designers* 1992/92. (McLean, Va.: Industrial Designers Association of America, 1992).

notes for painting and ethics

1 I owe the reminder that Richter's painting *Betty* can be understood as an experience of the nape to a friend.

2 But, as Levinas also claims, the relationship of an ethics of the "face to face," of one to an other, is behind the facade, prior to expression, experienced more forcefully in the nape of the neck. When asked to respond to a bust whose face is covered by a box by sculptor Sacha Sasno, Levinas suggests that the obliterated face is better experienced at the "napes of the necks of those people who wait in line at the entrance gate of Lubyanka prison in Moscow," for example. Emmanuel Levinas and Françoise Armengaud, "On Obliteration: Discussing Sacha Sasno," see *Art and Text* 33 (Winter 1989): 38.

3 Gerhard Richter, *The Daily Practice of Painting* (Massachusetts: MIT Press, 1995), 129–30.

4 Another friend reminds me that *vernissage* comes from the word vernir, which is "to varnish." A vernissage or opening of an exhibition is therefore by implication a day in which, during the Salons, the artists were authorized to varnish their paintings so that they might be considered finished and ready for exposure.

5 Jean-François Lyotard, "Conservation and Colour," *The Inhuman*, Trans. Geoffrey Bennington and Rachel Bowlby, (California: Stanford University Press, 1991), 146.

6 Ibid.

7 Daniel Buren is outspoken about the function of the museum. As he puts it, the museum is a privileged place with a triple role: "one, aesthetic: as frame which promotes a singular cultural viewpoint; two, economic: as promoting consumption and exposure; and three, mystical: as cloaking the art within the power of the museum thereby promoting an object to art status." Museums are another cloak. See Buren, "Function of the Museum," *Five Texts* (New York: The John Weber Gallery; London: The Jack Wendler Gallery, 1973), 57.

8 It has come to my attention, since the rewriting of this essay, that photo-souvenirs 383 and 384 reflect a 1987 piece by Daniel Buren entitled *Wall on Wall, Wall under Wall, Painting on Painting, Painting under Painting,* in which Buren "reframed" several Cranach paintings in the Cranach "room" of the museum, where they were hung, by constructing a parallel wall of stretched, striped fabric into which holes, corresponding to the size and positioning of the Cranachs, were cut. The Cranachs were then placed, every other one, in their corresponding holes, framed by Buren's stripes.

Buren notes afterwards: "work partially destroyed: certain constitutive elements of the piece—in other words, Cranach's works—have been preserved." In Daniel Buren, *Daniel Buren*, Photo-Souvenirs 1965 –1988 (Paris: Art Edition, 1988) 314.

9 We might consider the painting and the museum as the "stable treasure." See Maurice Merleau-Ponty, "Eye and Mind," *The Merleau-Ponty Aesthetics Reader: Philosophy and Painting*, ed. Galen Johnson and trans. James M. Edie (Illinois: Northwestern University Press, 1993), 149.

10 Christian Prigent, *Comme la Peinture: Like Painting (Daniel Dezeuze)*, trans. Tony Long (Paris: Yvon Lambert, 1983), 71.

11 Ibid., 72.

12 Ibid., 72.

13 For Levinas, the face, in its dislocation from its surface, is something that cannot be killed. "It is what cannot become a content, which your thought would embrace; it is uncontainable, it leads you beyond. It is in this that the signification of the face makes its escape from being, as a correlate of a knowing. Vision, to the contrary, is a search for adequation; it is what par excellence absorbs being. But the relation to the face is straightaway ethical. The face is what one cannot kill, or at least it is that whose *meaning* consists in saying: "thou shalt not kill." Murder, it is true, is a banal fact: one can kill the Other; the ethical exigency is not an ontological necessity." In Emmanuel Levinas, *Ethics and Infinity: Conversations with Phillippe Nemo*, trans. Richard A. Cohen (Pittsburgh: Dequesne University Press, 1985).

14 Lyotard, "Conservation and Colour," 151.

15 Emmanuel Levinas, *Totality and Infinity* (Pittsburgh: Duquesne University Press, 1961), 199.

16 Lyotard, "Sublime and the Avant-Garde," *The Inhuman*, 93.

17 Lyotard, "After the Sublime, the State of Aesthetics," *The Inhuman*, 137.

18 Richter, 84.

19 John Rajchman, *Truth and Eros, Foucault, Lacan and the Question of Ethics* (New York and London: Routledge, 1991), 1.

20 Ibid., 26.

21 Richter, 245. Richter's abstract paintings appear to be thick pulls of paint.

notes for the politics of the artificial

1 In recent years several tendencies have challenged this emphasis. Among them is the conceptualization of design as strategic planning. Another is an emphasis on the interactive aspects of "smart" projects such as the Xerox copying machine. For a discussion of how changes in human experience stimulate new forms of design prac-

tice, see Richard Buchanan, "Wicked Problems in Design Thinking," *Design Issues* 8, no. 2 (Spring 1992): 5–22.

2 See Herbert Simon, *The Sciences of the Artificial* (Cambridge, Mass.: MIT Press, 1969), 4, and John Chris Jones, *Designing Design* (London: Architecture and Technology Press, 1991).

3 Branzi has devised the term "second modernity" to characterize our present moment.
"What I mean by this term," states Branzi, "is an acceptance of Modernity as an artificial cultural system based neither on the principle of necessity nor on the principle of identity but on a set of conventional cultural and linguistic values that somehow make it possible for us to go on making choices and designing." For Branzi the principles of necessity and identity may refer to the modern movement's concern with function and its faith in objects that could embody a sense of absolute value. He characterizes the second modernity in terms of a set of theorems that differentiate the conditions of design from the prior period. This term enables him to continue talking about a "project for design," as the designers of the first modernity did, without having to ignore either postmodernism's critical responses to modernism or the cultural complexities of the present that it has recognized. See Andrea Branzi, "An Ecology of the Artificial" and "Towards a Second Modernity," in Andrea Branzi, *Learning from Milan: Design and the Second Modernity* (Cambridge, Mass.: MIT Press, 1988). See also Branzi, "Three Theorems for an Ecology of the Artificial World," in *La Quarta Metropoli: Design e Cultura Ambientale* (Milan: Domus Academy Edizioni, 1990).

4 Simon, 4.

5 Simon, 6.

6 Simon, 6.

7 Donna Haraway, "A Manifesto for Cyborgs: Science, Technology, and Socialist Feminism in the 1980s," *Socialist Review* 80, (March–April 1985): 60. Haraway reflected on her essay in several subsequent interviews. See Constance Penley and Andrew Ross, "Cyborg at Large: Interview with Donna Haraway," in *Technoculture*, eds. Constance Penley and Andrew Ross, *Cultural Politics*, vol. 3 (Minneapolis: University of Minnesota Press, 1991) 1–20, followed in the same volume by Donna Haraway, "The Actors Are Cyborg, Nature Is Coyote, and the Geography is Elsewhere: Postscript to 'Cyborgs at Large'," 21–26. See also Marcy Darnovsky, "Overhauling the Meaning Machines: An Interview with Donna Haraway," *Socialist Review* 21, no. 2 (April–June 1991): 65–84.

8 Gianni Vattimo, "An Apology for Nihilism" in Vattimo, *The End of Modernity: Nihilism and Hermeneutics in Postmodern Culture,* translated and with an introduction by Jon R. Snyder (Baltimore: Johns Hopkins University Press, 1988), 21.

9 Vattimo, 21.

10 William Gibson, *Neuromancer* (New York: Ace Books, 1984). For a reflection on the relation of Gibson's novels to central issues of postmodernism, see Peter Fitting, "The Lessons of Cyberpunk," in Penley and Ross, *Technoculture*, 295–316.

11 Jean Baudrillard, "The Precession of Simulacra" in Baudrillard, *Simulations* (New York: Semiotext(e), 1983), 3.

12 Baudrillard, 11.

13 Baudrillard 10.

14 Jean-François Lyotard, *The Postmodern Condition: A Report on Knowledge,* translated by Goeff Bennington and Brian Massumi (Minneapolis: University of Minnesota Press, 1984), xxiv.

15 Baudrillard, xxiv.

16 Mark Sagoff, "On Making Nature Safe for Biotechnology," in *Assessing Ecological Risks of Biotechnology,* ed. Lev Ginzburg (Stoneham, MA: Butterworth-Heinemann, 1991), 345.

17 Fitting 299.

18 Paula Gunn Allen, "The Woman I Love is a Planet; The Planet I Love is a Tree," in *Reweaving the World: The Emergence of Ecofeminism,* ed. and with essays by Irene Diamond and Gloria Feman Orenstein (San Francisco: Sierra Club Books, 1990), 52.

19 Carol P. Christ, "Rethinking Theology and Nature," in Diamond and Orenstein, 58.

20 Starhawk, "Power, Authority, and Mystery," in Diamond and Orenstein, 76

21 Haraway, 69

22 Haraway, 81.

23 For an extensive survey of virtual reality research, see Howard Rheingold, *Virtual Reality* (London: Secker & Warburg, 1991).

24 "An Interview with Jaron Lanier," *Whole Earth Review* (Fall 1989): 110.

25 Dennis Doordan, "Nature on Display," *Design Quarterly* 155 (Spring 1992): 36.

26 A hopeful alternative to this conclusion is the current discussion within the Internet community on the relation of electronic space to the body.

27 Ann Branscomb, "Common Law for the Electronic Frontier," *Scientific American* 265, no. 3 (September 1991): 112.

28 This theme is particularly significant in light of the current emergence of right-wing, xenophobic, and fundamentalist groups around the world whose messianic militancy has posed a severe challenge to liberal democracy. The survival of democratic institutions and the struggle for social justice now require significant attention and action by many who may find it more tempting to ignore this call and devote their primary attention to the electronic realm.

29 Pierre Teilhard de Chardin, "The Phenomenon of Spirituality," in Teihlard de Chardin, *Human Energy* (London: Collins, 1969), 109.

30 Teilhard de Chardin, 110.

31 A recent exhibition catalog by Jeffrey Deitch and Dan Friedman is entitled *Post-Human* (New York: J. Deitch, 1992). The Australian performance artist Stelarc has created a performance that deconstructs the idea of the human through an intensive relation of biology and technology. See Stelarc, "Da strategie a cyberstrategie: prostetica, robotica ed esistenza remota." *Il Corpo Tecnologico: La Influenze delle Tecnologie sul Corpo e sulle Sue Facolta,* ed. Pier Luigi Capucci (Bologna: Baskerville, 1994), 61–76. Similar themes are addressed in *Incorporations* [Zone 6], edited by Jonathan Crary and Sanford Kwinter (New York: Zone, 1992).

32 Haraway, 82.

33 The opposite course is taken by Hans Moravec in his search for congruencies between humans and machines. See Hans Moravec, *Mind Children: The Future of Robot and Human Intelligence* (Cambridge, Mass.: Harvard University Press, 1988).

34 Tony Fry, "Crisis, Design, Ethics," unpublished paper presented at Notre Dame University, February 1993.

35 The work of the Japanese industrial designer Kenji Ekuan is a good example of how spiritual values can be self-consciously brought into design practice. Trained as a Buddhist priest before becoming a designer, Ekuan views products as more than functional objects. See Kenji Ekuan, "Smallness as an Idea," in *Design and Industry,* ed. Richard Langdon, Design Policy vol. 2, (London: Design Council, 1984), 140–43. In this paper Ekuan makes special reference to the butsudan, a small portable Buddhist altar that can be installed in the home. He writes that "the butsudan represents the essence of man's life in a condensed form." It is "a portable device that helps the Japanese people communicate with their ancestors and, above all, with themselves." I cite his characterization of the *butsudan* as indicative of his aim to embody spiritual values in material products.

36 Martin Buber has addressed the question of depth in human relationships in his seminal book *I and Thou,* translated with a prologue and notes by Walter Kaufmann (New York: Scribner's, 1970). I discussed Buber's work as the basis for a new design ethics in my article, "Community and the Graphic Designer," *Icographic* 2, no. 4 (March 1984): 2–3.

37 Sterling made these comments as part of a presentation at the Cooper-Hewitt conference, "At the Edge of the Millennium" in New York City, January 15–18, 1992. See Bruce Sterling and Tucker Viemeister, "Momentum," in *The Edge of the Millennium: An International Critique of Architecture, Urban Planning, Product and*

Communication Design ed. Susan Yelavich (New York: Whitney Library of Design, 1993), 149.

38 A leading organization in this field is the Eco-Design Foundation in Sydney, Australia. For information, contact the foundation at P.O. Box 369, Rozelle, New South Wales 2039, Australia. An important book that demonstrates the kinds of new products that can result from an alternative design paradigm is Nancy Jack Todd and John Todd, *From Eco-Cities to Living Machines* (Berkeley: North Atlantic Books, 1994). This is a revised version of an earlier edition which was entitled *Bioshelters, Ocean Arks, City Farming: Ecology as the Basis of Design* (San Francisco: Sierra Club Books, 1984).

39 Simon, 3.

notes for the violence of public art

1 See Uli Schmetzer, *Chicago Tribune*, 1 June 1989, p. 1.

2 For an excellent discussion of the way the events in China in June 1989 became a "spectacle for the West," overdetermined by the presence of a massive publicity apparatus, see Rey Chow, "Violence in the Other Country: Preliminary Remarks on the 'China Crisis,' June 1989," *Radical America* 22 (July–August 1989): 23–32. See also Wu Hung, "Tiananmen Square: A Political History of Monuments," *Representations* 35 (Summer 1991): 84–117.

3 Zhang Longxi, "Western Theory and Chinese Reality," *Critical Inquiry* 19:1 (Autumn 1992): 114.

4 Michael North, *The Final Sculpture: Public Monuments and Modern Poets* (Ithaca, NY: Cornell University Press, 1985), p. 17. *Tilted Arc* is "traditional" in its legal status as a commission by a public, governmental agency. In other ways (style, form, relation to site, public legibility) it is obviously nontraditional.

5 For an excellent account of this whole controversy and the decision to remove *Tilted Arc*, see *Public Art/Public Controversy: The Tilted Arc on Trial*, edited by Sherrill Jordan et al. (New York: American Council for the Arts, 1987).

6 On the neoconservative reactions against controversial forms of state-supported art in the late 1980s, see Paul Mattick, Jr., "Arts and the State," *Nation* 251:10 (1 October 1990): 348–58.

7 G. E. Lessing notes that beauty in visual art was not simply an aesthetic preference for the ancients but a matter of juridical control. The Greeks had laws against caricature, and the ugly "dirt painters" were subjected to censorship. See Lessing's *Laocoon: An Essay upon the Limits of Poetry and Painting*, translated by Ellen Frothingham (1766; New York: publisher, 1969), pp. 9–10.

8 Thomas Crow, "Modernism and Mass Culture in the Visual Arts," in *Pollock and After: The Critical Debate*, edited by Francis Frascina (New York: Harper and Row, 1985), p. 257.

9 See Kate Linker's important essay, "Public Sculpture: The Pursuit of the Pleasurable and Profitable Paradise," *ArtForum* 19 (March 1981): 66.

10 Scott Burton summarizes the "new kind of relationship" between art and its audience: "it might be called public art. Not because it is necessarily located in public places but because the content is more than the private history of the maker" (quoted in Henry Sayre, *The Object of Performance* [Chicago: University of Chicago Press, 1989], p. 6).

11 See Sayre, *The Object of Performance*, pp. 2–3.

12 For a shocking example of an artist's misrepresentation of these issues, see Frederick E. Hart, "The Shocking Truth about Contemporary Art," *The Washington Post*, 28 August–3 September 1989, national weekly edition, op-ed. section. It hardly comes as a surprise that Hart is the sculptor responsible for the figural "supplement" to the Vietnam Veterans' Memorial, the traditional monumental figures of three soldiers erected in the area facing the Memorial.

13 See Robert Morris, "Fissures," unpublished manuscript, Guggenheim Museum Archives.

14 Lawrence Alloway, "The Public Sculpture Problem," *Studio International* 184:948 (October 1972): 124.

15 See Leo Bersani and Ulysse Dutoit, "The Forms of Violence," *October* 8 (Spring 1979): 17–29, for an important critique of the "narrativization" of violence in Western art and an examination of the alternative suggested by the Assyrian palace reliefs.

16 Habermas first introduced this concept in *Structural Transformation of the Public Sphere*, translated by Thomas Burger and Frederick Lawrence (Cambridge, MA: MIT Press, 1989). First published in German in 1962, it has since become the focus of an extensive literature. See also Habermas's short encyclopedia article, "The Public Sphere," translated by Sara Lennox and Frank Lennox, *New German Critique* 1, no. 3 (Fall 1974): 49–55, and the introduction to it by Peter Hohendahl in the same issue, pp. 44–48. I owe much to the guidance of Miriam Hansen and Lauren Berlant on this complex and crucial topic.

17 See Joan Landes, *Women and the Public Sphere in the Age of the French Revolution* (Ithaca, NY: Cornell University Press, 1988), p. 3.

18 Rey Chow notes the way the "Goddess of Democracy" in Tiananmen Square replicates the "*King Kong* syndrome," in which the body of the white woman sutures the gap between "enlightened instrumental reason and barbarism-lurking-behind-the Wall," the "white man's production and the monster's destruction" (Chow, "Violence in the Other Country," p. 26).

19 See Charles Griswold, "The Vietnam Veterans' Memorial and the Washington Mall: Philosophical Thoughts on Political Iconography," *Critical Inquiry* 12, no. 4 (Summer 1986): 709. Griswold reads the VVM as a symbol of "honor without glory."

20 These issues, and a suggestion that the "healing" provided by the VVM may have as much to do with nationalist amnesia and historical revisionism as with critical commemoration, are discussed by Marita Sturken in "The Wall, the Screen, and the Image: The Vietnam Veterans' Memorial," *Representations* 35 (Summer 1991): 118–142.

21 See Catharine Mackinnon, *Feminism Unmodified* (Cambridge, MA: Harvard University Press, 1987), especially pp. 172–73 and 192–93.

22 For more on the distinction between totemism and fetishism, see my "Tableau and Taboo: The Resistance to Vision in Literary Discourse," *CEA Critic* 51 (Fall 1988): 4–10.

23 See Miriam Hansen, *Babel and Babylon: Spectatorship in American Silent Film* (Cambridge, MA: Harvard University Press, 1991), p. 7: "On one level, cinema constitutes a public sphere of its own. . . . At the same time cinema intersects and interacts with other formations of public life. . . ."

24 Habermas, *The Structural Transformation of the Public Sphere*, pp. 159–60.

25 The removal of *Titled Arc* is all the more remarkable (and ominous) in view of this strong presumption in favor of permanence.

26 The fate of the Berlin Wall is a perfect illustration of this process of disfiguration as a transformation of a public monument into a host of private fetishes. While the Wall stood it served as a work of public art, both in its official status and its unofficial function as a blank slate for the expression of public resistance. As it is torn to pieces, its fragments are carried away to serve as trophies in private collections. As German reunification proceeds, these fragments may come to signify a nostalgia for the monument that expressed and enforced its division.

27 By the phrase "economy of violence," I mean, quite strictly, a social structure in which violence circulates and is exchanged as a currency of social interaction. The "trading" of insults might be called the barter or "in-kind" exchange; body parts (eyes, teeth notably) can also be exchanged, along with blows, glares, hard looks, threats, and first strikes. This economy lends itself to rapid, runaway inflation, so that (under the right circumstances) an injury that would have been trivial (stepping on someone's sneakers, smashing a radio) is drastically overestimated in importance. As a currency, violence is notoriously and appropriately unstable.

28 Murray Kempton's review (*New York Review of Books*, 28 September 1989), pp. 37–38, is perhaps the most hysterically abusive of the hostile reviews. Kempton condemns Spike Lee as a "hack" who is ignorant of African-American history and guilty of "a low opinion of his own people" (p. 37). His judgment of Mookie, the character played by

Spike Lee in the film, is even more vitriolic: Mookie "is not just an inferior specimen of a great race but beneath the decent minimum for humankind itself" (p. 37).

29 One of the interesting developments in the later reception of *Do the Right Thing* has been its rapid canonization as Spike Lee's "masterpiece." Critics who trashed the film in 1989 now use it as an example of his best, most authentic work in order to trash his later films (most notably *Malcolm X*) by contrast.

30 I am indebted to Joel Snyder for suggesting this distinction between self-respect and acknowledgment.

31 Quoted in Spike Lee and Lisa Jones, *Do the Right Thing: A Spike Lee Joint* (New York: Simon and Schuster, 1989), caption to p. 30.

32 Terrence Rafferty ("Open and Shut," review of *Do the Right Thing*, in *The New Yorker*, 24 July 1989) makes all three complaints. Rafferty (1) reduces the film to a thesis about "the inevitability of race conflict in America"; (2) suggests that the violent ending comes only from "Lee's sense, as a filmmaker, that he needs a conflagration at the end"; and (3) compares Lee's film unfavorably to Martin Scorsese's *Mean Streets* and *Taxi Driver*, where "the final bursts of violence are generated entirely from within." What Rafferty fails to consider is (1) that the film explicitly articulates theses that are diametrically opposed to his reductive reading (most notably, Love Daddy's concluding call "My People, My People," for peace and harmony, a speech filled with echoes of Zora Neale Hurston's autobiography); (2) that the final conflagration might be deliberately staged—as is so much of the film—*as a stagey, theatrical event* to foreground a certain requirement of the medium; (3) that the psychological conventions of Italian-American neorealism with their "inner" motivations for violence are among the issues under examination in *Do the Right Thing*.

33 This interpretation was first suggested to me by Arnold Davidson, who heard it from David Welberry of the Philosophy Department at Stanford University. It received independent confirmation from audiences to this paper at Harvard, California Institute of the Arts, Williams College, University of Southern California, UCLA, Pasadena Art Center, the University of Chicago's American Studies Workshop, the Chicago Art History Colloquium, and Sculpture Chicago's conference on "Art in Public Places." I wish to thank the participants in these discussions for their many provocative questions and suggestions.

34 The "purity" of the Goddess of Democracy is surely compromised by the mixture of sources and motives that went into its production and effect. As Wu Hung notes, "it was not a copy" of the Statue of Liberty, and yet it "owed its form and concept" to "other existing monuments"—most notably the image of "a healthy young woman," specifically "a female student"—to stand for a new concept of the public sphere ("Tiananmen Square: A Political History of Monuments," p. 110). The students'

motives, moreover, ranged from revolutionary idealism to "mere" reform of government corruption and the hope for opportunities in more open exchanges with capitalist economies. Some observers, no doubt, saw the statue as an appeal to the true spirit of Maoism beneath the disfigured portrait.

35 This charge is made by Jerome Christensen in "Spike Lee, Corporate Populist," *Critical Inquiry* 17:3 (Spring 1991): 582–95. A more detailed rejoinder is provided in my "Seeing *Do the Right Thing*," in the same issue, pp. 596–608.

36 One of the more astonishing claims of Christensen's essay is its treatment of Lee's filmmaking as "the most advanced expression of the emergent genre of corporate art" (p. 589), a development in which "films . . . are rapidly being transformed into moving billboards for corporate advertising" (p. 590). This "emergence" and "transformation" will be news to film historians who have traced the links between corporate advertising and filmmaking to the earliest days of the industry. See Miriam Hansen on the commodification of the teddy bear in early cinema in her "Adventures of Goldilocks: Spectatorship, Consumerism, and Public Life," *Camera Obscura* 22 (January 1990): 51–71, and Jane Gaines, *Contested Culture: The Image, the Voice, and the Law* (Chapel Hill, NC: University of North Carolina, 1991), especially her analysis of commodity "tie-ups"—"the consumer goods and services that have been linked with the release of motion pictures" (p. xiii).

permissions

"Anticultural Positions," by Jean Dubuffet, translated by Joachim Neugroschel. From *Jean Dubuffet: Towards an Alternative Reality*, edited by Marc Glimcher, Pace Publications, Inc. and Abbeville Press, 1987, and reprinted with permission.

"Political Space Part I: Moonmark" by Jeffrey Kipnis. Reprinted with permission of the author. Previously published in *Assemblage* 16, December 1991.

"Sex Objects" by Ellen Lupton. Excerpted from *Mechanical Brides: Women and Machines from Home to Office*, by Ellen Lupton, New York: Cooper-Hewitt, National Design Museum, and Princeton Architectural Press, 1993. Reprinted with permission.

"The Politics of the Artificial" by Victor Margolin. From *Leonardo*, 28.5 (October, 1995), pp. 349–356. ©1995 by the International Society for the Arts, Science and Technology (ISAST). Reprinted with permission, MIT Press Journals.

"The Violence of Public Art: *Do the Right Thing* by W. J. T. Mitchell. From his book *Picture Theory: Essays on Verbal and Visual Representation*. Copyright © 1994, University of Chicago Press. Reprinted with permission.

photo permissions

contributors

Jean Dubuffet (1901–1985, French), artist and writer on art, his work has been the focus of numerous major international museum exhibitions. Dubuffet was also a collector and champion of *Art Brut*; his collection consisted of over 5,000 works of what is often referred to today as Outsider Art.

Keller Easterling created, with Richard Prelinger, *Call it Home*, a laserdisc history of American suburbia from 1934–1960. She is also author of *American Town Plans*, a book and HyperCard diskette. Her new book looks at eccentric episodes in American infrastructure building. She is an Assistant Professor of Architecture at Columbia University.

Hans Haacke, artist and Professor of Art, The Cooper Union, has had numerous museum and gallery exhibitions, both national and international. He shared the Golden Lion Award of the Venice Biennial 1993 with Nam June Paik, and published jointly *Free Exchange*, a conversation with Pierre Bourdieu.

Hachivi Edgar Heap of Birds, artist and Associate Professor of Art at the University of Oklahoma, is a headsman in the Cheyenne Elk Warrior Society, Oklahoma. His exhibitions include the Walker Art Center, the Museum of Modern Art, Exit Art, and the New Museum.

Jeffrey Kipnis, Associate Professor, Department of Architecture, The Ohio State University, has published in *Assemblage* and is the author of *In the Manor of Nietzche, A Choral Work: a Collaboration between Jacques Derrida and Peter Eisenman,* and *Architectural Strategies.*

Joseph Koncelik is Director of the Center for Rehabilitation Technology at the Georgia Institute of Technology. He is an industrial designer and author of *Designing the Open Nursing Home* and *Aging and the Product Environment* and numerous articles on design for the aging and disabled.

Maya Lin is an architect and sculptor involved in a range of activities that include architectural commissions, public artworks, and private sculpture. She is the designer of the Vietnam Veterans Memorial in Washington, D.C., and recipient of a Presidential Design Award.

Laura Lisbon is a painter and an Assistant Professor in the Department of Art at The Ohio State University. Her exhibitions include the Wexner Center for the Arts; Michael Klein Gallery, NYC; and the Everson Museum.

Ellen Lupton is the Curator of Contemporary Design at The Cooper-Hewitt, National Design Museum in New York City. She has curated numerous exhibitions including "Mechanical Brides: Women and Machines from Home to Office," and "Mixing Messages." A graphic designer and writer, she has produced a wide range of books and exhibition catalogues.

Victor Margolin, Associate Professor of Design History at University of Illinois, Chicago, is the founding editor and currently co-editor of the journal *Design Issues,* editor of *Design Discourse: History Theory Criticism,* co-editor of *Discovering Design: Explorations in Design Studies* and *The Idea of Design,* and author of *The Struggle for Utopia: Rodchenko, Lissitzky, Moholy-Nagy, 1917–1946.*

W. J. T. Mitchell is the Gaylord Donnelley Distinguished Service Professor in the Department of English Language and Literature and the Department of Art at the University of Chicago and editor of the Journal *Critical Inquiry.* The College Art Association recently awarded him the Charles Rufus Morey Book Award for *Picture Theory.*

Thomas McEvilley, Professor, Institute for the Arts, Rice University, is a contributing editor of *Artforum.* He is the author of numerous books and articles, including *Art and Discontent: Theory at the Millennium,* and *Art and Otherness: Crisis in Cultural Identity.* He received the College Art Association Frank Jewett Mather Award in 1993.

Victor Papanek is an industrial designer and J. L. Constant Distinguished Professor, School of Architecture and Urban Design at the University of Kansas. He is the author of *Design for the Real World, Design for Human Scale,* and *The Green Imperative.*

Stephen Pentak is a painter and a Professor in the Department of Art at The Ohio State University. His exhibitions include the Grace Borgenicht Gallery, the Wexner Center for the Arts, and the Columbus Museum of Art. He is co-author of *Design Basics.*

Jessica Prinz is an Associate Professor of English at The Ohio State University. She has published articles on art and literature in *Contemporary Literature, Journal of Modern Literature,* and *Genre,* and is the author of *Art Discourse/Discourse in Art.*

Richard Roth is an artist and a Professor in the Department of Art at The Ohio State University. His exhibitions include the Whitney Museum of American Art; Museum of Modern Art, Saitama, Japan; and Feigen, Inc., Chicago. He is a recipient of a National Endowment for the Arts Visual Artists Fellowship.

Susan King Roth is an Associate Dean in the College of the Arts, The Ohio State University, and Associate Professor in the Department of Industrial, Interior, and Visual Communication Design. She is a designer and design researcher, and has published articles in *Innovation, The Journal of Visual Literacy, Ethics and Values in Design Education,* and *Visible Language.*